The Art of Arousal

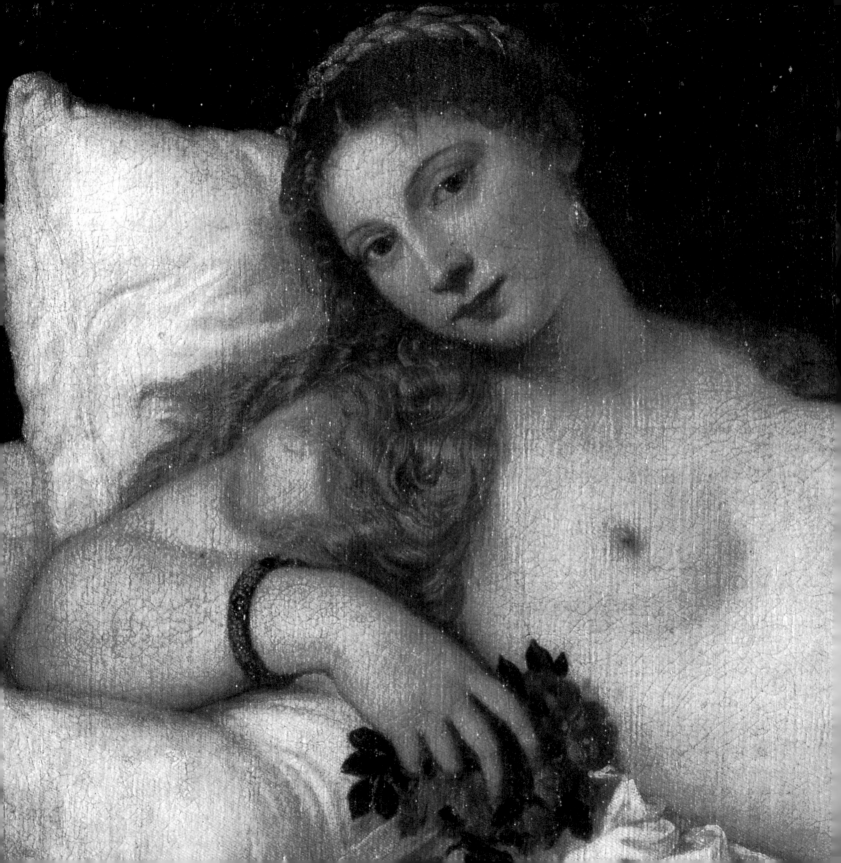

The Art of Arousal

DR. RUTH WESTHEIMER

ABBEVILLE PRESS • PUBLISHERS
New York • London • Paris

FRONT COVER: *Detail of Antonio Correggio,*
Jupiter and Io, *c. 1532. See page 123.*
BACK COVER: *Detail of Roy Lichtenstein,* We Rose up Slowly, *1964. See page 94.*
FRONTISPIECE: *Detail of Titian,* Venus of Urbino, *1538. See page 12.*

EDITOR: Nancy Grubb
DESIGNER: Patricia Fabricant
PRODUCTION EDITOR: Sarah Key
PICTURE EDITORS: Anne Manning, Lori Hogan, and Margot Clark-Junkins
PRODUCTION MANAGER: Matthew Pimm

First edition

Library of Congress Cataloging-in-Publication Data

Westheimer, Ruth K. (Ruth Karola), 1928–
 The art of arousal / Ruth Westheimer.
 p. cm.
 Includes index.
 ISBN 1-55859-330-6
 1. Erotic art. 2. Feminine beauty (Aesthetics)
I. Title.
N8217.E6W47 1993
704.9'428—dc20 92-25989
 CIP

Contents

Preface

Doing this book has proven to me that it is never too late to start off in a brand new direction. Just one year ago I would never have believed that I could walk into a museum and pick out pictures that are not only sexually arousing but that retell the great stories of mankind. Now I almost live in museums!

When I first started working on this book, I didn't know anything about art, and that's why I've written it in partnership with a serious art historian who's a very good friend of mine. He had photocopies made of stacks and stacks of images, and then we spent days giggling and choosing the illustrations for the book. Right at the beginning we decided that we'd only use pictures in which everyone was having a good time—that left out all the rape scenes that art history is filled with. And then we decided that rather than organizing the book by date or by culture or by some other traditional structure, we'd use the images to illustrate the progression of an erotic relationship, from the first glance to postcoital bliss. To the best of our ability we've tried to make it multicultural and multisexual, with something for everyone, though we've tended to favor the figurative over the abstract and the refined over the raw.

Art history has been notoriously skittish about dealing with the sexuality of the art it studies, and the current fuss over censorship is

making matters even worse. What we've tried to do here is to make clear that these images do, indeed, have strong erotic content, though in some cases it has been varnished over by generations of asexual interpretation. Some of the works in this book were, in fact, originally made explicitly to whet the sexual appetites of the patrons who commissioned them.

In the texts that follow, the art history is all by my friend and the comments about the works' sexual content come from me—the surprise for both of us was how arousing the art turned out to be. I urge you to tuck some of these images away in your erotic imagination. Not only will you have sexy dreams, but your waking moments will be sexier too.

Working with an art historian has shown me how little I knew about art, how much there is to learn, and how exciting it all is. After you look at the pictures and read the texts in this book—and maybe make love with your partner, having been stimulated by the material between these two covers—you will recognize the delights of sexual and artistic variety that await your discovery. Maybe you'll even go out and buy your lover not another box of chocolates but books on art. And who knows—maybe some of you will even be inspired to start painting your beloved—naked. If that happens, be sure to let me know.

I invite you to come with me on this great new adventure!

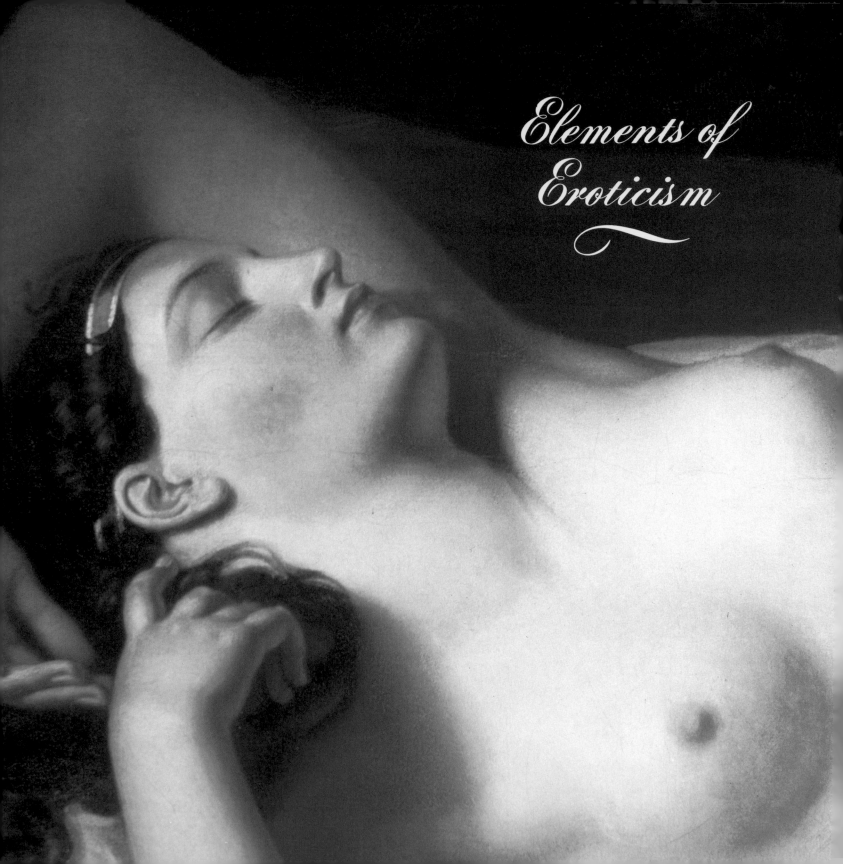

Elements of
Eroticism

\mathcal{M} ost of the images in this book show two or more people engaged in a sexual encounter. This chapter is an exception in that it shows the elements of eroticism— the two kinds of bodies, male and female, that come together in sex, and also the parts of the body that are particularly arousing.

One of the earliest known art objects, the so-called Venus of Willendorf, is a prehistoric figurine of a woman who is not a beauty by contemporary standards. Squat and short, with a huge belly and breasts, she probably represented fertility or abundance. Soon, however, art took on a different purpose. The ancient Greeks, for example, were intensely interested in the concept of beauty, which was first symbolized by perfected naked men and later by perfected naked women. The Greek notion of beauty—which stood as a paragon until the early twentieth century—recognizes that the appreciation of beauty is mixed with sexual desire. An admission of this sexuality can be found in the pose of the *Aphrodite of Knidos;* if she were not potentially so arousing, she would not have to cover herself so modestly. (The Greeks must have thought either that female genitalia were too exciting for viewers or not aesthetically pleasing—we don't know which.)

Taboos aside, this chapter includes lots of genitalia—female and male. The great Renaissance artist Leonardo thought that genitalia were hideous and the sexual act repugnant, but fortunately few artists agreed with him. Sex has been one of the principal concerns of art in all cultures, and the finest artists of all times have made the human body the instrument of beauty and feeling—as you will discover when you turn the page.

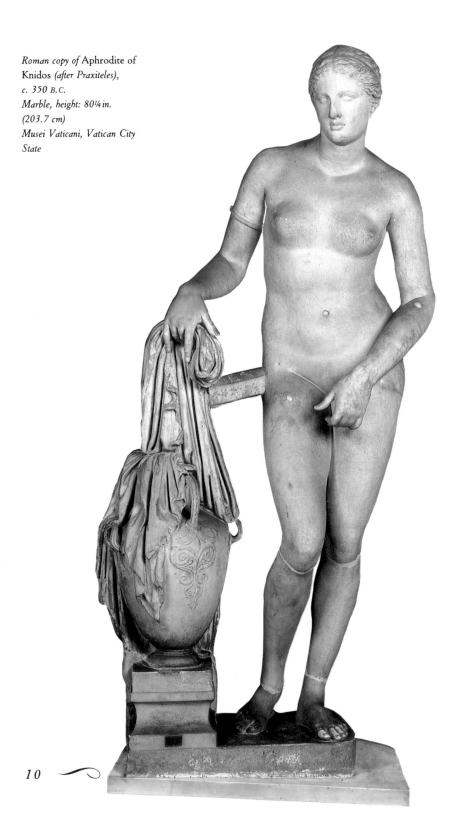

Statues of Aphrodite, the goddess of love (called Venus by the Romans), almost always showed her clothed or at least partially draped, until the Greek artist Praxiteles created a nude sculpture for a temple on the island of Kos. According to the Roman historian Pliny, the locals rejected the statue because it was nude, and the people of Knidos, off the coast of Turkey, cheerfully took it instead. It became one of the most celebrated sculptures of antiquity; pilgrimages were made to the circular temple that housed the statue, which was visible from all sides.

Aphrodite is shown about to step into a ritual bath, holding in her hand the gown that she has just removed. Seemingly surprised by some unexpected visitor, she modestly covers her *mons veneris*—literally, her "mound of Venus," or pubic area. As she shifts her weight, lifting one hip and the opposite shoulder, she adopts a pose that was to become standard for nearly all classical sculptures of upright nudes. She is shown as a perfected human being, with all unsightly bulges and wrinkles removed and her proportions regularized. And, unlike Praxiteles' sculpture of the male god Hermes, *Aphrodite* has no pubic hair; her *mons* has been idealized into a smooth bump just like that on a Barbie doll. Even to the libidinous Greeks, there may have been something shameful about female genitalia— a taboo that remains in full force today.

What made this *Aphrodite* most famous was its nonetheless lifelike quality. An ancient writer named Lucian recounted a story about a youth who fell in love with the statue and bribed the temple guardian to let him spend the night with it. (A blemish on the statue's thigh was said to result from this

encounter.) Even in Praxiteles' time, credit for the beauty of the statue was shared with the sculptor's model, Phryne. Lucian exclaimed, "So great was the power of the craftsman's art that the hard unyielding marble did justice to every limb."

Praxiteles' original statue is lost. Of the fifty or so copies of it, this marble in the Vatican is considered by many to be the best.

~

*I*n contrast to the modest poses prescribed by Greeks and Romans for female nudes, male statuary was shamelessly naked. Even less inhibited were depictions of satyrs—lusty creatures with goatlike ears, horns, and even an occasional tail. When not assisting Bacchus in making wine, satyrs were exclusively preoccupied with the pursuit of sex. They would grab the warm body of any mammal—man, woman, nymph, or donkey, and sometimes even cold roadside statuary— to gratify their sexual desires. But more often than not their singleminded attempts were frustrated, and they were frequently depicted as being pushed away by the objects of their desire. They were laughed at, chided, and even had their ears teasingly pulled.

This satyr lies exhausted, perhaps after an unusually successful debauch. In his deep sleep he unselfconsciously spreads his beautifully muscled legs. One of them, the satyr's right leg, is not original to the sculpture but is instead a restoration by the Italian sculptor Bernini. In contrast to the languorous sensuality of the rest of the figure, the new leg is tense and angular, representing a spirit rather different from that of the original sculptor.

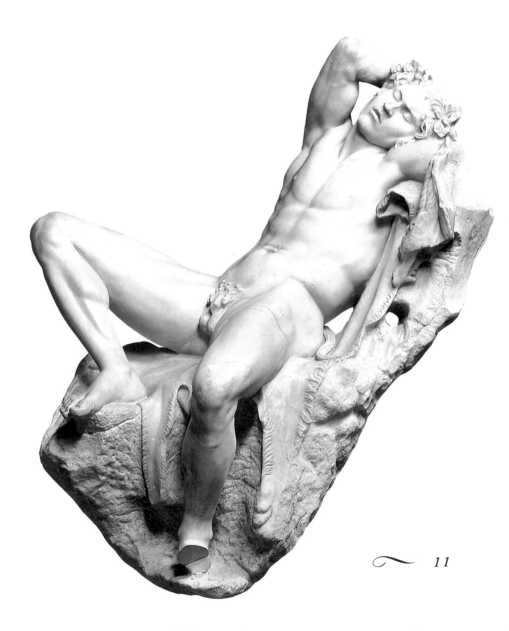

Barberini Satyr, c. 200 B.C.
Hellenistic
Marble, height: 84⅝ in.
(215 cm)
Staatliche Antikensammlungen
und Glyptothek, Munich

~ *11*

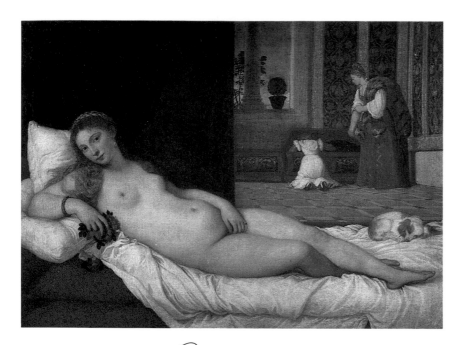

*Y*ou enter [the Uffizi] and proceed to that most-visited little gallery that exists in the world—the Tribune—and there, against the wall, without obstructing rag or leaf, you may look your fill upon the foulest, the vilest, the obscenest picture the world possesses—Titian's Venus. It isn't that she is naked and stretched out on a bed—no, it's the attitude of one of her arms and hand. If I ventured to describe that attitude there would be a fine howl. . . . There are pictures of nude women which suggest no impure thought—I am well aware of that. What I am trying to emphasize is the fact that Titian's Venus is far from being one of that sort."

When Mark Twain published these words in 1880, he was one of the first to admit publicly what thousands before had no doubt thought privately: that beneath the time-honored varnish of this canvas and the august reputation of the supreme painter Titian

there lies an extremely erotic image. *The Venus of Urbino* is perhaps the first overtly provocative female nude of the Italian Renaissance—and the prototype for many of the great nudes of the centuries that follow.

Titian based his figure's pose on a painting by Giorgione (the *Sleeping Venus* now in Dresden), which Titian had actually worked on while serving as Giorgione's apprentice. Giorgione's nude modestly covers her *mons veneris* while she sleeps, but Titian's looks immodestly at the viewer while keeping her left hand in the same place. (It may be the suggestion that she strokes herself as we watch that got Mark Twain so flustered.) With that simple shift from a sleeping to a staring beauty, Titian altered our role from voyeur to participant in an act of sexual solicitation and thereby heightened the erotic content of the picture immeasurably.

However carnal the appeal of Titian's picture may be, it was probably intended as an allegory of marital bliss. Venus holds a bouquet of roses, her emblem of beauty and love, while the topiary of myrtle in the window symbolizes everlasting congeniality. The dog represents fidelity, and the two maidservants in the background arrange clothing in a *cassone,* a type of chest that traditionally contained a bride's trousseau.

Some art historians believe that this work was commissioned in honor of the marriage of its first owner, Guidobaldo II, son of the duke and duchess of Urbino, but this cannot be proved. The painting remained in Urbino until it was taken to Florence in 1631, by which time it was already well known to artists all over Europe through engravings and painted copies.

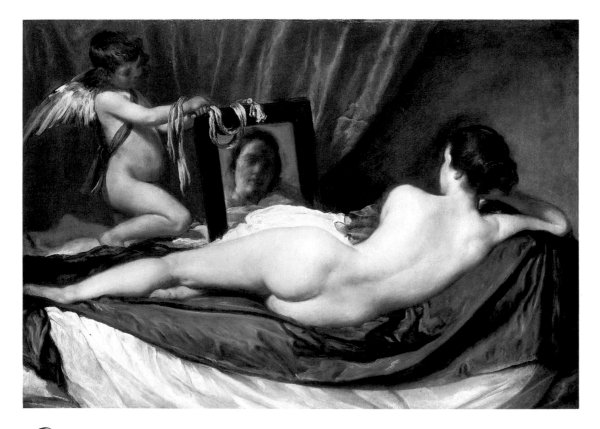

*E*ven though female nudes are extremely rare in Spanish painting, two of the most famous nudes in the history of art were painted by Spaniards. Velázquez painted his *Toilet of Venus* to hang alongside a Venetian painting (now lost) that closely related to Titian's *Venus of Urbino* (opposite). A century and a half later Goya painted his *Nude Maja* (page 14) to hang next to Velázquez's *Venus*.

Velázquez cleverly chose to take the pose of the earlier Venetian nude and reverse it. Not only did this allow him to create one of the most beautiful backs ever painted, but it also enabled him to show a highly sensual nude while avoiding the problem of genitalia. Since nothing in the pose is inherently offensive, Velázquez did not need to idealize the figure to make it conform to standards of propriety, and he was therefore free to portray the goddess as a living, breathing mortal. He placed the model's left arm so as to emphasize the curve of her hip and her slim, delicate waist; her pearly skin is set off by the swath of black satin on her couch. The artist arranged for Cupid to hold a mirror so that Venus could assess her beauty, but she seems to look at us instead.

This picture became so identified with an aggressively male eroticism that early in the twentieth century a crusader for women's rights stormed into the museum and slashed the painting in protest. The suffragette's fate is, sadly, long forgotten, but the painting has been expertly repaired.

on Manuel de Godoy, the most powerful man in Spain, received the Velázquez *Venus* (page 13) as a gift from the duchess of Alba in 1800. That same year a visitor to Godoy's palace recorded seeing Goya's nude along with the Velázquez in the same room.

Being a thoroughly modern artist, Goya had, of course, updated Velázquez's picture. With Godoy (who was effectively the head of government for King Charles IV) to protect him from the Spanish Inquisition, Goya could dispense with the accessories that projected Velázquez's nude into the safely distant realm of mythology. Goya's woman is thus not an idealized Venus but a frankly contemporary woman endowed with elements of mortal flesh and blood—like pubic hair—that continue to shock. (The representation of pubic hair in Western art had been implicitly banned since ancient times, and Goya's picture was one of the first to break the taboo.) Traditionally the pose of arms up behind the head represented sleep, as in Giorgione's *Venus,* but here the

pose serves the provocative purpose of thrusting the breasts up and out and completely exposing the torso. No wonder that, after Godoy had been banished from Spain, the Inquisition investigated Goya for being the author of "various obscene pictures."

Soon after completing this work Goya painted a version with a clothed model, and some evidence suggests that they were fitted together in a mechanical frame so that the nude could be conveniently hidden behind the clothed version. The latter, also in the Prado, is hardly less provocative, for the pose implies that the woman is ready to undress. Her gypsylike costume is that of a *maja*—a slang term for a woman of loose morals. The appealing old story that the duchess of Alba, who was in fact Goya's lover, had served as the artist's model has been disproved, but what remains is the conviction that a living woman had posed for him, and that he was able to bring the erotic charge he experienced to the image he created.

Francisco Goya (1746–1828)
Nude Maja, c. 1800
Oil on canvas, 38⅜ x 75¼ in.
(98 x 191 cm)
Museo del Prado, Madrid

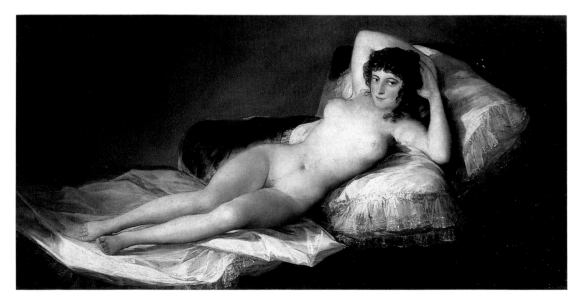

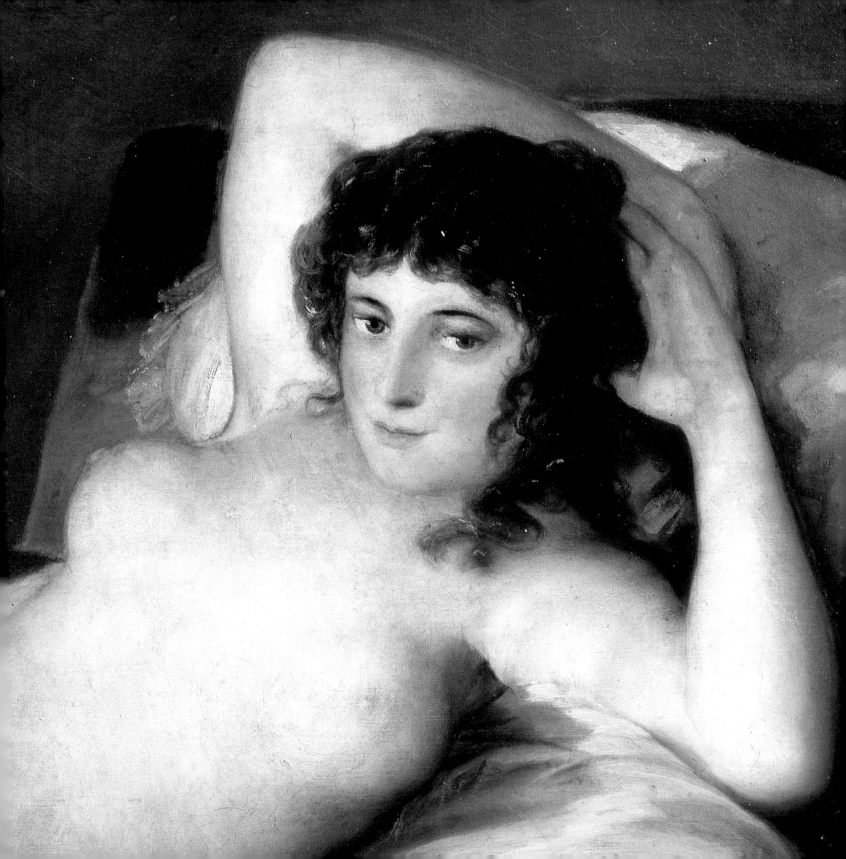

In deliberate opposition to the overtly sexual art by Boucher and others of the Rococo age, the Neoclassical artists, led by Jacques-Louis David, declined to paint sensuous nudes. But then Ingres and Eugène Delacroix, the two artists who defined French painting after David, once again returned the female figure to center stage. Both artists were passionate about women. Delacroix painted them with an abandon that seems as natural as sex itself, whereas Ingres created an ideal of icy sensuality that was all the more enticing because the ideal was so obviously unattainable.

Like Delacroix, Ingres located his sexual fantasies in Near Eastern harems, where they could evade European taboos. He transformed the Venuses of Giorgione and Titian into mortal women whose sinuous curves and twisting movement embodied not just beauty but the rhythmic motions of sex itself. Ingres's odalisque—an odalisque is a kind of concubine—turns her head away from the viewer, displaying her body for the viewer's delectation while directing her own attention to the music that wafts through the picture. (Ingres's picture is also an allegory of the five senses.) This odalisque seems to be saying, "You may look, but you may not touch," and the eunuch guard is there to ensure that no one goes any farther.

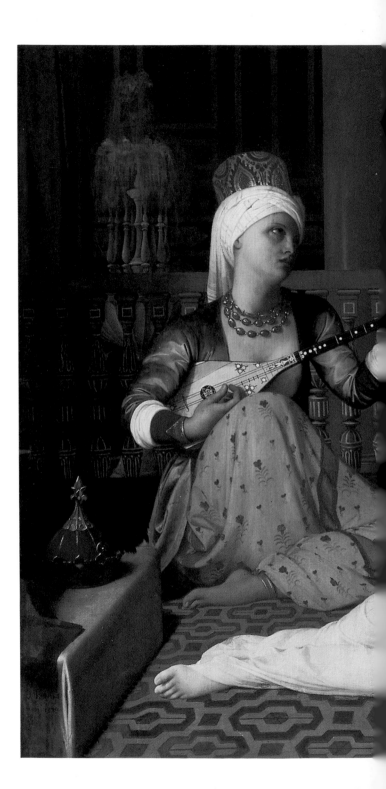

Jean-Auguste-Dominique Ingres
(1780–1867)
Odalisque with Slave,
1836–40
Oil on canvas mounted on panel,
30⅛ x 40⅞ in.
(76.5 x 104 cm)
The Fogg Art Museum,
Harvard University, Cambridge,
Massachusetts; Bequest of
Grenville L. Winthrop

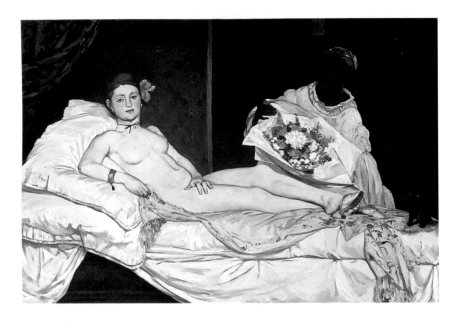

Manet's celebrated painting is different from all its nude forebears in that it was painted to make a sensation at the Paris Salon rather than for the personal delectation of a private patron. But the response to the paintings he exhibited in the 1863 Salon had been so troubling that Manet waited until 1865 to show this one. The delay, however, did not soften the outcry. *Olympia* was attacked on every possible issue: the subject matter (the influence of prostitutes and courtesans in contemporary Paris), the borrowings from the Old Masters, the painting technique, even the short legs and small breasts of the model, Victorine Meurent, were all severely criticized. Manet's friend Charles Baudelaire, who had heard about the painting but not yet seen it, enigmatically wrote to the artist, "You are but the first in the decrepitude of your art."

Visitors to the Salon promptly recognized that Manet's painting depicted a prostitute and her maid. Unlike the well-known courtesans previously painted by other artists, Olympia was seen as common and base. Gone were the oriental trappings of Jean-Auguste-Dominique Ingres, the mythological attributes of Velázquez, the domestic allegory of Titian. (The single indicator of wealth, the gold bracelet, actually belonged to the artist's mother! We do not know, however, whether Manet gave the bracelet to the model or indeed whether Meurent and Manet were lovers.) Much in the spirit of Goya's *maja* (page 14), Manet's Olympia is manifestly contemporary and confident of her sexual prowess.

Manet provoked his audiences by alluding to Titian's *Venus of Urbino* (page 12) while substituting an undermining message: Titian's faithful dog becomes Manet's promiscuous cat, and Venus's domestics rustling through the bridal trousseau become the maid who brings in a bouquet sent by the most recent client. Most disturbing of all, we are no longer welcomed by Venus's engaging gaze but instead repelled by Olympia's arrogant stare. Yet the beauty of this extraordinary painting is irresistible. The subtlety of the play of Olympia's creamy flesh against white sheets and of the maid's dark skin against her pink robe are unequaled in the history of art. Many subsequent artists—from Paul Cézanne and Paul Gauguin to Pablo Picasso, Henri Matisse, Red Grooms, and Sylvia Sleigh—have paid homage to Olympia's power as an icon of sex, if not of love.

Cats have long been associated with promiscuity, and names for cats in both French (*chatte*) and English (*pussy*) also refer to female genitalia. Thus the association of a cat with a female nude is not unusual; just a few years before this painting was made Manet had placed a provocative black cat on the bed of his *Olympia* (opposite). But only rarely is a cat the attribute of a male nude. A seventeenth-century Bolognese artist named Giovanni Lanfranco painted a well-known picture of a nude man with a cat, but more than anything else that work was a parody of the tradition of great female nudes.

While Renoir may have intended this work to allude to paintings such as *Olympia* and Gustave Courbet's nudes of the 1850s and 1860s, his reference is neither ironic nor parodistic. Instead he seems to have included the cat in order to make the image of this preadolescent boy more sensual. He made the image more feminine by showing the boy from behind to avoid the genitals, by emphasizing the rounded hips, and by minimizing the width of the shoulders.

It is thought that the son of Renoir's close friend Charles Le Coeur posed for this painting. We do not know what the Le Coeurs thought of the work, but its prurient potential must not have been evident. Renoir would never have risked offending them.

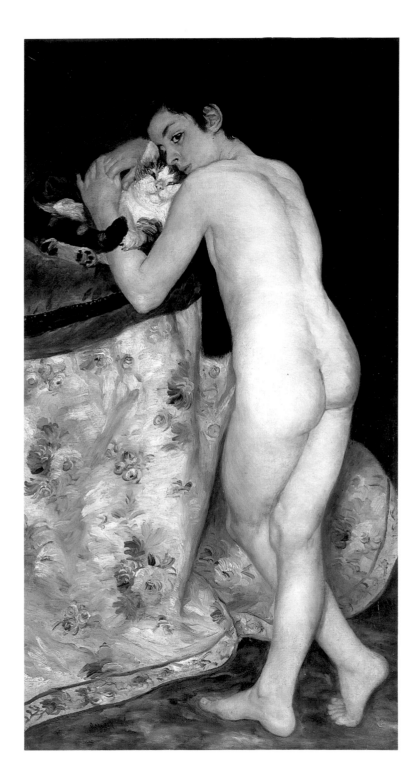

John Vanderlyn (1775–1852)
Ariadne Asleep on the Island
of Naxos, *1809–14*
Oil on canvas, 68½ x 87 in.
(173.9 x 220.9 cm)
The Pennsylvania Academy of
the Fine Arts, Philadelphia; Gift
of Mrs. Sarah Harrison (The
Joseph Harrison, Jr., Collection)

*V*anderlyn was an American artist who studied in France. The inspiration for this painting is not French, however, but Italian, harking back to the great nudes of Giorgione and Titian. Rather than a sleeping Venus, this is Ariadne, wife of Theseus and daughter of the King of Crete. Theseus, half-mortal and half-divine, endeared himself to the Athenians by killing, with Ariadne's aid, the Minotaur—a horrible monster on Crete that demanded young Athenian boys and girls as sacrificial victims. Instead of keeping his helpful wife, Theseus dumped Ariadne for her sister, Phaedra, only to be very unhappy for the rest of his life. Ariadne, on the rebound, married the biggest good-time Charlie of antiquity, Bacchus. Presumably, she lived happily ever after.

Vanderlyn shows Ariadne in a moment of repose, unaware that she is being watched. Does Vanderlyn expect that we observers will assume the role of lusty Bacchus, or was he himself aroused by the power he had to create such a beautiful being? Famously irascible, Vanderlyn was even told to drink beer daily to put him in a better mood. He never married but was an infamous woman chaser. Here he possesses on canvas what he could never have in the flesh. Is it a coincidence that the model turns her head away from the artist?

Explaining his subject matter to a friend, Degas said, "Two centuries ago I would have painted *Susannah at Her Bath;* now I paint mere women in their tubs." The story of Susannah is a story of voyeurism, and it is appropriate that in his celebrated series of pictures of bathing women, the artist took the voyeur's point of view. Degas, a heterosexual who never married, once stated that he depicted women as if they were seen through a keyhole, and that is in fact the only logical place for us, as observers, to imagine ourselves as we look at this pastel. A woman stretches out on a bath towel thrown on the floor of her bedroom. The cheap zinc tub glistens with the remains of her meager sponge bath. She must be unaware of our presence because her pose seems so unselfconscious, yet she covers her face in a way that suggests self-defense, and this gesture is enough to cast us in the role of interloper.

Although he does not make much of the quotation, Degas borrowed the pose from Alexandre Cabanel's *Birth of Venus* (1863), a painting that became famous the instant it was purchased by the emperor of France, Napoleon III. Cabanel's voluptuous nude, riding weightless on a brilliant green wave, also brings her arm to her face, but she holds it high enough to peek out from under the shadow. The contrast with Degas's nude could not be greater. His bather's body is far from perfect: the breasts seem meager, the hip bony, and the stomach slightly bulging. Degas's nude is antierotic to almost any man other than one with a taste for voyeurism. Many women, however, look at Degas's pictures and feel that he has succeeded in representing women just as they themselves believe they look when they are naked, alone in the privacy of their rooms.

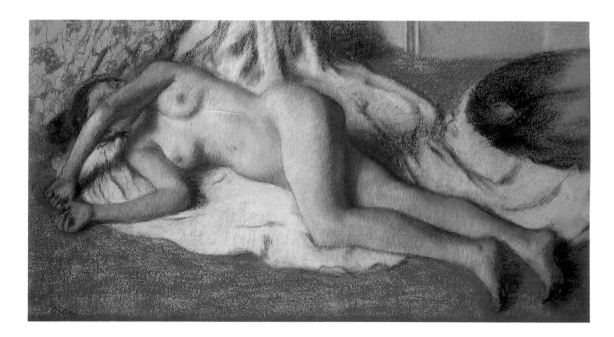

Edgar Degas (1834–1917)
Bather Stretched Out on the Floor, *c. 1886–88*
Pastel on paper, 18⅞ x 34¼ in. (48 x 87 cm)
Musée d'Orsay, Paris

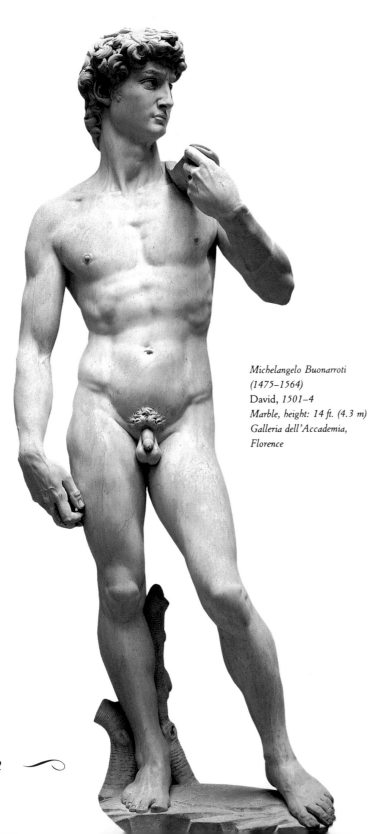

Michelangelo Buonarroti
(1475–1564)
David, 1501–4
Marble, height: 14 ft. (4.3 m)
Galleria dell'Accademia,
Florence

Michelangelo was the first artist since the ancient Greeks to make visible his wholehearted belief that beauty was epitomized by the perfected male body. His *David* is an embodiment of his ideal male, and it is interesting that his ideal is charged with sexual energy—a quality not called for by the biblical story of David and Goliath. Traditionally David was shown as a barely adolescent youth; it was his courage and self-confidence, not his sexual prowess, that enabled him to vanquish the giant Goliath. But Michelangelo made his David a giant, too, and gave him the figure of an athletic young adult. Although David turns his head to assess the enemy, his muscular torso, outsized limbs, and large genitals face us squarely.

Since ancient times, idealized figures, such as Apollo, had been given small genitals; large genitals were the attributes of brutes or satyrs. Michelangelo restored sexuality to the beautiful man. For this and other reasons—such as the romantic poems he wrote to a young male friend—it is thought that he may have been homosexual.

Michelangelo carved his figure from a huge marble block that had been cut one hundred years earlier for statuary for the Florence Cathedral. After considerable discussion, *David* was set up outside the seat of the republican government, the Palazzo della Signoria, as a warning to any power, large or small, that might have designs on the independent city-state of Florence.

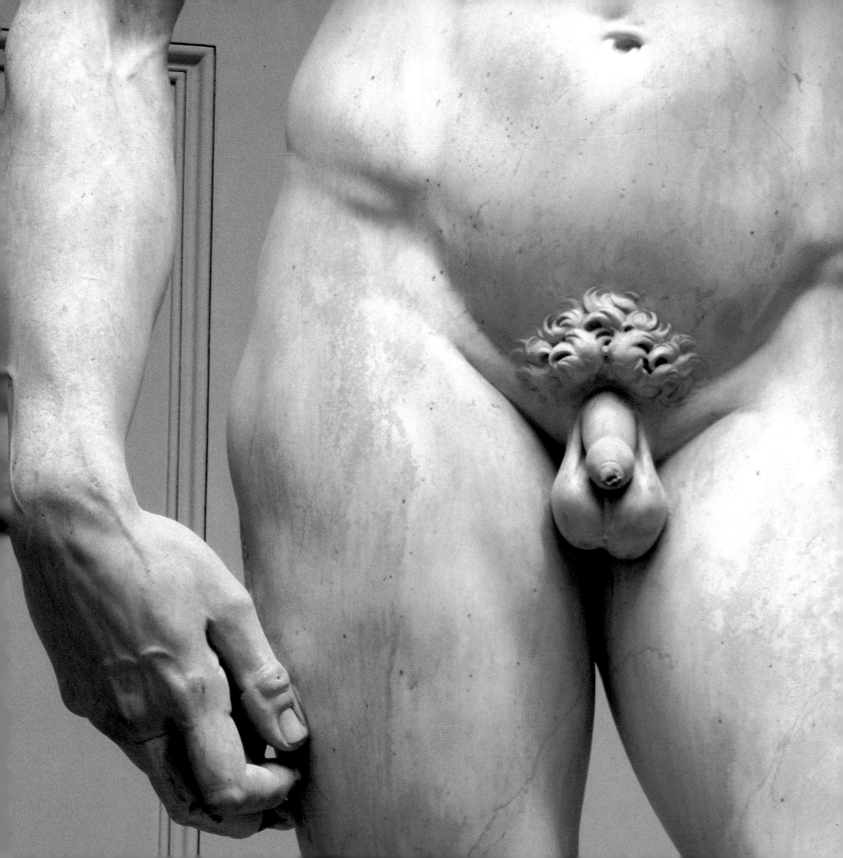

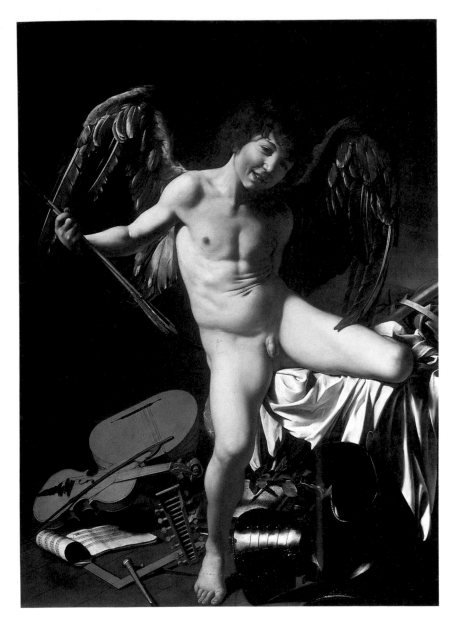

Although scholars still debate the sexual content of Caravaggio's early pictures of boys in fancy dress, most writers have finally accepted the fact that the artist was a homosexual—court papers of 1603 mention that he consorted with a young man of ill-repute—and that his important early patron in Rome, Cardinal del Monte, shared with him a taste for pretty boys. It is astonishing how reluctant some modern art historians have been to admit this important facet of Caravaggio's personality, and it is no less surprising to read their circuitous arguments denying the overt sexuality of the artist's pictures.

In this work, commissioned by Marchese Giustiniani, Caravaggio quite appropriately adopted Cupid's conquering pose from Michelangelo's sculpture *Victory*. But he made the quote into a parody by substituting a flirtatious boy in place of Michelangelo's heroic figure. With an insolent smile, the god of love triumphs over all worldly pursuits: music, represented by the lute; poetry (the quill and book); geometry (the compass); astronomy (the globe of the heavens); war (the armor); government (the crown and scepter); and fame (the laurel wreath). Although Cupid is usually shown as an asexual creature—he is always young and usually winged—here Caravaggio was careful to reveal not only his breasts but his genitals and buttocks as well. It is sometimes thought that the model was one of the artist's sexual companions, Giovanni Battista, who may also have consorted with the artist's patrons and friends.

Michelangelo da Caravaggio
(1571–1610)
Amor Vincit Omnia (Love
Conquers All), 1602
Oil on canvas, 61⅜ x 44½ in.
(156 x 113 cm)
Gemäldegalerie, Staatliche
Museen, Berlin

*B*athrooms are an obvious place for sex. One is often undressed, one is often freshly washed, and the narrowness of most bathrooms means that body contact is virtually inescapable. And although baths and sex were frequently linked during the Renaissance (when baths were a rare luxury), modern painting deals with the subject infrequently—perhaps because contemporary bathrooms are not very picturesque.

It seems interesting that this painting does not show genitalia, only the model's shapely buttocks. He bends over to show them to us, and even turns to look, in a manner that invites us to consider the desirability of anal intercourse. Reaching out toward him are three penislike shapes yearning to stroke those buttocks. Is that the artist's subconscious desire made manifest? The artist says no, he simply wanted to avoid having to paint the model's feet and so he inserted a plant. What would Freud say about that answer?

Hockney has made no attempt to hide his homosexuality—a courageous attitude on his part, especially in the early 1960s. Curiously, however, his paintings are rarely erotic. Although they often show handsome men, they never show the act of sex taking place. Hockney's art is always cool and somewhat distant, and it could well be that the passions of sex would unduly heat up the atmosphere he works so hard to maintain.

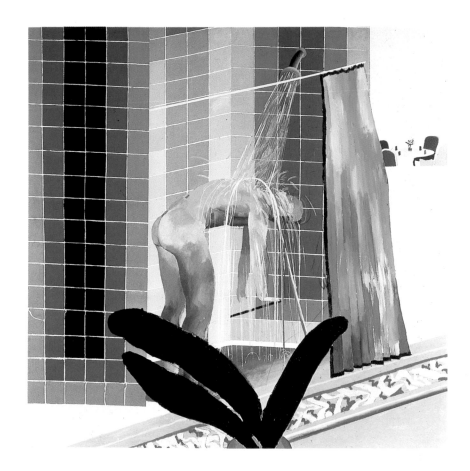

David Hockney (b. 1937)
Man Taking Shower in
Beverly Hills, 1964
Acrylic on canvas, 65½ x
65½ in. (167 x 167 cm)
Tate Gallery, London

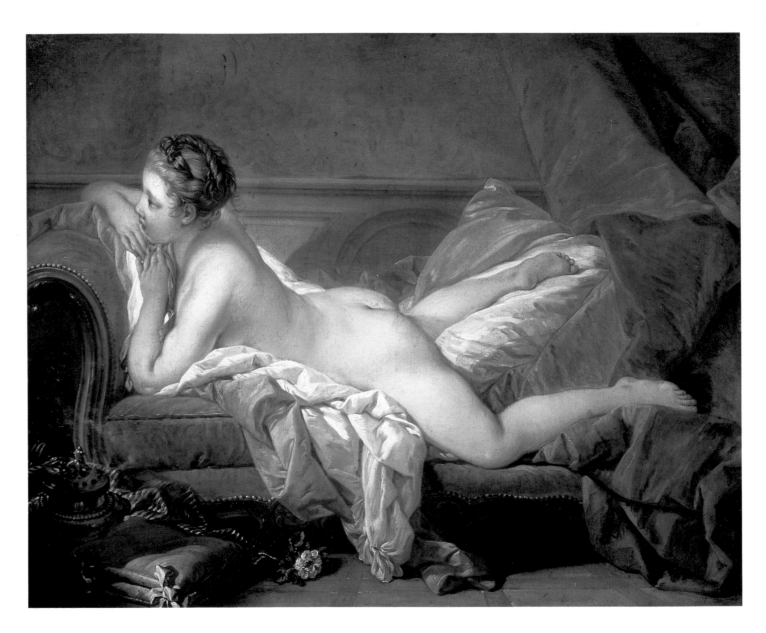

François Boucher (1703–1770)
The Blonde Odalisque, *1752*
Oil on canvas, 23¼ x 28⅜ in.
(59.1 x 73 cm)
Alte Pinakothek, Munich

oucher's paintings were celebrated in his day for their frank acknowledgment that sex could be an important element of high art. (Later in the century they were severely criticized as symptoms of a depraved sensibility.) In this work, no doubt commissioned for a man's pleasure, Boucher painted a voluptuous young woman not as a Venus but as a contemporary beauty who was ripe for sex. More than that, her pose indicates that no kissing or foreplay is going to be necessary; she is already on her stomach and seems ready for intercourse. But because she does not look at us, unlike Titian's Venus or Goya's *maja* (pages 12, 14), it seems that she has resigned herself to a sexual encounter that she will not initiate herself.

At first we might conclude that the youth of the woman expressed a particular preference of the artist's. We can think, for example, of the very young but erotic girls painted by Renoir. But her youth may reflect not just the artist's ideal but also that of the French king. At about the time Boucher painted this girl, Louis XV was having an affair with an adolescent. The marquis d'Argenson recorded in his journal in 1753, "It is certain that the King's present concubine is a little girl of fourteen who used to serve the painter Boucher as a model." Youth, however, was not simply an erotic preference for the king; he had, d'Argenson noted, a horror of venereal disease. (As well he should, given how promiscuous he was. Safer sex is not only a twentieth-century concern!) He therefore had his valet find him pubescent virgins—a choice that today would be not only immoral but illegal. The girl in Boucher's painting may in fact be the one with whom the king had an affair, and it is possible that this painting was made for the king himself.

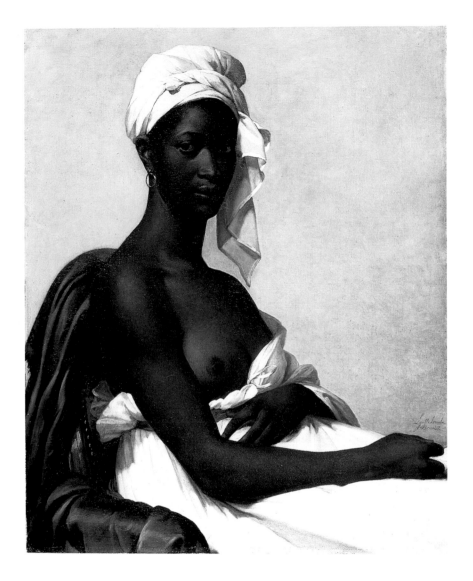

Women sometimes bared their breasts for female artists rather than male, and it is fascinating to observe the difference in result. This beautiful woman is shown as proud but not aggressive; she looks at us with interest but not provocation; she exposes her breast knowingly but without solicitation. She is neither passive nor submissive.

When Marie-Guillemine Benoist exhibited this work at the Salon of 1800, it was interpreted by some as alluding to the 1794 decree that banned slavery in France. The model—whose name, alas, has been lost—is thought by some to have been an Antillaise servant to the painter's brother-in-law. Benoist was a remarkably precocious artist who was a student first of Elisabeth Vigée-Lebrun and then of Jacques-Louis David. In 1804 Napoleon began to commission portraits from her and thereby ensured her success, but when her husband received a high government post ten years later, propriety (and her husband) demanded that she cease to exhibit publicly lest he be embarrassed by having a working wife.

Marie-Guillemine Benoist
(1768–1826)
Portrait of a Negress, *1800*
Oil on canvas, 31⅝ x 25⅝ in.
(81 x 65.1 cm)
Musée du Louvre, Paris

Manet recognized that an isolated fragment of the body might carry a stronger erotic charge than an entire figure. His journal-writing contemporary, Edmond de Goncourt, wrote with great excitement about his own favorite spot: "At present the nape of a woman's neck, both the round nape and the thin nape, with its indiscreet tuft of curly hair on the glowing flesh, produces an aphrodisiac effect on me. I find myself following the nape of a neck—for the pleasure of looking at it—as other men follow a pair of legs."

The long tradition of paintings that show a female model with bare breasts originated, as did so many other sensual types, with the Venetian painters. Tintoretto's *Woman Who Uncovers Her Breast,* which Manet may have seen at the Prado in Madrid, could well have been the specific precedent for this work. But models have bared their chests for artists for thousands of years, and Manet has recorded the event with a freshness and sense of discovery that belie his considerable experience with the opposite sex. The model's opulent breasts, surrounded with a bit of her shirt as a bouquet might be wrapped by a florist, have been painted with an Impressionistic virtuosity that surpasses Renoir at his own game. So dazzling is the brushwork, in fact, that the sexual power of the picture is somewhat diffused.

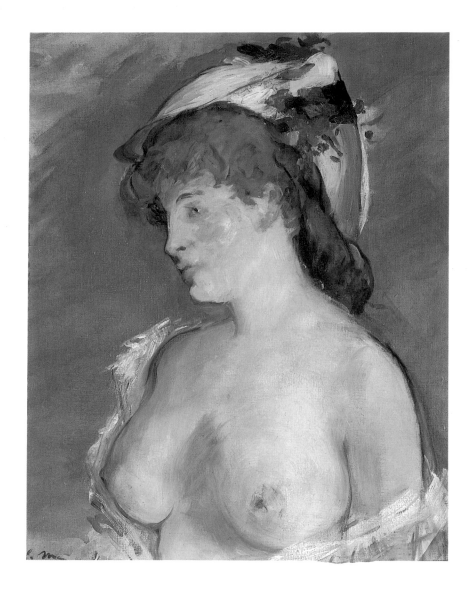

Edouard Manet (1832–1883)
The Blonde, *c. 1878*
Oil on canvas, 24⅜ x 20¼ in.
(62 x 51.5 cm)
Musée d'Orsay, Paris

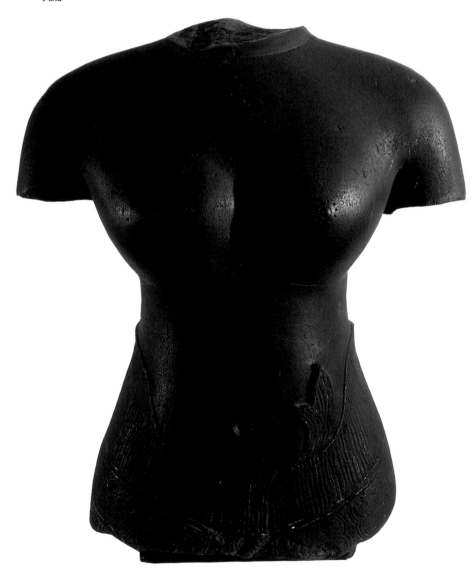

Female Torso, *1010–80*
Cambodian (Khmer)
Dark gray sandstone (polished),
15½ x 14 x 5¾ in.
(39.4 x 35.6 x 14.6 cm)
Albright-Knox Art Gallery,
Buffalo; Charles W. Goodyear
Fund

Sometimes just looking can be a power-ful turn-on. Especially when one is looking at a perfectly formed torso—in this case, one with firm breasts, erect nipples, toned abdomen, and hips encircled by a hint of form-fitting drapery. The more we look at this Cambodian torso, the greater the desire to touch it, and the more we touch, the more frustrating it becomes, for it is made of hard sandstone, not of soft, warm flesh.

The idea of lusting after a sculpted figure goes back to an ancient Greek legend. On the island of Cyprus a sculptor named Pygmalion fell passionately in love with the statue of a woman that he was in the process of carving. Poor, frustrated Pygmalion—he kissed marble lips that could not return his caresses; he stroked cold stone that remained unrespon-sive. Finally the goddess of love, Venus, heed-ed Pygmalion's prayers and turned his sculp-ture into a live woman named Galatea. They lived happily ever after, of course.

The highly polished surface of this eleventh-century Cambodian torso under-scores the blatant sensuality of the woman's—probably a goddess's—body. Originally the figure had a head, arms, legs, and feet. If, as is thought, she was like other sculptures of the period that have survived intact, her face had a smile and her hair was smoothed back in a chignon. But over time this particular statue has been damaged so that only the torso remains. Now we are left not with the representation of an entire body but with only those parts that so often arouse longing and erotic excitement.

Here Bacchus does not just address the viewer, he solicits us. He offers a glass of wine with one hand (Bacchus is the god of drink) while with the other, he fiddles with his robe in a manner that suggests that he is ready to take it off—recalling that it is Bacchus who presides over orgies. Caravaggio no doubt knew that the lifelike treatment of the boy's beautiful skin would appeal to the refined sensibility of his patron, Cardinal del Monte, just as much as the extraordinary trompe-l'oeil still life in the foreground.

Following in the tradition of half-length figures with exposed breasts established by Raphael and Giorgione, Titian and Veronese, Caravaggio substituted a boy for the women usually depicted bare-chested and then cloaked him with mythological references in order to make the homosexual imagery acceptable in mixed company. The artist's patrons, however, might well have recognized the boy's resemblance to Antinoüs, the Bythnian boy who was loved by the Roman emperor Hadrian.

Careful observers will note that Bacchus's nipples are almost erect. The nipples of both sexes become erect as the person becomes aroused, but this very natural phenomenon causes anxiety in some men, who consider it an unnervingly "feminine" response.

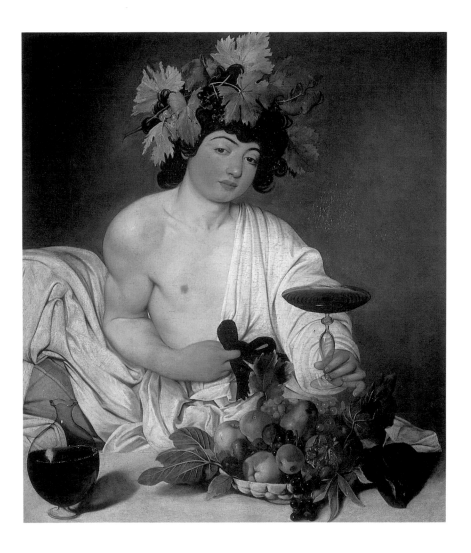

Michelangelo da Caravaggio (1571–1610)
Young Bacchus, c. 1597
Oil on canvas, 37⅜ x 33½ in.
(94.9 x 85.1 cm)
Galleria degli Uffizi, Florence

*R*odin's art centered on sexuality, and it is therefore not too surprising that his archetypal woman is not a Venus but a headless being defined by her sexual parts. The rough handling of the material in this sculpture—which would have been modeled in clay before being cast in bronze—was equated, even in Rodin's time, with the raw sexuality of the sculptor, who was notorious for his sex drive. In an appreciation of Rodin, the critic Charles Morice referred to art as the sculptor's mistress: "In his hours of work, of action, he attacks her, penetrates her, he clasps her in the drunkenness of triumphant love."

Rodin originally created *Iris* as a muse to be suspended above the head of Victor Hugo on a monument dedicated to the writer. However, the artist changed his mind and completed the monument with different muses. *Iris* remained in his studio, where it was much commented on by his many visitors, male and female.

*G*eorgia O'Keeffe always denied that her pictures of flowers were symbolic of human sexual organs, but many observers have found them to be extremely suggestive, if not necessarily erotic. (She seemed as attracted to feminine irises and cannas as to phallic calla lilies and jack-in-the-pulpits.)

After all, flowers *are* sexual organs, and O'Keeffe chose to paint them in a way that intensified their sexual connotations; it is almost impossible not to perceive *Red Canna* as a stylized vagina.

A statement O'Keeffe made in a 1939 exhibition catalog reveals her own thinking on the issue: "Well—I made you take the time to look at what I saw and when you took time to really notice my flower you hung all your own associations with flowers on my flower and you write about my flower as if I think and see what you think and see of the flower—and I don't."

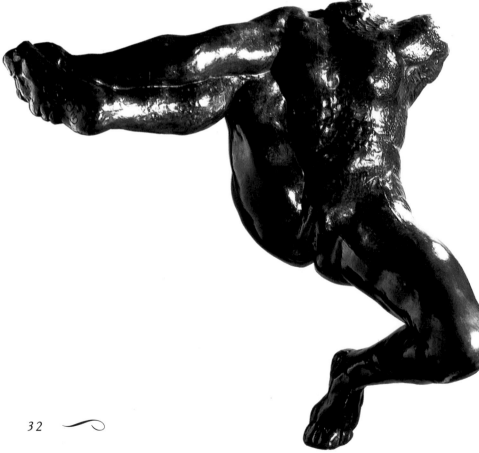

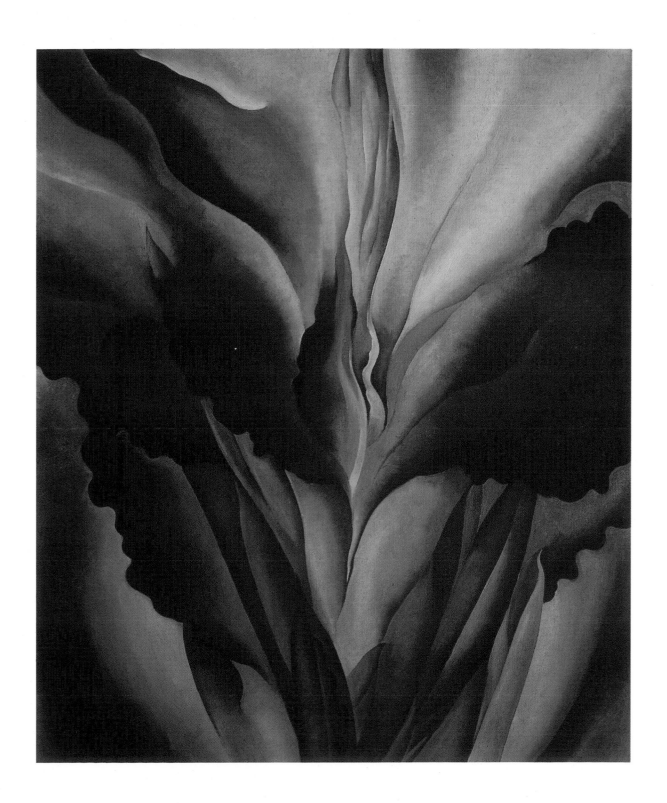

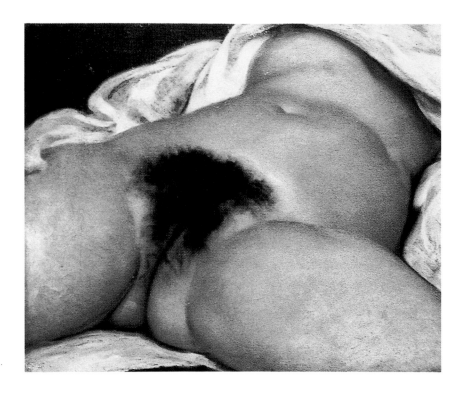

Gustave Courbet (1819–1877)
Origin of the World, *c. 1866*
Oil on canvas, 18⅛ x 21⅝ in.
(46 x 55 cm)
Private collection

Courbet's title is curious yet apt, for he has in fact depicted the very place from which we all emerged. But the appearance of that place is strangely unfamiliar to many men and even some women. The taboo against representing female genitalia remains so strong that this image still shocks, despite years of exposure to *Playboy, Penthouse,* and other sexually explicit magazines. What is most shocking about the work is the total objectification of the female figure. A male nineteenth-century critic named Maxime du Camp made sarcastic note of this offense: "Through an extraordinary lapse of memory the artist, who had studied his model from the life, failed to represent the feet, the legs, the thighs, the belly, the hips, the chest, the hands, the arms, the shoulders, the neck and the head."

This work, of course, deliberately provokes a sexual response (and suggests the model's own state of arousal by showing her nipple as decidedly erect). Courbet made the painting for Khalil Bey, a rich Turkish diplomat living in Paris. Before he gambled his fortune away in the late 1860s, Bey formed an enormous collection of fine French paintings, including such celebrated erotica as Ingres's *Turkish Bath* and Courbet's *Sleepers* (page 170). It is thought that even the libertine Bey hid the painting, first behind a curtain and later behind a snowy landscape by Courbet.

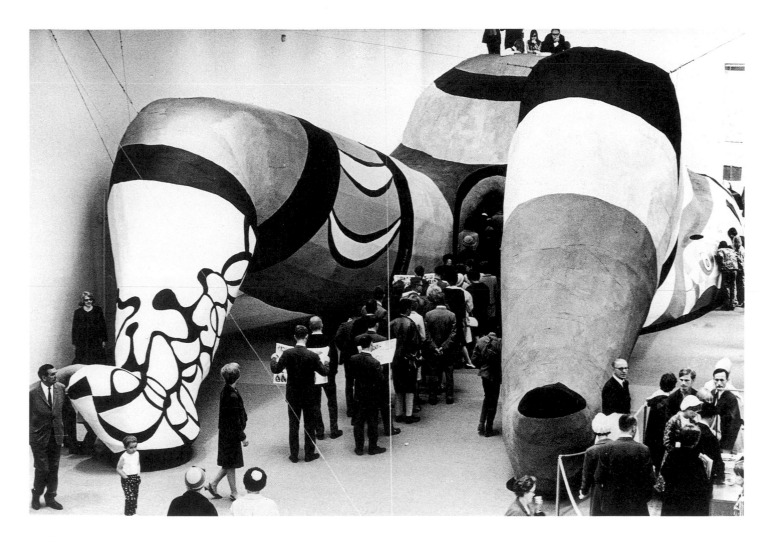

These Stockholmers assume the role of modern-day Lilliputians as they patiently wait in line to enter the enormous female Gulliver that has landed at their museum. That they enter through her vagina seems just as natural as the curiosity of the children at right, who peer through portholes in the giantess's abdomen. Inside there is a movie theater, exhibition hall, and cafeteria: the total woman. Unlike the female genitals in Courbet's painting (opposite), which are portrayed as a mysterious and forbidden place, the vagina of Saint Phalle's *Hon* is an unthreatening doorway to multiple possibilities.

Niki de Saint Phalle has always made the subject of her art human sexuality, which she explores in a manner akin to that favored by non-European artists. She treats fertility, rites of passage, and fetishes with a riotous humor that is a welcome relief from the deadly seriousness of most discussions about human nature.

Niki de Saint Phalle (b. 1930)
Hon (She), 1963
Mixed media, 20 x 82 ft.
(6.1 x 25 m)
Moderna Museet, Stockholm

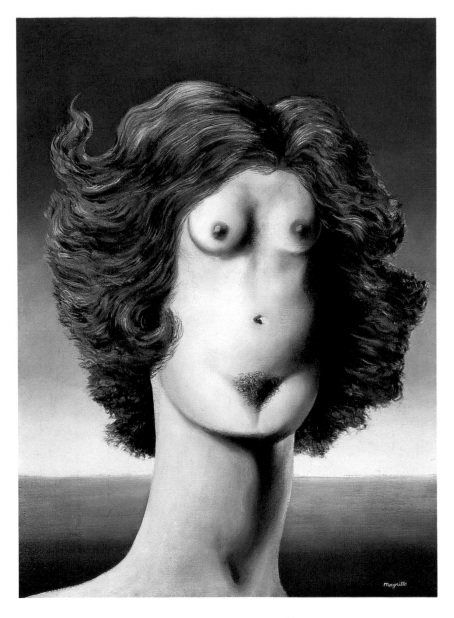

In the spirit of ancient amulets in which a human figure was given a penislike head, Magritte has substituted genitalia for a woman's facial features. Much of Magritte's Surrealism rested on the shock value of an unexpected juxtaposition such as this one, but unlike the works of Salvador Dalí, Max Ernst, or Pablo Picasso, Magritte's art was less overtly concerned with sex.

Sex was, however, a crucial component in the program of the Surrealist artists who followed the poets André Breton and Georges Bataille, for they found that dealing explicitly with sex was the most effective way to shock middle-class viewers. The Surrealists professed to worship women. "In Surrealism, woman will have been loved and honored as the great promise, a promise that subsists even after it has been kept," wrote André Breton. But in fact they reduced women to objects of male fantasy at best, and at worst, portrayed them as life- and genital-threatening creatures. The Surrealists were avid readers of Sigmund Freud, and it is possible that, by representing female genitals on this penislike shape, Magritte was referring to Freud's notion of the inherent bisexuality of all humans.

René Magritte (1898–1967)
The Rape, 1934
Oil on canvas, 28¾ x 21½ in.
(73.1 x 54.6 cm)
The Menil Collection, Houston

*L*ike a Hindu god meditating, Clemente shows himself bringing his hands to his lips in an inscrutable gesture. The iconlike penis touches his hands in what must be part of a masturbatory ritual, but the atmosphere is far more tranquil than in Egon Schiele's angst-ridden self-portrait (see page 153). In a strange reversal, this fantasy is not arousing to the viewer. It is so self-involved, so inward turning, that there is no room for us to insert our own desires into this vision of sexuality.

Francesco Clemente (b. 1952)
Light, 1991
Pastel on paper, 20¼ x 13 in.
(51.3 x 33 cm)
Gagosian Gallery, New York

*Michael von Zichy
(1827–1906)
Detail of* Study of Hands,
*c. 1870
Ink on paper
Location unknown*

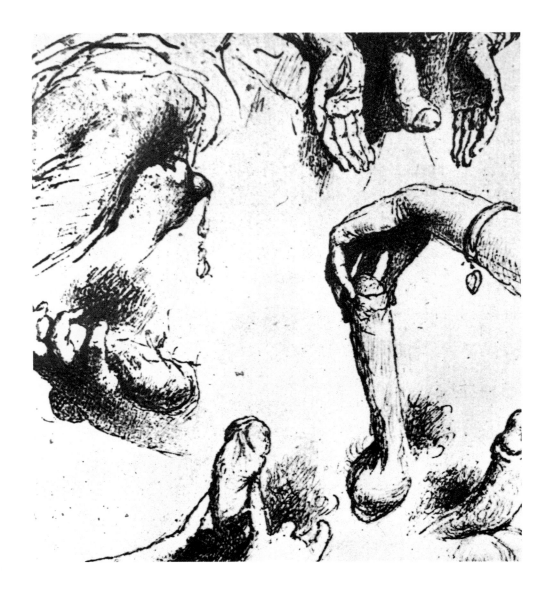

*P*enises, more often than not, are represented with great gravity by male artists, so it is refreshing to find someone who could look at them with humor. Here a woman—recognizable as such by her bracelet—cajoles, prods, chastises, and teases a penis that is sometimes reluctant, sometimes cooperative, but never arrogant or proud. The drawing was made by a court artist to Czar Alexander II who over his lifetime produced a series of prints called *The Cycle of Love,* which charts the sexual career of an artist from adolescent masturbation to married life. Like this work, they are pornographic in intent but not salacious or tawdry.

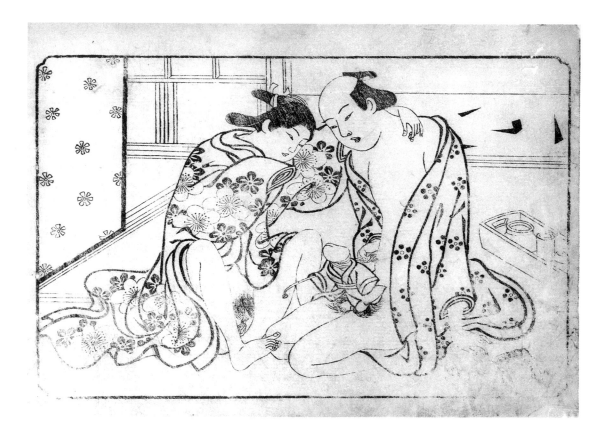

Sukenobu (1671–1751)
Courtesan Decorating Her
Lover's Penis, c. 1720
Black-and-white woodblock print,
approximately 6 x 8 in.
(15.2 x 20.3 cm)
Ronin Gallery, New York

Only a very secure man would let a woman dress his erect penis in a kimono, thus turning his organ into a little person with (if you look closely) an appendage that will stimulate his partner. Lovers of all societies have played this game of decorating bodies. Lady Chatterley and her gamekeeper garnished each other's genitalia with flowers, and there are thousands of other similarly lighthearted ways to celebrate a partner's sexuality. Such imaginative games can be great fun, and I hope this penis has an entire wardrobe that will be changed every week.

The widespread custom of calling a penis by a first name—like Dick or John Thomas—helps to personify this sexual organ as a provider of pleasure for both the man and his partner. In addition, it no doubt helps some men by objectifying the penis and thereby reducing anxiety about their ability to keep an erection.

One more lesson: these two are definitely not rushing, and couples should remember to take their time. They should also keep in mind that good sex takes place not just between the waist and the knees but also between the ears, and a fertile imagination will always make it better.

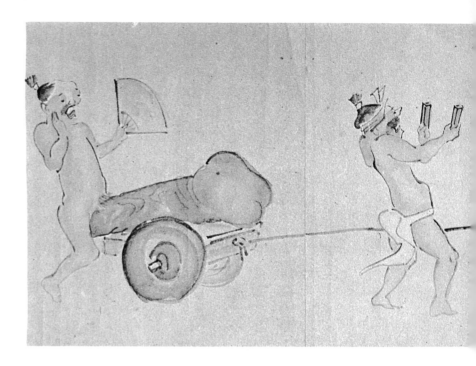

Since time immemorial, men—but rarely women—have been obsessed with penis size. The truth of the matter is that the size of the penis does not affect female sexual pleasure, for even a small penis can stimulate the clitoris sufficiently to bring a woman to orgasm. It is skill, patience, and understanding that make a man a good lover, not a large penis. More important to a woman's orgasm than a penis is her own willingness to give herself up to the sexual pleasure that leads to orgasm. The greatest lover in the world cannot give a woman an orgasm unless she allows herself to have it.

But men dream on. An unwavering convention of Japanese erotic art is the inflated penis. An eighteenth-century artist named Jichosai (or Nichosai) poked fun at this convention in a scroll that depicts a mock battle of penises. After all, men are always comparing the sizes of their penises, so why not settle it with a contest? Here one contestant enters the scene with a penis so large that it requires four stout men to pull the cart on which it rests. A man with clapping blocks marks the beat of the march. The contestant, who has a worried look, carries a fan—perhaps to keep his penis from overheating.

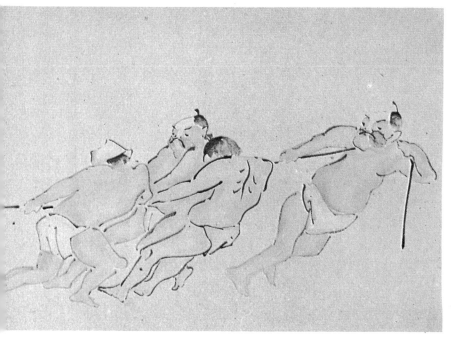

Seated Figure with Large
Phallus, *200 B.C.–A.D. 500*
Colima, Mexico
Burnished red and orange slip
with incised decoration,
9½ x 9 x 7½ in.
(24.1 x 22.9 x 19.1 cm)
*Los Angeles County Museum of
Art; Proctor Stafford Collection,
museum purchase with Balch
Funds*

This little man is so astonished by his big penis that he has to sit down to take it all in and brace himself with his arms to keep his balance. His wonderment is coupled with an exhibitionist's sensibility: "Look at me, and look at what I can produce." No wonder Mexicans are considered such good lovers!

Scholars still cannot decide whether these figurines, which were found in West Mexican tombs, represent supernatural beings or ordinary mortals. This figure has been called a "phallic performer," something most men consider themselves to be even if their measurements are not as impressive as this fellow's. His job was probably closer to that of a priest or a ritual actor than that of a stand-up comedian.

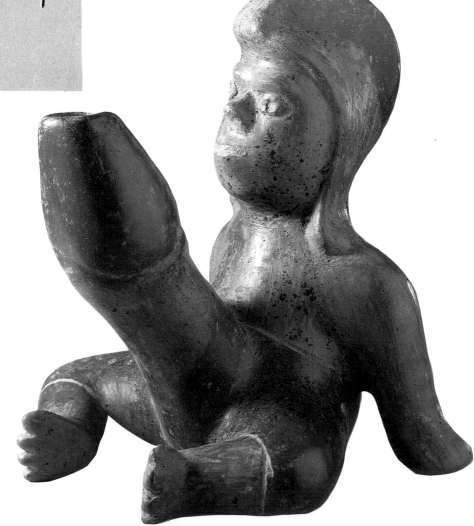

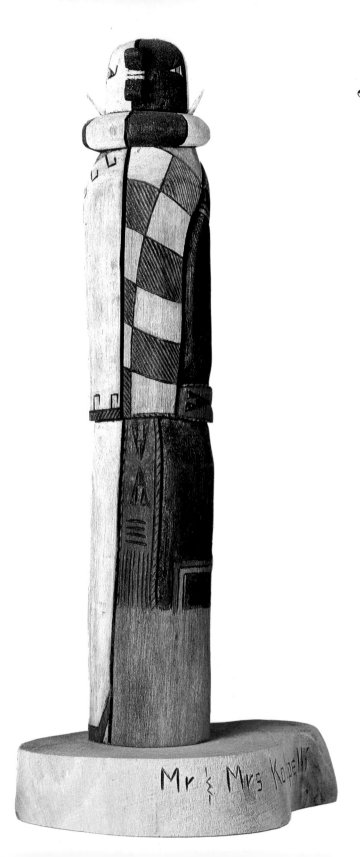

Mr & Mrs Kokpelli

This is a contemporary version of a tradi-
tional Kachina doll, made by a gifted
Hopi carver named Fred Koruh. It looks like
a single figure until it is taken apart, and then
we find that, in fact, it is composed of a male
and a female whose sexual parts fit neatly
together. Their union can be read as symbol-
izing the fact that every human, male or
female, has aspects of the opposite sex's erot-
ic sensibility, and it is the mixture of the two
that makes up each individual's sexual identi-
ty. The most satisfying sexual encounters
represent more than just a momentary joining
of two bodies by providing completion, the
making of a whole that is greater than the
sum of its parts. The desire for this whole-
ness through physical union with a partner is
certainly a vital element of humanity's insis-
tent sex drive.

Kokopelli, the mythical Hump-Backed
Flute Player, is a Kachina (or spirit) that is
sometimes male and sometimes female.
Kachina dolls are used in Hopi families to
instruct the girls—never the boys—about the
multitude of Hopi gods. Kokopelli, in partic-
ular, is intended to provide a form of sex edu-
cation: female Kokopellis often pull up their
skirts to point at their genitals, while the
male ones are often shown in a state of
arousal. What is refreshingly honest about
Mr. and Mrs. Kokopelli is that Mr. has a penis
and testicles of normal scale, so the Hopi girl
for whom this doll was intended would be
prepared for marriage with realistic expecta-
tions about the male anatomy.

Fred Koruh
Mr. and Mrs. Kokopelli,
c. 1988
Cottonwood root, 10½ x 5 x
3½ in. (26.6 x 12.7 x 8.9 cm)
Chuck and Jan Rosenak

The Pleasures
of Looking

All of our senses can give us pleasure; through hearing, touch, taste, and smell we can experience every aspect of a lover's body. But sight is perhaps the sense we value most. For many people it is looking that sets in motion the first stages of a sexual response. Even a quick glance can be sexually exhilarating—the sight of an ankle, the nape of a neck, or just the swing in someone's walk can be felt all the way down the spine and lead to rapture.

Sometimes the pleasure in looking becomes so intense that just watching becomes sexually satisfying as an end in itself rather than as a prelude to lovemaking. You can see this voyeurism in Thomas Hart Benton's gawking farmer and in Edgar Degas's engaging *Admiration*. Believe me, no matter how appealing these pictures may be, making love with a responsive partner is a lot more fun!

The pictures in the second half of this chapter are less about the sexual aspects of looking than about the erotic connection between the artist and his (in this chapter all the artists happen to be male) model. In these cases the artists enjoyed a double pleasure from sight. The first pleasure was looking at their beautiful models (and likely getting aroused by them and therefore painting even greater pictures—*if* they could keep their minds on the task at hand). The second pleasure was looking at the arousing image as they created it.

Sometimes, as in Ingres's picture of Raphael, the artist could not resist taking a break to embrace his model. But he turns to look not at her but at her image, which to him is more captivating. Picasso, on the other hand, would rather break for sex. He was a lusty creature with few inhibitions, and his models were invariably the women he currently loved. It is undeniable that he used them shamelessly for his art, but being used in that way may have made them feel (for the moment anyway) more desirable and even ennobled by having been transformed into a work of art.

Finally, the long tradition of artist and voluptuous model is lovingly spoofed by William Wegman, whose slinky Lolita, sexy as she is, is a real dog!

Titian (1490–1576)
Venus and the Organ Player,
c. 1550
Oil on canvas, 58¼ x 85⅜ in.
(148 x 217 cm)
Museo del Prado, Madrid

*T*his is one of five paintings in which Titian paired a reclining nude woman with a musician. It is thought by most scholars that the artist intended to illustrate a then-fashionable Neo-Platonic argument over which was the supreme vehicle for apprehending beauty: ears that could hear music or eyes that could see a perfect human being. There seems to be no correct answer to this Renaissance conundrum.

What is so extraordinary about this painting—apart from the sensual nude, the lush depiction of wine red velvet, and the view into an extensive park furnished with peacocks and game—is the direction of the musician's gaze. He stares not at Venus's lovely face but at her genitals, making explicit the sexual nature of the very act of looking. He looks at her crotch in order to be aroused, and, presumably, we are aroused in turn by the sight of this sexual gaze.

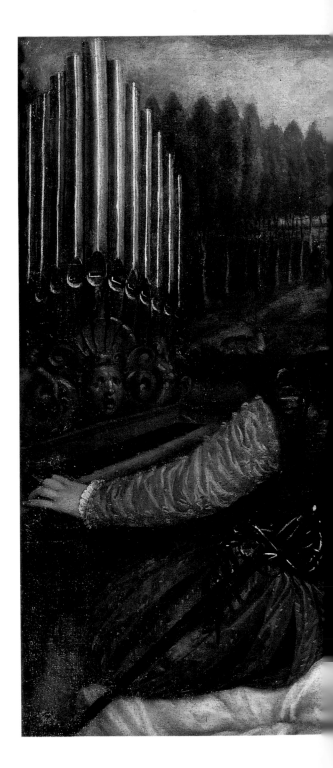

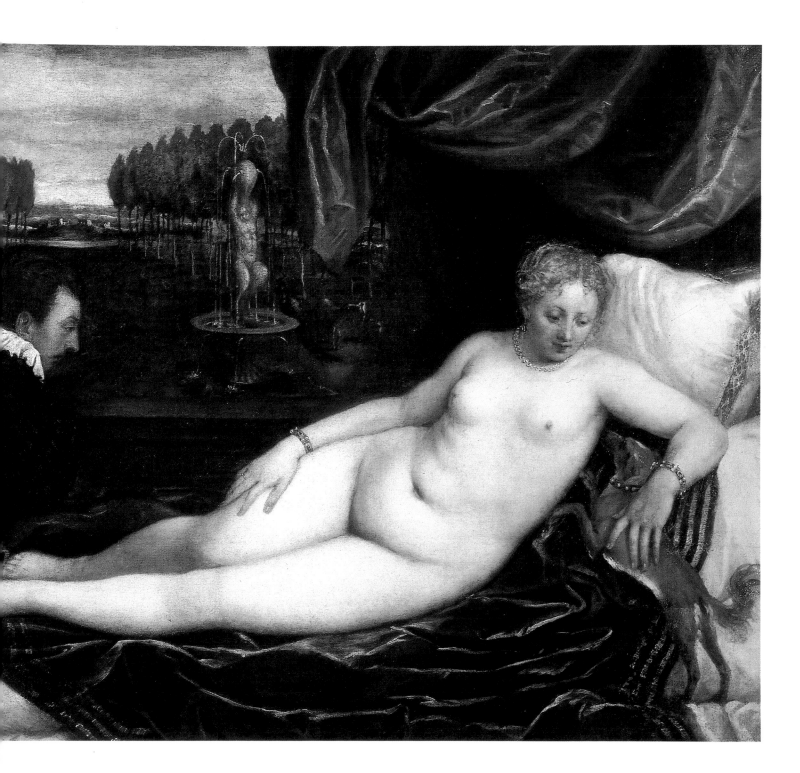

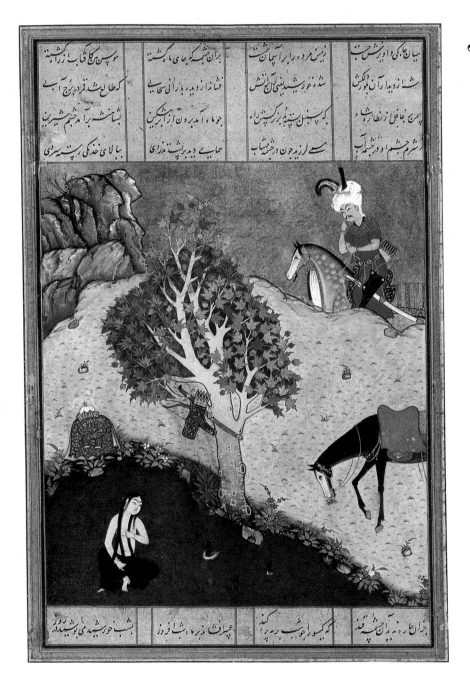

This is an illustration of a remarkable love story that came about because of pictures. An Armenian princess named Shirin and an Indian prince named Khosrow fell in love without ever meeting. All they had to go on were portraits and descriptions of each other, but that was enough to kindle desire.

One day Khosrow was out hunting, and by chance he came upon a beauty bathing in a pool. It was Shirin. Neither recognized the other, but they were smitten nonetheless. Khosrow was timid and respectful, Shirin startled but not frightened. She quickly got dressed and left, and it was many years before the lovers met again. When they did, their joy at rediscovering each other was perfect, but politics prevented their union—instead, they each became the monarch of their separate lands. But their lives continued to intertwine until at last they were able to marry. The story, alas, ends in tragedy: Khosrow was assassinated in his sleep and—with a gesture that anticipated Shakespeare's tale of Romeo and Juliet—Shirin stabbed herself in Khosrow's tomb.

Sheikh Zadeh (Iranian, 16th century)
Khosrow Catches Sight of Shirin Bathing in a Pool, 1524–25
Leaf from a manuscript of the Khamseh (five epic poems) by the poet Nizami
Colors and gilt on paper, 12 5/8 x 8 3/4 in. (32 x 22.3 cm)
The Metropolitan Museum of Art, New York; Gift of Alexander Smith Cochran, 1913

The biblical story of Bathsheba is about the act of looking and its consequences. David, king of the Israelites, "arose from off his bed, and walked upon the roof of the king's house: and from the roof he saw a woman washing herself; and the woman was very beautiful to look upon. . . . And David sent messengers and took her; and she came in unto him, and he lay with her" (2 Samuel 11:2–4). The beautiful woman, Bathsheba, was married to one of David's generals, Uriah. David eliminated this inconvenience by ensuring that Uriah was killed in battle. His happiness was dashed, however, when the prophet Nathan accurately predicted the death of their child because it was conceived in sin. Only after David asked forgiveness from God did Bathsheba give birth to their second child, Solomon, who succeeded David as king.

Rembrandt allows us to enjoy Bathsheba's nudity just as David did, but he invites us to consider her dilemma, as David did not. Characteristically, Rembrandt chose to portray a revealing and poignant moment of reflection. Bathsheba has just read the letter in which David has asked her to come to him. She is flattered but also fully conscious that being consort to the king may well destroy her marriage. (At this point in the story, she could not have imagined that David would kill her husband.) The psychological strength of Rembrandt's depiction becomes even clearer when we compare it to a contem-

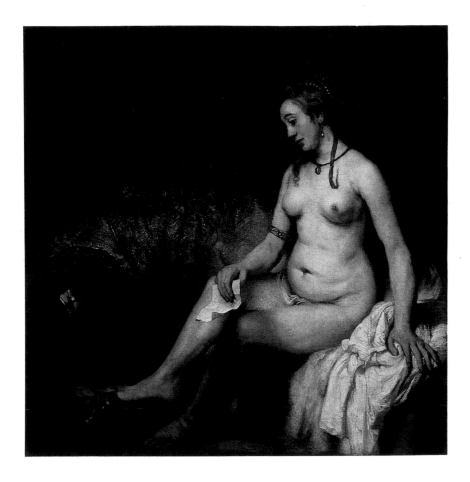

porary painting by Peter Paul Rubens, who showed Bathsheba's unclouded delight and excitement in receiving a letter delivered by a royal page. Rubens ignored the difficulty of the decision that she would have to make in order to focus on Bathsheba's luscious nudity and the splendor of David's palace, whereas Rembrandt focused on a human quandary with which almost anyone could identify.

Rembrandt van Rijn
(1606–1669)
Bathsheba with King David's
Letter, 1654
Oil on canvas, 55⅞ x 55⅞ in.
(142 x 142 cm)
Musée du Louvre, Paris

Women—and the occasional man—have been depicted rushing through the air on swings ever since antiquity, but never more frequently than in the 1700s. It is no surprise that such an exciting activity would be a recurrent theme in that century devoted to pleasurable pursuits, for it afforded the artist a wonderful opportunity to create a splendid landscape on a fine day, peopled by figures in picturesque costumes and animated by dogs, birds, butterflies, and so on. Antoine Watteau and Nicolas Lancret made several such pictures, but the best known is this painting by Fragonard, the most famous of his three canvases of women on swings and one of the most clearly erotic works of its day.

The painting was ordered from the artist, and the terms of the commission make the erotic intent explicit. The baron de Saint-Julien, a courtier to King Louis XV, first asked a painter named Gabriel-François Doyen to execute it, but he declined and recommended Fragonard instead. Doyen told a friend what Saint-Julien had asked for; the patron had pointed to his mistress and said: "I should like to have you paint Madame on a swing that a bishop would set going. You will place me in such a way that I would be able to see the legs of this lovely girl." Understanding the baron's intent, Doyen responded, "Ah! Monsieur, it is necessary to add to the essential idea of your picture by making Madame's shoes fly into the air and having some cupids catch them."

As one scholar has explained, "love and the rising tide of passion" constitute the essential idea of Fragonard's painting. In making this idea visible, Fragonard improved upon the original suggestions of Saint-Julien and Doyen. He spared the clergy the embarrassment of pushing the swing (Saint-Julien was the receiver general for the French clergy) and provided a dense grove to shield the pusher, whose clothes betray no special identity. There are no flying cupids to catch the shoes of the mistress; instead, Fragonard painted a replica of Etienne-Maurice Falconet's 1757 statue of Cupid requesting silence while love unfolds. The unfolding drama is, of course, all about sex. The man, crouching in a rosebush, has doffed his hat; the woman, her pink skirts flying open, has kicked off her shoe. We viewers are left to wonder about the height not just of her flight, but of her passion.

Jean-Honoré Fragonard
(1732–1806)
The Swing, *1767*
Oil on canvas, 31¾ x 25¼ in.
(81 x 64.2 cm)
Wallace Collection, London

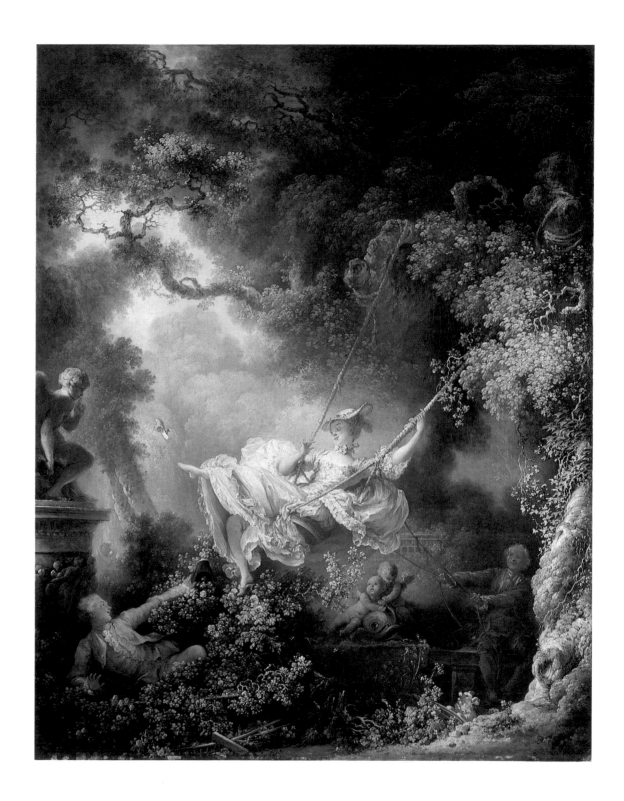

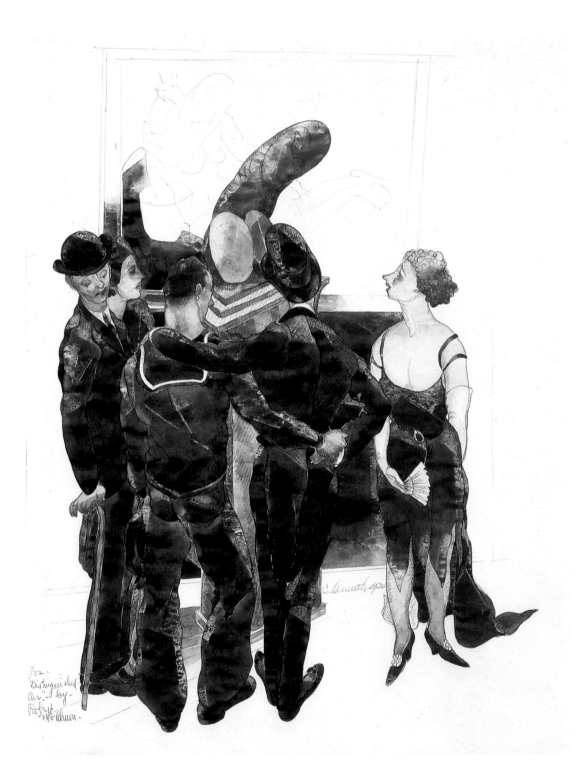

Charles Demuth (1883–1935)
Distinguished Air, *1930*
Watercolor on paper,
14 x 12 in. (35.5 x 30.4 cm)
Whitney Museum of American
Art, New York; Purchase, with
Funds from the Friends of the
Whitney Museum and Charles
Simon

emuth named this work after Robert McAlmon's short story about the homosexual milieu in Berlin—a milieu best known today through the stories by Christopher Isherwood that were the basis of the movie *Cabaret*. Recognizable from McAlmon's story is the overdressed and drug-dependent American woman at right, as well as the top-hatted and tailcoated central figure, a homosexual dandy with a "distinguished air" who had a crush on a handsome serviceman. But Demuth lifted the action out of a bar and placed it in a museum, where Constantin Brancusi's blatantly phallic *Princess X* is on view before a painting of a female nude.

Sex is everywhere in this clever satire: in the display of the woman's breasts and her fan-covered crotch, in the tender holding of hands as the two men gaze on Brancusi's penislike sculpture, and in the distracted stare of the bowler-hatted man at the sailor's tight pants. The man in the bowler may be a stand-in for Demuth, who styled himself as a dandy. Demuth has wittily underscored what we all can observe any day we visit a museum: that art excites an erotic impulse.

⁓

erhaps more than any artist other than Picasso, Degas chronicled the humor of sex. Here he shows how a voyeuristic impulse can drive men into ridiculous situations. A client at a bordello crouches, fully dressed, beside an iron bathtub, while his paid paramour for the moment rises like Venus from the waves. Her short and stubby body betrays that she is no goddess, but the round-faced client could not care less. He is enraptured by her and by the fulfillment of his fantasy.

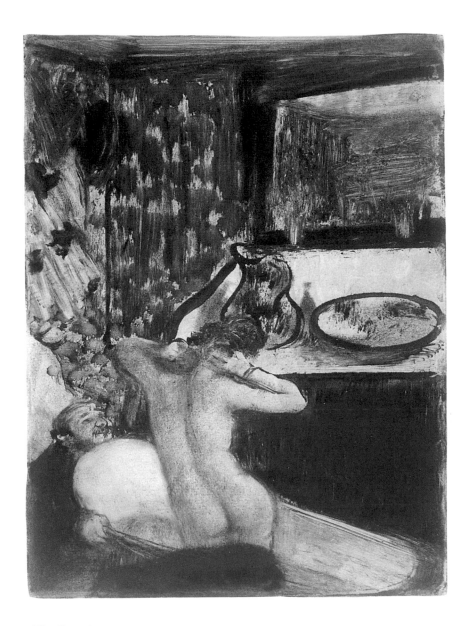

Edgar Degas (1834–1917)
Admiration, 1876–77
Monotype in black ink heightened
with red and black pastel, plate:
8½ x 6⅜ in. (21.5 x 16 cm)
Bibliothèque d'Art et
d'Archéologie, Universités
de Paris; Jacques Doucet
Foundation

⁓ 53

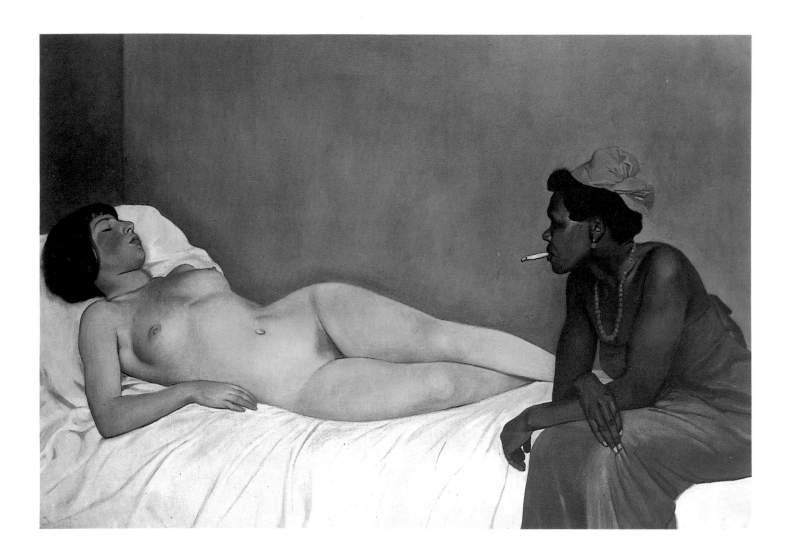

54

ℋere Vallotton, a painter of the early twentieth century who was involved in anarchist politics, replaces the stereotypical gaze of the white male painter with that of the black woman at right. With more than idle curiosity, she stares at the other model, who sleeps in the characteristic pose of a "display nude," a pose used by painters from the Renaissance to the present day to display a woman's body for male delectation. What is the black woman thinking? Rarely has an artist made a gaze so active. Is she coolly analyzing the white model's curves? Is she contemplating the advantages a white has in European society? Or does she have sexual thoughts? Her phallic cigarette may be an important clue that the artist has included to direct our own ideas.

The haystacks are casting long shadows and so the farmer heads home. Along the way he stops to examine a vision more potent than any dream he has ever had: a magnificent nude goddess napping beside the creek in which she has just bathed. Benton's title tells us something the farmer probably does not know: he has found Persephone, the beautiful queen of Hades, god of the underworld.

Persephone was born to Demeter, goddess of agriculture, and her brother Zeus. Hades had to abduct the young Persephone in order to get her to hell to live with him. Demeter was so distraught over losing the company of her daughter that she ignored her crops all over the world. This neglect became intolerable to the mortals, and so Zeus intervened, making Hades eventually agree to allow Persephone to stay above ground for all but three months a year. Those months, when the earth was deprived of her beauty, became winter.

Benton's clever composition allowed him to place a sophisticated, academic-style nude within the context of his animated vision of rural America—a juxtaposition that ordinarily would have been as incompatible as oil and water.

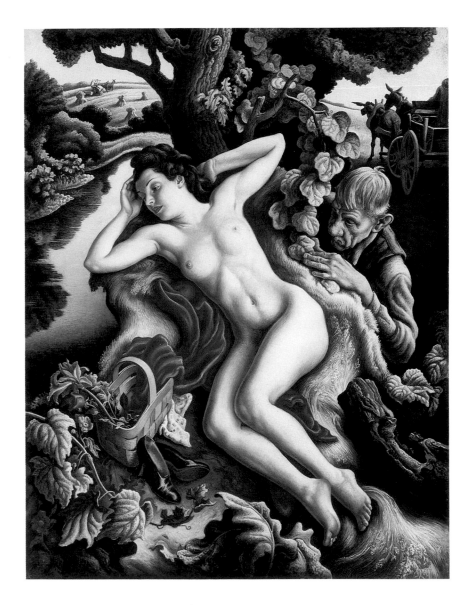

Thomas Hart Benton (1889–1975)
Persephone, 1938
Tempera with oil glazes on linen over panel, 72⅛ x 56⅛ in. (183 x 142 cm)
The Nelson Atkins Museum of Art, Kansas City; Acquired through the Yellow Freight Foundation Art Acquisition Fund, Mrs. H. O. Peet, Richard J. Stern, The Doris Jones Stein Foundation, the Jacob L. and Ella C. Loose Foundation, Mr. and Mrs. Richard M. Levin, and Mr. and Mrs. Marvin Rich

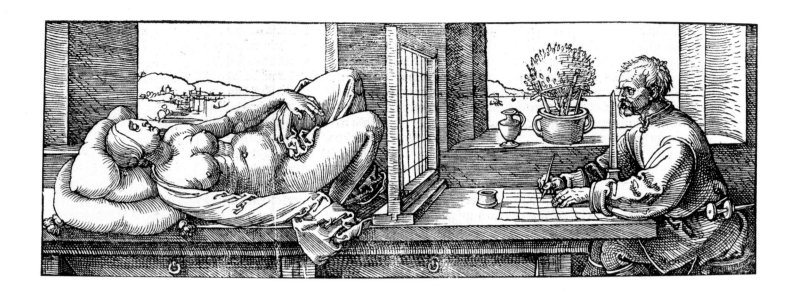

For artists and architects, one of the most thrilling events of the fifteenth century was the establishment of a scientific, arithmetic method of perspective that enabled draftsmen to suggest in two dimensions the three dimensions of the world around them. In many respects the new system of linear perspective was just as arbitrary and artificial as the old-fashioned atmospheric perspective it replaced, but to most artists that did not matter. The new method was a way to impose visual order on the disorderly world around them.

Like many artists of his day, Dürer was obsessed with the science of art. Perspective, proportion, the canons of beauty, the art of the ancients, the art of his Italian contemporaries, the new techniques of reproduction—all fascinated him. In this illustration to a manual for artists, Dürer has demonstrated how to use gridded glass in tandem with squared paper in order to facilitate the rendering of a difficult form—in this case, the drastically foreshortened female figure. By looking through the glass, the artist observes, for example, that the woman's left eye falls at the intersection of two lines, and therefore he positions the eye at the same intersection on his paper. By plotting many such coordinating points, he can accurately reproduce what he observes. What makes this illustration exciting, however, is the prospect of seeing such a beautiful nude woman. That the obelisk-like pointer is reminiscent of a penis and that the woman's legs are positioned so that the artist might see between them underscores the connection between looking and desiring.

icasso often depicted explicit scenes of rape and of mutual intercourse, but he also tended to insert a sexual component into otherwise innocent compositions, as in this painting completed two days before New Year's Eve in 1953. It had been inspired by a recent experience: opening his bedroom door and catching sight of his sleeping mistress, the beautiful Françoise Gilot (herself a talented painter).

Making her appear in the painting like a splendid recumbent nude of the Renaissance, he included domestic details, like the child's toy on the shelf above the bed, that create an atmosphere similar to that in Titian's *Venus of Urbino* (page 12). But the fulcrum of the painting is the shadow cast by the artist as he opened the door. Unmistakably phallic, the shadow introduces the identity of the artist into the picture and provides a male counterpoint to the feminine curves of Gilot's body. Throughout his career Picasso depicted many such sleep watchers—stand-ins for the artist contemplating the object of his desire.

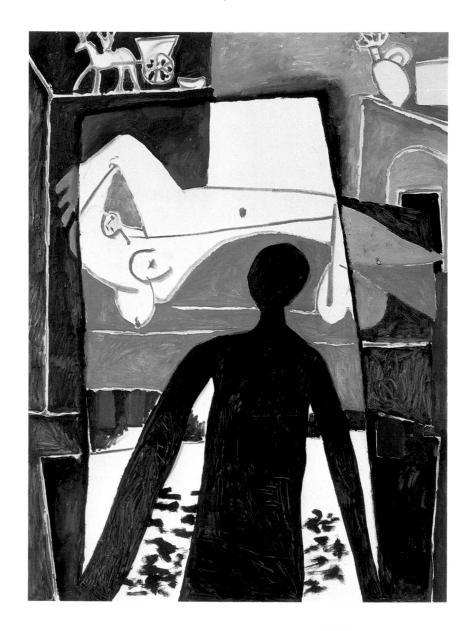

Pablo Picasso (1881–1973)
The Shadow, *December 29, 1953*
Oil and charcoal on canvas, 50¾ x 37¾ in. (129.5 x 96.5 cm)
Musée Picasso, Paris

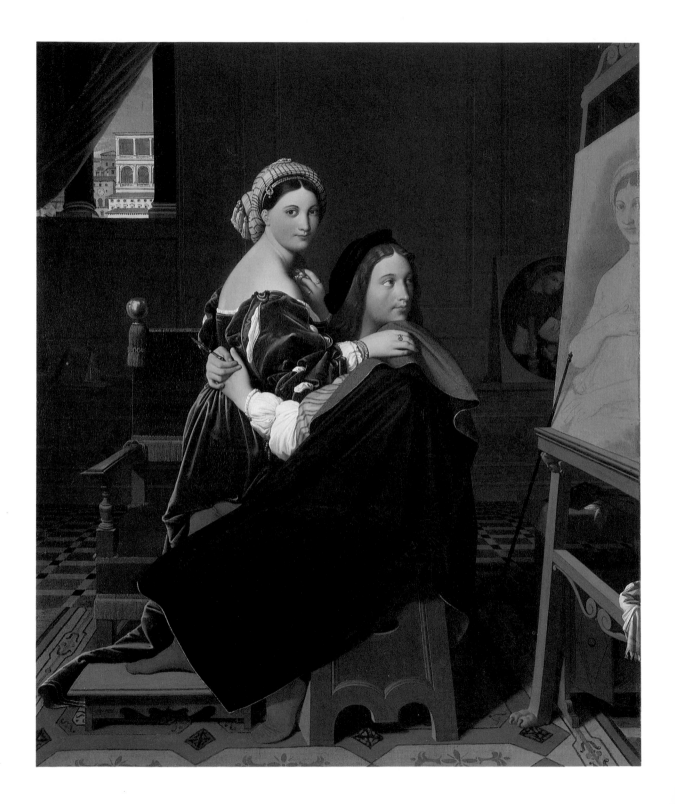

Models were often the muses of artists; sometimes, too, they were artists' mistresses and occasionally became their wives. In this work Ingres chronicled the old belief that the great Renaissance painter Raphael's purported mistress, known as La Fornarina (the baker's daughter), served as his model for a famous half-length nude, here shown on the easel.

Both painter and model have interrupted their work for a spontaneous embrace, but both are distracted. The sumptuously dressed model turns to look at the observer, while the artist, who has been given an uncanny resemblance to one of Raphael's depictions of Jesus Christ, stares fixedly at the portrait he has made of the model. Given the choice between the reality of his model and mistress and the illusion of her, Raphael seems to prefer the illusion. (Proof, perhaps, that sexual attraction is more mental than physical!) But Ingres likely intended to illustrate not his understanding of sexual dynamics but rather one of his key axioms: that art was the artist's true mistress. "Let's love art," he instructed his students, "let us love it with passion, and let's deliver ourselves to it wholly."

Perhaps better than any art historian's explanation, Picasso's etching reveals some of the messages underlying Ingres's *Raphael and the Fornarina*. Picasso has undressed both painter and model so that they will be unencumbered in their lovemaking —an activity only chastely implied in Ingres's painting. Picasso contorts their bodies to

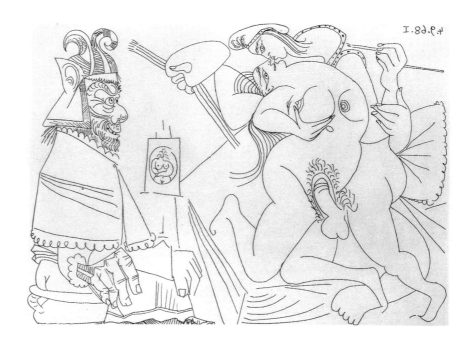

reveal their sexual organs and turns the canvas that Raphael had been working on so that the nude can be clearly seen. The model is too consumed by sex to look outward, as she does in the Ingres, but she does offer the viewer a breast, so no one feels left out.

In order to make blatant the voyeuristic nature of Ingres's painting, Picasso has placed an onlooker—a rather bestial pope— in, rather than outside, the painting. The pope's chair is empty in the Ingres (Raphael was famous for his portrait of Pope Julius II), but in the Picasso it has been irreverently transformed into a chamber pot, a different kind of throne, from which he observes it all.

Robert Colescott (b. 1925)
Beauty Is in the Eye of the
Beholder, *1979*
Acrylic on canvas, 84 x 66 in.
(213.4 x 167.6 cm)
Arlene and Harold Schnitzer,
Portland, Oregon

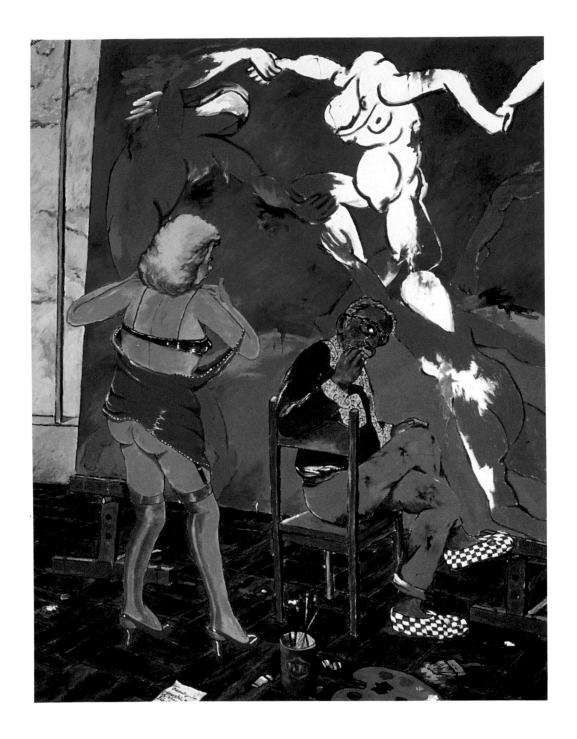

*R*obert Colescott, a contemporary American artist, has portrayed himself as if he were the great Henri Matisse painting one of his most famous works, *The Dance* (now in the Hermitage Museum, Saint Petersburg). The key to this picture was carefully inscribed by Colescott on the piece of paper lying on the studio floor: "Beauty is in the eye of the beholder."

With this painting the artist asks the question "what if?" What if Matisse were a black American—how would we view his pictures? Would we consider them beautiful? What if Matisse's models were shaped like the model in Colescott's picture, thick of waist, long of leg, and with shocking bleached blonde hair—would we consider them beautiful? Colescott made his model's body similar to that of the woman at the right of Matisse's *Dance* in order to underscore that the misshapen figures of Matisse's joyous dancers are not beautiful in themselves; rather, the beauty lies in what the artist has done with those figures. Beauty is truly in the eye of the beholder, and Colescott reminds us that we should not be enslaved by standards imposed on us either by classical canons or by contemporary advertising.

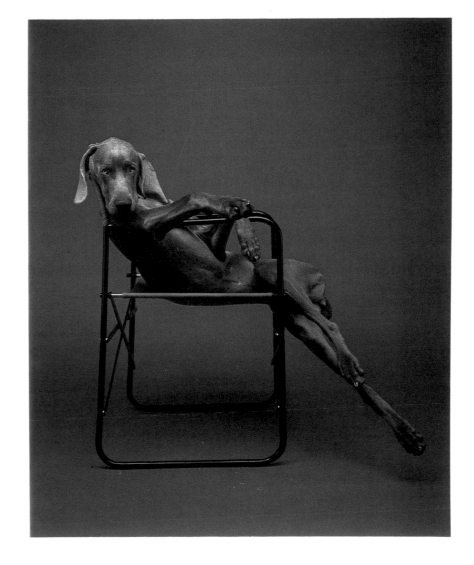

⌒

*W*egman is a contemporary artist who has dressed up his family of dogs—all Weimaraners—in order to photograph them in humorous situations. By using animals rather than people as his models he is able to make hilarious images that challenge stereotypes of human behavior.

This beauty, to whom the photographer gave the name of Vladimir Nabokov's teenage temptress Lolita, looks out at the viewer with faintly disguised boredom. Posed as a slinky studio nude, with one leg coyly lifted to suggest a sultry modesty, she bares not one breast but eight. She knows, as does her master, that eroticism is largely in the mind of the beholder.

William Wegman (b. 1943)
Lolita, *1990*
Polaroid/Polacolor ER
photograph, 24 x 20 in.
(60.9 x 50.8 cm)
Private collection

Flirtation and Seduction

Of all the pictures in this book, those in this chapter might seem the most alien to us today. That is because the art of prolonged courtship is largely lost—especially in our rushed, urbanized society, where everyone is always in a hurry. But we can start to relearn the skills of flirtation and seduction by looking at these pictures and learning from them. What we see here are the elements of arousal in its earliest stages, which are not only pleasurable for the moment but essential for the moments to come.

Teenagers might laugh at the fifteenth-century French tapestry in which a man tenderly holds a heart that he is about to offer to the object of his desire. But this offering of oneself is in fact the first step in any sexual encounter of quality. What the pictures by Watteau and Fragonard show us is the importance of conversation and of creating an intimate space away from others—which is why so many of these encounters take place in secluded corners of parks or woods. Instinctively, we want to isolate ourselves from the stresses and worries of everyday life so that we can create a mood conducive to romance.

Playfulness and surprise come across as vital ingredients of the first encounter. So does persistence—Fragonard (not to mention Shakespeare!) shows us that some lovers will use ladders, if necessary, to attain their goals. And pictures by Manet, Renoir, and William H. Johnson make clear how important dance can be as a mating ritual. Their paintings reveal the sexual charge that infuses the most innocent of dances and remind us that, at least in old-fashioned dancing, the opportunity to whisper in each other's ear could lead to intimacy even in a public place.

Not all of these pictures chronicle successful flirtations, and the failures, too, have points to teach us. The parable of Joseph and Potiphar's wife, for example, tells us that grabbing does not always get you what you want.

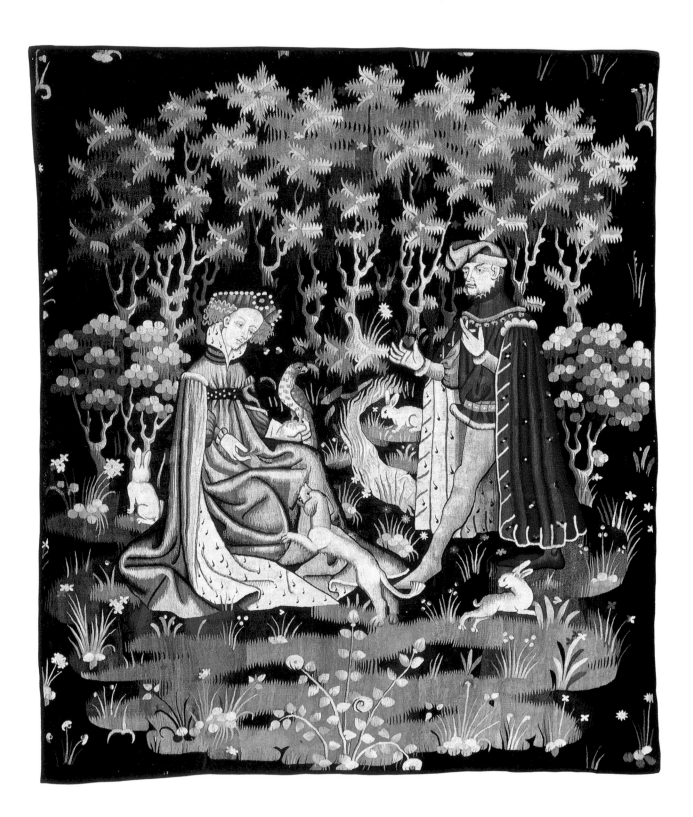

A well-dressed courtier advances toward a damsel in sumptuous costume. She holds a hunting falcon with one hand and with the other feeds a playful dog, symbol of fidelity. The gentleman—only a gentleman could afford that outfit—offers with the right hand, his most important hand, a heart, and with his left he gestures toward his breast, dwelling place of his heart.

It does not require a Ph.D. in sexual therapy to see that this couple is off to a wonderful start. She is too modest to look him straight in the eye, but by playing with the dog she conveys to the courtier that she will be faithful to him. He strides toward her deliberately and unerringly, and with his touching gesture he tells her he will give her what is dearest to him, his heart—which is to say his affection, his love. Those frisky and promiscuous rabbits are keeping their distance, because these lovers will be true to each other. It was known in medieval times, as it is today, that the idea of fidelity shared by both partners can be a powerful aphrodisiac.

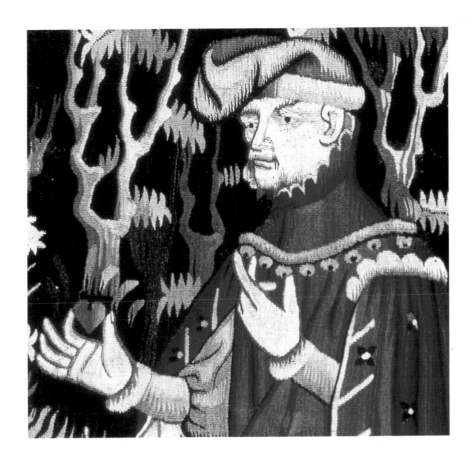

The Offering of the Heart,
early 15th century
Franco-Burgundian (Arras)
Wool tapestry, 82¼ x 101⅜ in.
(208.9 x 257.8 cm)
Musée National des Thermes
et de l'Hôtel de Cluny, Paris

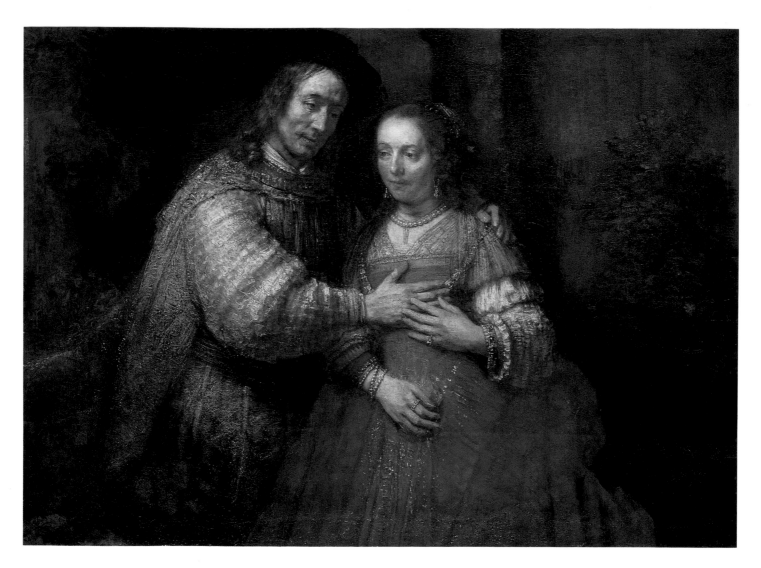

Rembrandt van Rijn
(1606–1669)
The Bridal Couple *(or The*
Jewish Bride*), c. 1665*
Oil on canvas, 47¾ x 65½ in.
(121.5 x 166.3 cm)
Rijksmuseum, Amsterdam

It would be difficult to imagine a more chaste embrace. This couple—thought by scholars to be a real-life Jewish couple portrayed in the guise of a biblical pair such as Jacob and Rachel or Isaac and Rebekah—are hardly gripped by passion. The man is clearly older than the woman, and their marriage was probably arranged by their families for financial or political reasons. Yet even though romance was far from anyone's mind, this painting exudes the sentiment of love. The groom tentatively but tenderly clasps his bride. She hesitantly touches his hand with her fingertips and protectively places her other hand over her womb. With caution they gaze toward each other indirectly, with eyes modestly cast down. They may be looking forward to their wedding night, but he will probably be an unadventurous lover, and she may never experience an orgasm. Rather than sex, they seem to be thinking, with tremendous anticipation, of their future children and their children's children.

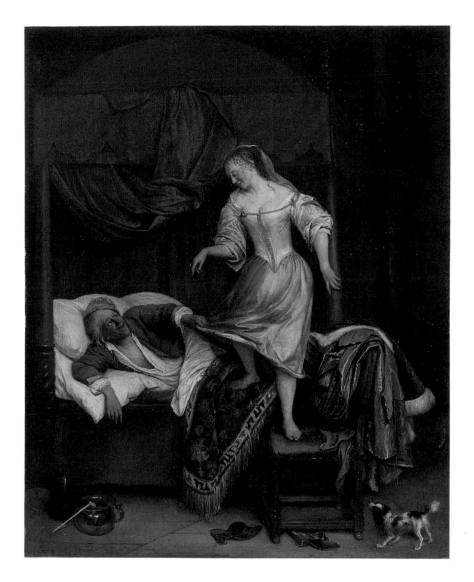

This frolicsome scene almost certainly takes place in a brothel: the debauched air of the man indicates his preoccupation with the sexual delights to come, and the woman's clothes identify her profession. It is unlikely that a respectable Dutch wife would wear her pearl earrings to bed, lest they be lost among the sheets. The inclusion of the little barking dog may be an ironic reference to fidelity, which dogs usually symbolize.

The playfulness of this couple—even if they are a couple for only one night—is in marked contrast to the sobriety of Rembrandt's bride and groom. Evidently Dutch burghers contemplated marriage much more seriously than sex.

Jan Steen (1626–1679)
The Seduction, c. 1668–72
Oil on panel, 19¼ x 15½ in.
(49 x 39.5 cm)
Museum Bredius, The Hague

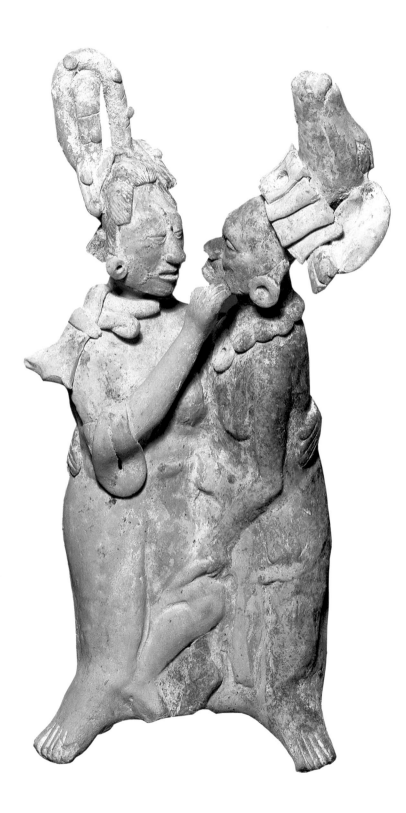

\mathcal{H}ere is a perfect example of what should always be remembered: It is never too late. Older people can enjoy a tender relationship. These stately Mayans must have known how important it is for older people to touch and to maintain a physical rapport in order to extract the full potential of life. It does not matter whether this couple will engage in full sexual intercourse. What is important is that they take time from their busy schedules—their headdresses lead us to assume that this is a king and a queen—to express their deeply felt devotion to each other. One scholar has observed that the Mayans were a well-balanced people with little need for obsessive eroticism. This evaluation seems to be confirmed by the graceful stance and elegant gestures of this handsome couple.

Mayan Whistle Figurine,
c. 9th century
Jaina Island, Campeche, Mexico
Ceramic, height: 10 in.
(25.6 cm)
Dumbarton Oaks Research
Library and Collections,
Washington, D.C.; Robert
Woods Bliss Collection of
Pre-Columbian Art

Joseph was the trusted, if self-righteous, slave of an officer named Potiphar. Potiphar's wife resented the young man's place in the household and decided to trap him by seducing him, then falsely accusing him of rape. She did not succeed. Joseph replied to her advances, "How then can I do this great wickedness and sin against God?" (Genesis 39:9).

This biblical tale was one that male artists traditionally used to portray woman as deceitful, insatiable, and whorish. The scene was usually depicted as an almost comic tug-of-war in the wife's bedroom, with both figures adopting exaggerated rhetorical gestures. In an etching by Rembrandt, Potiphar's wife (whose own name has not come down to us) desperately grabs Joseph, and her bedclothes have fallen away to reveal a fat and formless being. Finoglia here adopted a different point of view. The wife is shown as strong and powerful, a temptress whose sexuality is more masculine than feminine. For his part, Joseph resists, but not without reflection and perhaps some hesitation. From a psychological perspective, Finoglia's painting has a persuasive realism.

For many years this painting was thought to be by Artemisia Gentileschi, the gifted daughter of a Baroque painter named Orazio Gentileschi. Artemisia's paintings are noted for their dramatic action and chilling realism, an inversion of the stereotype of what a woman's art should be. Recently, however, this painting was reattributed to a Neapolitan man named Finoglia, about whom little is known.

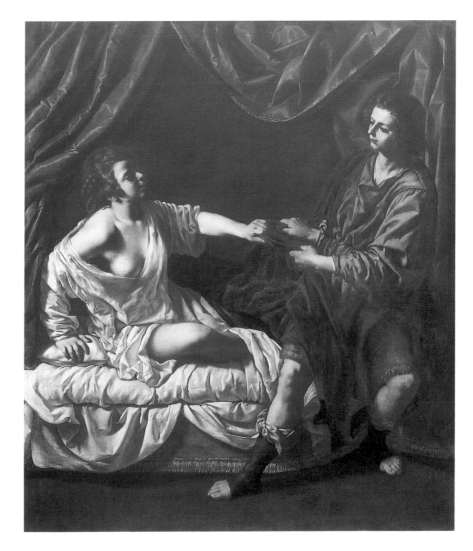

*Paolo Domenico Finoglia
(c. 1597–1651/53)
Joseph and Potiphar's Wife,
1622–23
Oil on canvas, 91¼ x 76⅜ in.
(231.8 x 194.9 cm)
The Fogg Art Museum,
Harvard University, Cambridge,
Massachusetts; Gift of Samuel
H. Kress Foundation*

69

Cross-dressing can be fun. It is not a practice confined to sexual deviants or to transsexuals (who sincerely believe they are trapped in the body of a sex different from their own). Rather it is often an amusing game played by intimates in which each assumes the role of the other. Here, for example, it is the woman who is the initiator, making an advance by lifting the skirt of her companion and placing her leg over his. He, on the other hand, implores her to take it easy. He does not want to be hurt! Although the point of this lithograph was originally to make light of the inversion of roles, the fact is that it underscores the importance of empathy within a relationship. Each partner needs to be able to see things from the perspective of the other, and what better way than for a woman to wear the pants around the house once in a while—and for a man to wear the skirt!

Octave Lassaert
Don't Be Cruel!
Lithograph
Location unknown

Watteau, the short-lived painter who captured with such gentle sweetness the appearance of the French aristocracy at the beginning of the eighteenth century, invented a genre of painting called the *fête galante,* in which elegant society was shown amusing itself, generally in idyllic outdoor settings. Social rituals at this time were becoming increasingly public, and as a result manners became more theatrical. The most influential theater then was the commedia dell'arte, which featured stock characters—the aggressive buffoon, the demure maiden, the lovesick clown—in comic situations that almost always centered around a love affair.

In this work Watteau shows revelers at a *fête galante* dressed as figures from the commedia dell'arte. The suitor at right, dressed as Harlequin, attempts with words to seduce the woman, dressed as Columbine. As he presses himself against her she pulls away, but her expression suggests that she is offended more by what he has said than by what he has done. To amplify the meaning of the action, a poem was appended to this work when it was reproduced as an engraving. It begins:

> *Do you want to triumph with women?*
> *Ignore their little bagatelles; . . .*
> *Love demands that one amuse him; . . .*
> *And often to a wise one he refuses*
> *All that a Harlequin obtains.*

Antoine Watteau (1684–1721)
Do You Want to Succeed
with Women?, *c. 1716–18*
Oil on canvas, 14½ x 9¾ in.
(37 x 24.9 cm)
The Wallace Collection, London

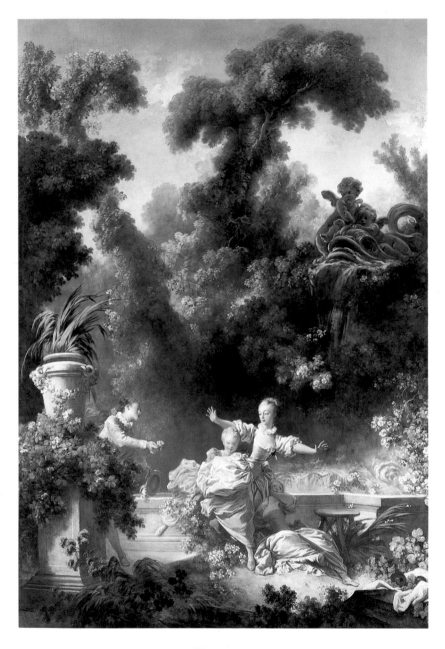

The Pursuit

Louveciennes, near Paris. Gardens were a favorite trysting place in the eighteenth century, and Fragonard's paintings celebrate the love that no doubt occurred in Madame du Barry's own garden. Since the canvases covered almost the entire surface of the pavilion's walls except for the glass doors that opened into the garden, a visitor to the room was surrounded by Fragonard's imaginary world, which could then be compared to the real world visible through the doors.

Scholars have been arguing for years about whether the paintings constitute a single courtship enacted in four scenes, and if so, about the correct order for the scenes. Others see four different kinds of courtship played out by four separate pairs of lovers. Either way, Fragonard's pictures are rich allegories in which the actions of the figures, the symbolism of the statues, the details of the landscape, and even the direction of the lighting all contribute to the meaning.

In *The Pursuit,* a young man tenderly offers a rose to a girl, who is so startled by this demonstration that she takes flight and in the process knocks over her two female companions. The palm in the vase at left is swept by the force of this encounter, and in the bushes above can be glimpsed a fountain representing two cupids restraining a speedy dolphin.

In *Surprise,* or *The Meeting,* a red-jacketed lover pops up unexpectedly, having scaled a ladder to gain access to a terrace. He is rebuffed by the girl, whose gesture is ambivalent: either she is saying "Go away!" or "Careful, we might be seen." The gesture of the statue, however, is clear: Venus, taking possession of the quiver, is disarming Cupid. It is not yet time for love.

*T*hese monuments to the art of courtship were commissioned in 1771 by Louis XV's official mistress, the comtesse du Barry, to decorate the walls of a new pavilion she had constructed in the garden of her château at

Jean-Honoré Fragonard
(1732–1806)
The Progress of Love,
1771–73
Oil on canvas
The Pursuit, 125½ x 84⅞ in.
(317.8 x 215.5 cm)
The Meeting, 125 x 96 in.
(317.5 x 243.8 cm)
Love Letters, 124⅞ x 85⅛ in.
(317.1 x 216.8 cm)
The Lover Crowned, 125⅛ x
95¾ in. (317.8 x 243.2 cm)
The Frick Collection, New York

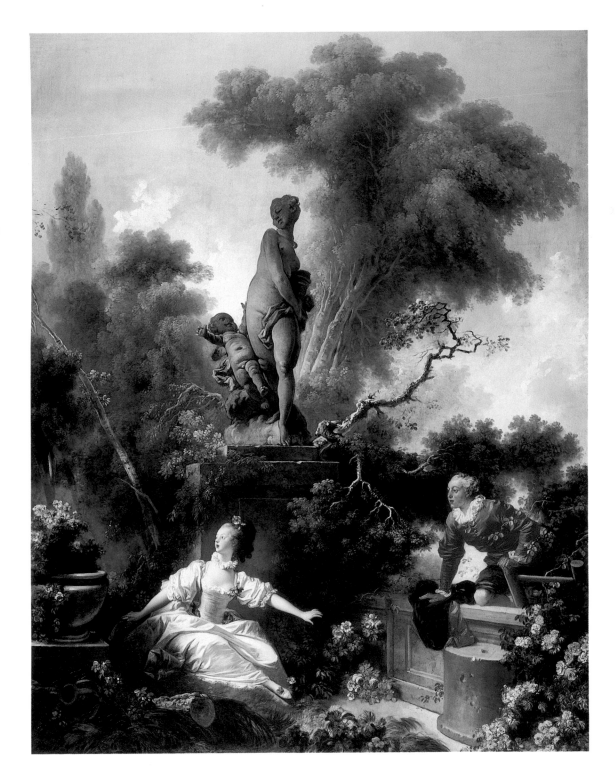

The Meeting

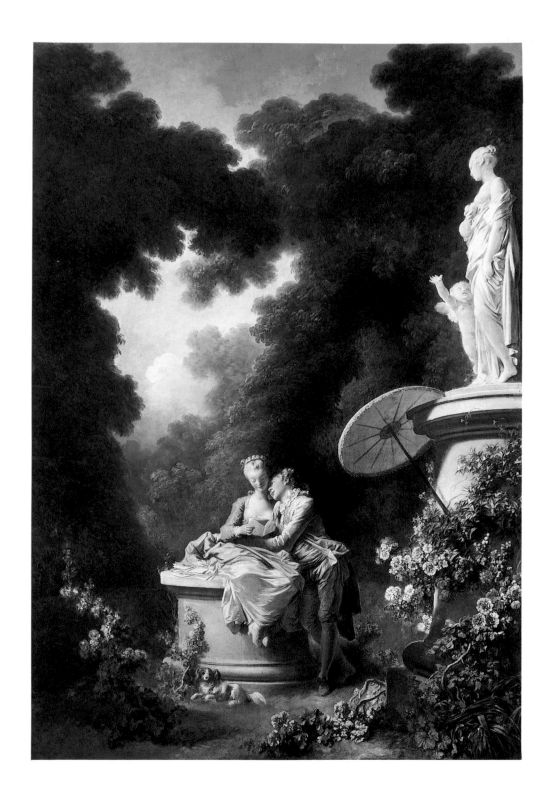

Love Letters

In *Love Letters,* an amorous couple reread their *billets-doux* and in the process seal their emotional bonds. The statue represents Cupid requesting the aid of Friendship to achieve his goal—love. Like the statue, the lovers are arranged on and around a pedestal, and at their feet is a dog. (Remember, the name Fido comes from the Latin for "I am faithful.") Roses grow vigorously up both pedestals, indicating that love is blossoming.

In *The Lover Crowned,* a couple making music together have put down their instruments to pose for their portrait. The man has decorated his lover with a garland, while she holds a floral crown over his head—in recognition, one presumes, of services performed in the name of love. It may also be a reference to Madame du Barry's lover, the king. Cupid, his work done, enjoys a well-deserved nap.

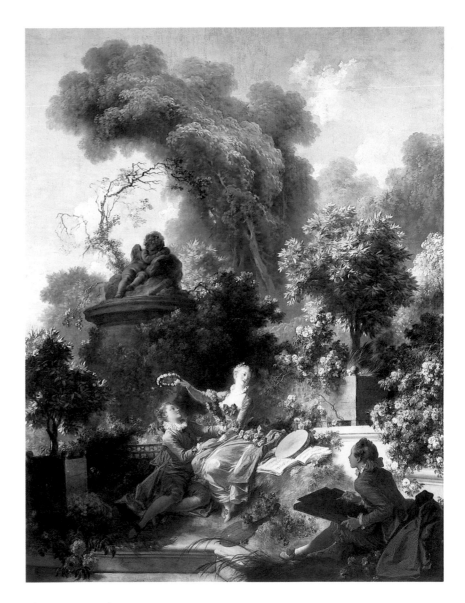

The Lover Crowned

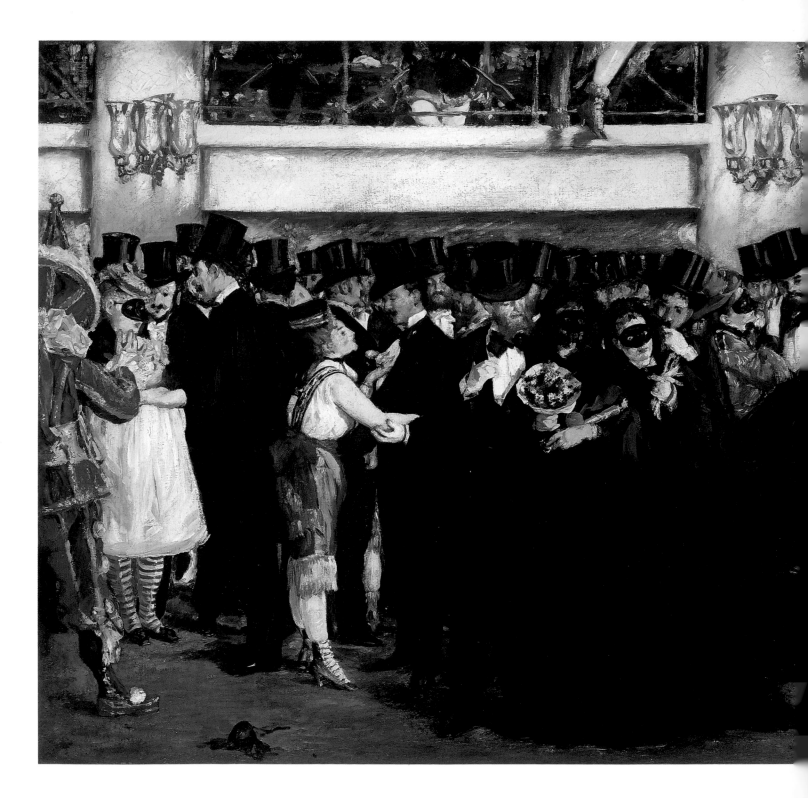

These top-hatted revelers at the opera are not dancing, as one would expect at a ball, but negotiating sexual liaisons. Even though there is nothing erotic about this worldly scene of high society, sex is nonetheless the subject: the pink-stockinged leg slung over the balcony is like a tradesman's sign announcing the availability of sex, as the art historian Linda Nochlin has observed.

In Manet's time the Paris Opéra was more about sex than it was about music, singing, or dance. Only well-to-do men could sit in the orchestra seats, and by controlling the repertory these subscribers ensured that their favorite singers and dancers were properly featured. But favorites were selected according to sexual not theatrical talent. The system was so openly corrupt that after a star would finish an aria the viewers would first applaud her—and then turn to applaud her "patron" in the audience.

Manet has painted the patrons as handsome men like himself. (Some art historians think that the man second from the far right is Manet.) We cannot tell who the women are or what they really look like beneath their costumes and masks. Their disguises facilitated the sexual advances of the men and gave the women freedom to act more boldly; Manet has made it clear that both sexes were active in the sexual commerce. (It may be no coincidence that the one woman who, like the men, is without a mask is wearing pants.) But commerce it is, for the sex obtained here was paid for not with thrills, or satisfaction, but with money.

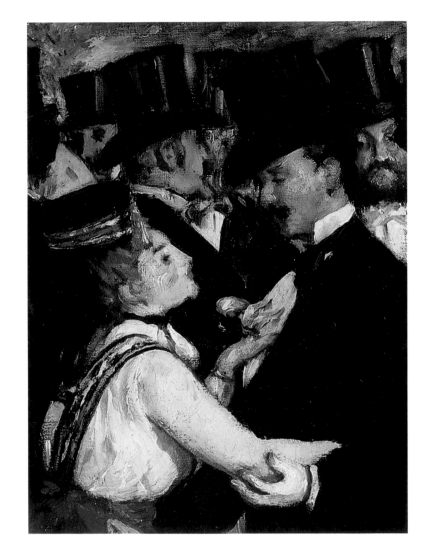

Edouard Manet (1832–1883)
Ball at the Opera, 1873
Oil on canvas, 23¼ x 28½ in.
(59 x 72.5 cm)
National Gallery of Art,
Washington, D.C.; Gift of Mrs.
Horace Havemeyer
in memory of her mother-in-law,
Louisine W. Havemeyer

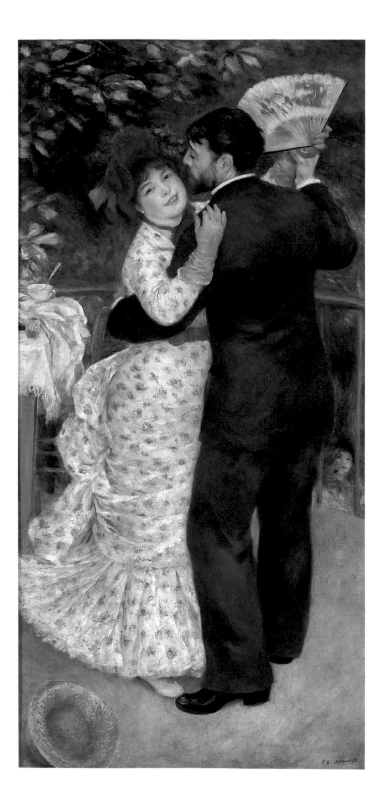

*R*enoir regretted the changes wrought by a modernizing society and longed for a return to a simpler past. His nostalgia is implicit in the three versions of the dancing couple that he painted on identically sized canvases in 1882–83.

In *Dance in the City* (Musée d'Orsay, Paris), an elegant, white-gloved couple turn stiffly before a mass of palms in a columned interior. In the work seen here, *Dance in the Country,* an affluent, well-dressed couple whirl spontaneously around a dining room. In the third painting (Museum of Fine Arts, Boston), traditionally thought to be set at the working-class pleasure garden in Bougival, outside Paris, a modestly dressed couple dance before a crowd of happy beer drinkers. Here gloves have been shed as a needless affectation. The couple press their bodies close to one another, and the man seems ready to kiss the girl. Cares have been discarded like the flowers and cigarettes that litter the floor. Although the painting is highly contrived, no more "natural" image of the pleasure of dancing has ever been concocted.

Music and dancing can be highly stimulating, which is why public dancing is actually outlawed in some small towns in the United States. It was not outlawed in New York, however, and it is exactly what William Johnson depicts in his *Jitterbugs III*.

Johnson was a black American artist, born in South Carolina. When he was seventeen, he moved to New York and spent much of his life in that city and in Europe. The dance halls and nightclubs of Harlem particularly intrigued him, and in *Jitterbugs III* he depicts a couple dancing the night away. The jitterbug was particularly popular in the early 1940s; the highly aerobic dance consisted of couples jumping, dipping, and swinging in carefully choreographed steps. In Johnson's silkscreen, the man seems to be in the process of dipping his partner; he supports her weight as her feet come off the ground and her arm flies back, obscuring her face from our view. Despite the angular forms of her body, her pose is highly erotic. Johnson takes care to show us the sensual curves of her legs, the arch of her back, and her erect breasts, shapes that are clearly echoed by the trumpets hovering above her head.

The crisp style of this silkscreen is based just as much on developments in contemporary European art as it is on African-American folk art. The energetic style and bright colors, as well as the subject matter, let us know that this is a painting about abandoning oneself—to the pulse of the music, to the lure of the dance, to one's partner, to one's self.

Kisses and
Other Foreplay

I cannot overemphasize the importance of foreplay—especially for women, who require more time to be sexually aroused. Unfortunately, it still is too often ignored. These pictures can be a guide to the various kinds of foreplay that are not only fun but key to real satisfaction for both partners. And they should help men, in particular, to become less goal oriented, to be less concerned about their erection and more concerned with the quality of the sexual encounter from start to finish. A good encounter will always yield a stronger orgasm. That doesn't mean that a quickie—or even a kiss or just a fleeting touch on the cheek—cannot be extremely enjoyable.

Gazing deep into the partner's eyes is a crucial first step to slow both partners down and to focus their attention on each other. Touching is inevitably next, whether it is fondling the partner's genitals, as in the *Red Figure Cup with Two Lovers*, or gently holding the neck and shoulders, as in the jug decorated by the Shuvalov Painter.

Then comes the all-important kiss. It is hard to imagine, but in some cultures there is no kissing; in ours, sexual kissing communicates both love and desire. We can kiss with our clothes on, as Chagall and Klimt show us, and we can kiss in the nude. We can kiss standing up, kneeling, sitting down, and lying down.

And what these pictures demonstrate is that kissing doesn't necessarily require *two* pairs of lips, because one can kiss the cheek, the neck, the earlobe, the belly button, or the base of the penis, near the testicles— just to name a few of the hundreds of erogenous zones we all have. (A good tip to remember is that the ridge from the testicles to the anus is very sensitive to touch.)

Not every pair of lovers is perfectly matched in size like Brancusi's loving couple, so Munch and others show men bending to accommodate their shorter female partners. (I like that very much!) And who would have thought that Hercules and Omphale would have been a good match,

81

given that both had such domineering personalities, but just look at their voluptuous kissing and their firm embrace. Their mouths are locked in union and they ignore the world around them. Not all kisses are going to be as passionate as theirs, but that does not mean they will not be stimulating. Cupid's gentle caress of Psyche's breasts in Canova's sculpture leads her to abandon herself to his ministrations.

Remember that kissing is not just foreplay—it should also be part of any extended sexual activity in bed. Because in bed, as Lautrec and Fragonard show, lovers are free to enjoy the whole body, touching and being touched. And that is almost always more satisfying than a quickie.

Marguerite Gérard
(1761–1837) and
Jean-Honoré Fragonard
(1732–1806)
The Stolen Kiss, c. 1785–90
Oil on canvas, 17⅝ x 21⅝ in.
(45 x 55 cm)
The State Hermitage Museum,
Saint Petersburg

A beautiful young woman proffers her cheek for a kiss, but she seems inexplicably pulled toward the right, away from her suitor. Her body leans into the young man's arms, but her eyes look warily in the opposite direction.

When we follow the line of the splendid striped shawl that extends from the girl's hand to the chair and sewing table, we see the cause for her concern: just visible through the half-open door is a room with people playing cards. With this one detail the artist encourages us to invent a scenario. The young woman has left the card party on the pretext of fetching her shawl, but what she really wanted was an excuse to see her admirer in private.

It would have been difficult for a daughter of a wealthy or noble family (the only families that could afford the expensive clothing and rich rooms depicted here) to escape the all-seeing eyes of her chaperone or her mother. And it is likely that the artists wanted us to understand that the young man is an unsuitable suitor. To judge by his informal clothing, he is probably a page or valet and therefore of a different class—all the more reason for the girl to fear discovery. But here nature triumphs over mores, sentiment over social conventions, and the excitement is heightened by the realization that this chaste embrace is a forbidden kiss.

A 1788 engraving included an inscription indicating that this painting was the work of Marguerite Gérard and Jean-Honoré Fragonard. Gérard, a talented artist who happened to be Fragonard's sister-in-law, was famous for brilliant renderings of satins and

silks that evoked seventeenth-century Dutch genre pictures. Because of the high quality of the painting, many scholars have considered it to be solely the work of Fragonard. But the seamlessly smooth technique is atypical of him and characteristic of her, so there are important reasons to count this as one of Gérard's finest pictures. Some writers think that Fragonard may have done no more than to suggest the subject to Gérard.

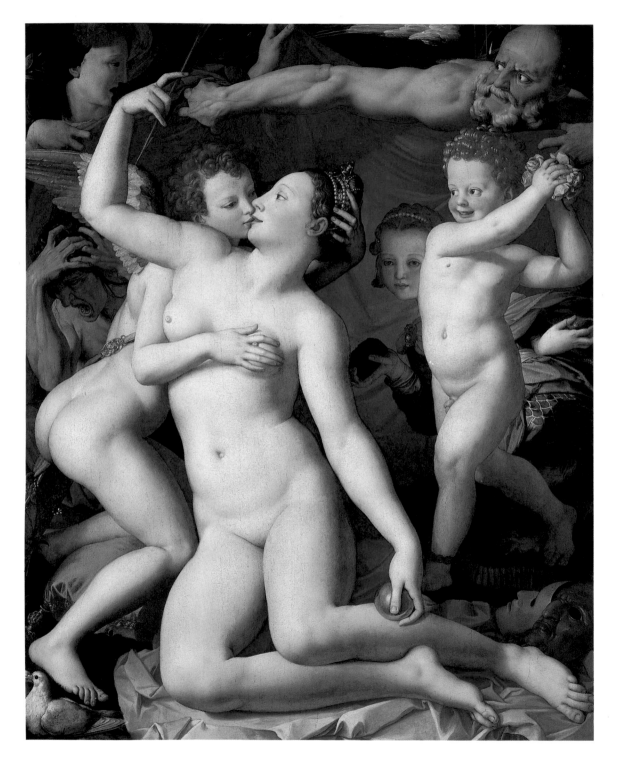

This may be one of the most perverse and chilling kisses in the history of art. In a deliberately complicated allegory, the Florentine painter Bronzino depicted Cupid, in a strangely sexual pose, congratulating his mother, Venus, on her victory in the beauty contest with Juno and Minerva. (Not even Venus knew who was Cupid's father—Jupiter, Mars, and Mercury are all contenders.) She holds the golden apple she won and teases his lips with her tongue, while he fondles her fruitlike breast.

Father Time, at upper right, pulls back a curtain to expose the figure of Fraud, upper left, recognizable by its ill-fitting wig. The young Folly, at right, is about to throw rose petals at the happy lovers. He is accompanied by Pleasure, who offers honey in one hand and a poisonous stinger in the other; Folly stands in such a way that the lovers will not see the stinger Pleasure conceals. Behind Cupid, at the left, Jealousy rips out its hair, but the lovers cannot see it either. In due course Father Time will pull the curtain to reveal Jealousy as the consequence of love, just as pain will be revealed as a consequence of too much pleasure.

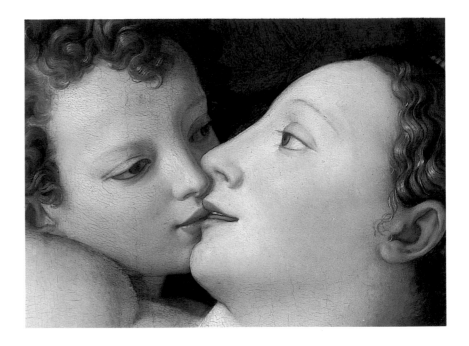

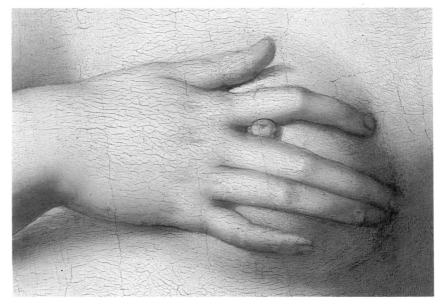

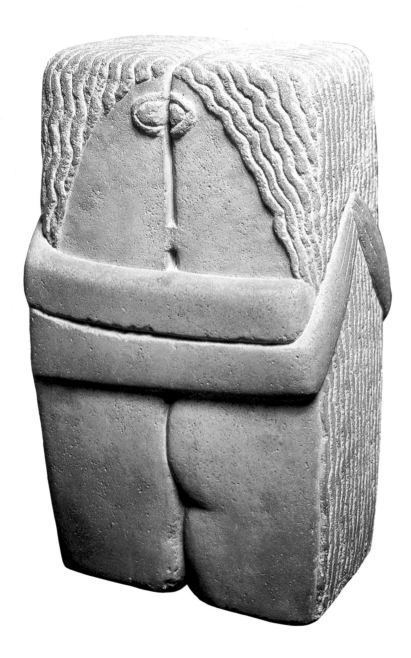

The greatest kiss is one in which both partners release all inhibitions and virtually melt into each other, simultaneously possessing and submitting to possession. At that point, time is suspended and bodies know no boundaries. For as long as humans have left written records, poets have described this extraordinary sensation with words, but no early depictions of a kiss have survived. In its utter simplicity, Brancusi's stone block refers to the prehistoric sculptures of the Cyclades; in the complete union of the embrace, he has captured a feeling that is both universal and contemporary.

Over the course of forty years Brancusi made eight versions of *The Kiss*. Each version was more geometric, stylized, and vertical than the last, until the united lovers ultimately became the sturdy column of a great gate. Brancusi called the portal the *Gate of the Kiss*, but he could just as well have called it the gate of love, since the foundation of true love is expressed in this emblem of mutuality and equality.

Constantin Brancusi
(1876–1957)
The Kiss, *c. 1912*
Limestone, height: 23 in.
(58.4 cm)
Philadelphia Museum of Art;
Louise and Walter Arensberg
Collection

When Munch gave a copy of this print to a publisher in 1902 he said, "Now you possess a print, which, because of its alleged immorality, could not be exhibited." But what, indeed, was immoral about this loving embrace? The nudity of the man and woman, even when the artist was careful not to show their genitals? What *are* couples meant to wear in their own bedrooms?

Typically for a male artist, Munch showed the man as the powerful initiator of the kiss and the woman as the adoring receptor. But the image was interpreted quite differently in its day. When the playwright August Strindberg saw a painting by Munch of this same composition, he described it in very negative, misogynistic terms: "The fusion of two beings, the smaller of which, shaped like a carp, seems on the point of devouring the larger as is the habit of vermin, microbes, vampires and women." The hateful notion of the "femme fatale," the fatal or devouring woman, was popular in artistic and intellectual circles at the turn of the century, and Strindberg had clearly succumbed to it.

Perhaps in response to criticism, Munch clothed the two lovers in his subsequent versions of *The Kiss*. But in the later versions he emphasized the fusion of the figures even more, making the kiss, in the words of a modern writer, the "symbol of immutable union."

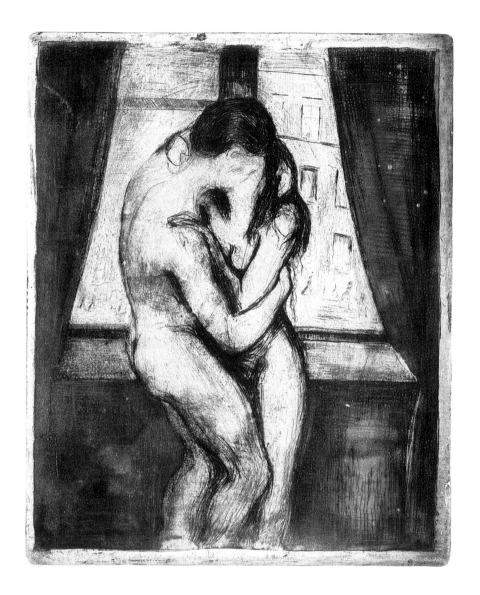

Edvard Munch (1878–1944)
The Kiss, *1895*
Etching, 12¾ x 10⅜ in.
(32.9 x 26.3 cm)
Munch-Museet, Oslo

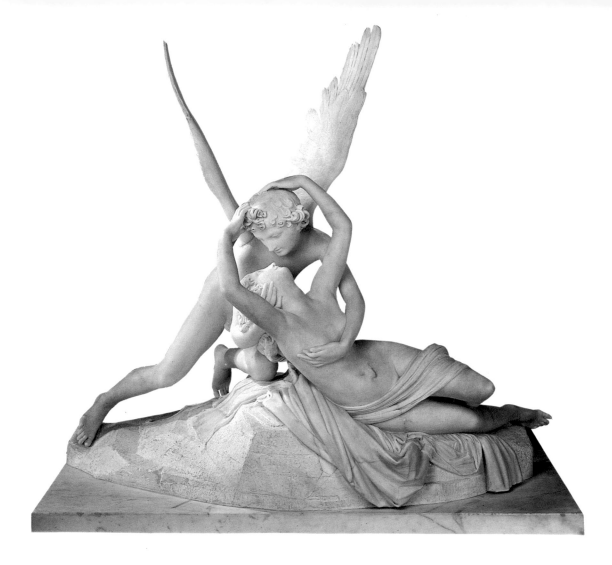

Despite the icy marble and the cool Neoclassical stylization of the figures, Canova has made a kiss that still engenders responses as passionate as that of the nineteenth-century French novelist Gustave Flaubert: "I looked at nothing else in the gallery. I returned to it several times and at last kissed the armpit of the swooning woman who stretches her long marble arms towards Love. And the foot! The head! The profile! May I be forgiven. It was my first sensual kiss in a long while. It was also something more; I kissed beauty itself. It was to genius that I dedicated my ardent enthusiasm."

Although it was Cupid who inspired love in others, it was Psyche who inspired him to love. They always met in darkness, and Psyche was forbidden to look at him; when she did, he disappeared—making him a classic example of a man fearful of intimacy. But there is no hint here of that unhappy moment—only a tender caress of Psyche's breast, which shows that Cupid knew how to arouse a woman.

\mathcal{S}ometimes a kiss can be simply a way of saying hello or good-bye. At other times, though, a kiss can be a sensual experience, sending the participants into a blissful state in which they are oblivious of all else. In this sculptural fragment we see two lovers completely enthralled by one another. Their kiss is highly erotic; the woman arches her back against her partner's body while he strokes her breasts and peels away the flimsy fabric that veils the lower half of her body. These lovers are enjoying one another to such an extent that they have no need for the outside world—their sinuous contours are intertwined to create a beautiful, self-sufficient unit.

This eleventh-century sandstone fragment comes from Madhya Pradesh, the largest state in India. The area is known for its numerous temples, the facades of which are decorated with scenes of erotic love. Interestingly, these sexy scenes are often interspersed with scenes from the life of Buddha. These loving couples may seem a strange choice for religious decorations, but it is thought that they are derived from Neolithic times, when fertility rites were performed in the fields to ensure successful crops in the coming season.

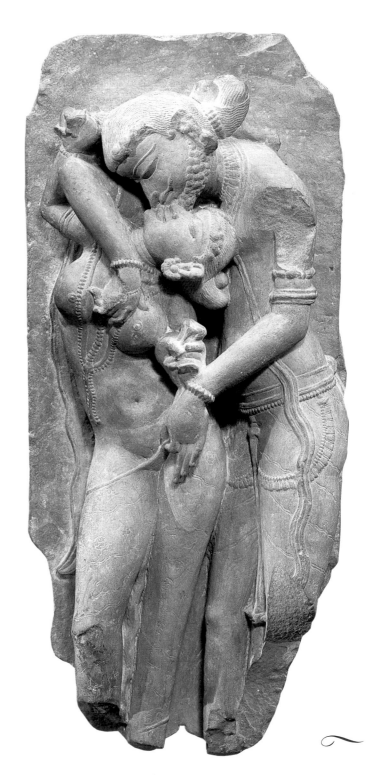

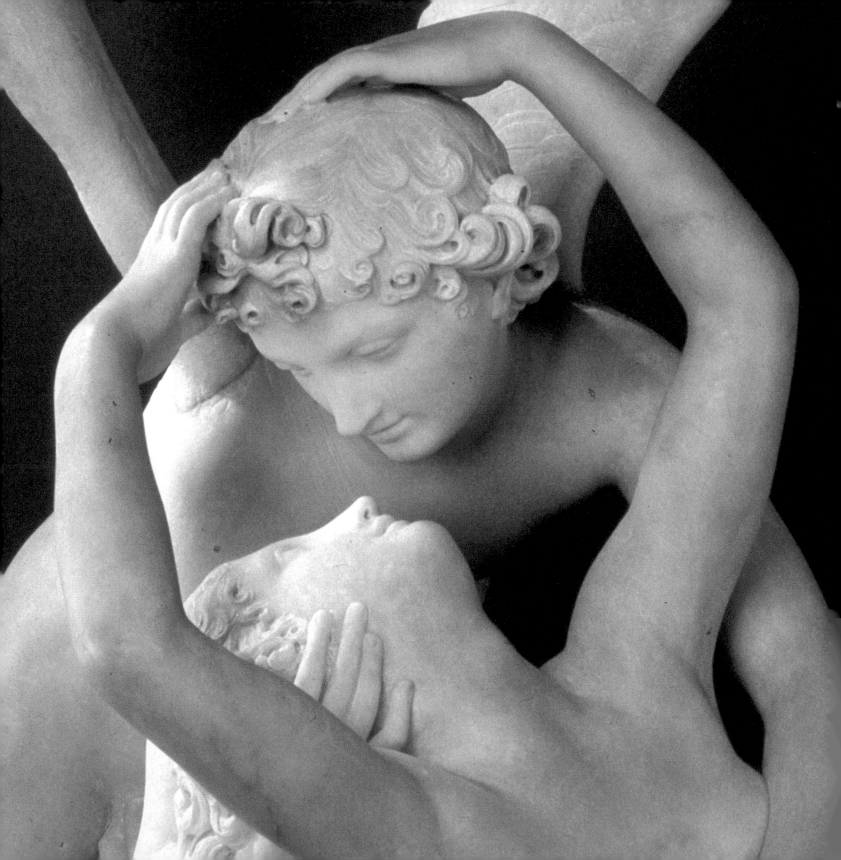

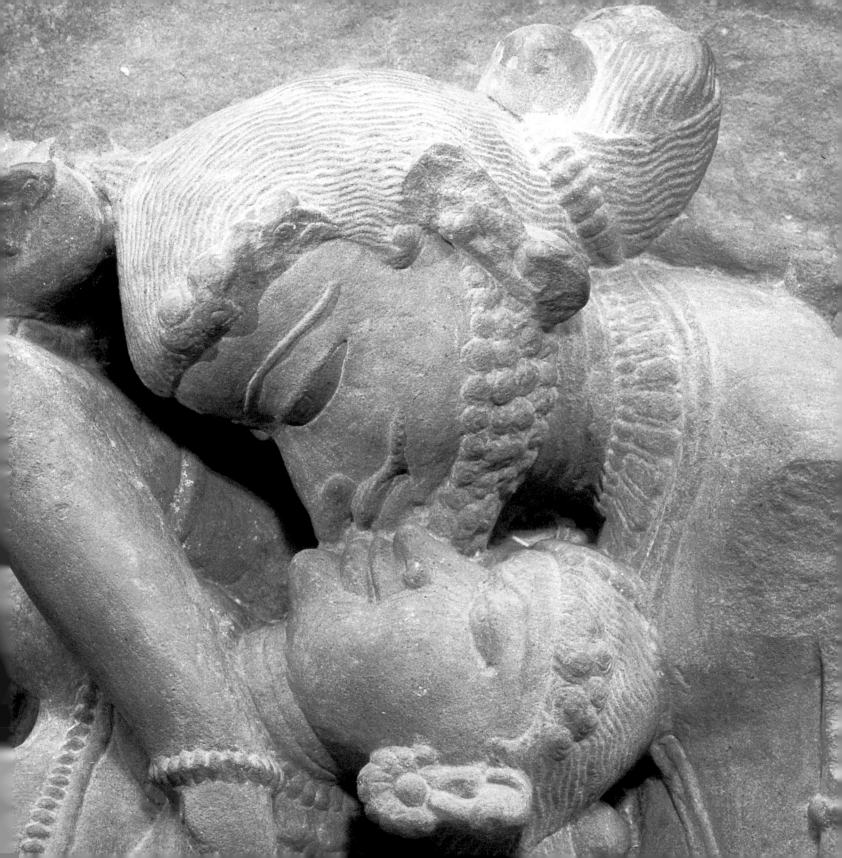

Marc Chagall (1887–1985)
The Birthday, *1915–23*
Oil on canvas, 31¾ x 39¼ in.
(81 x 15.4 cm)
Private collection

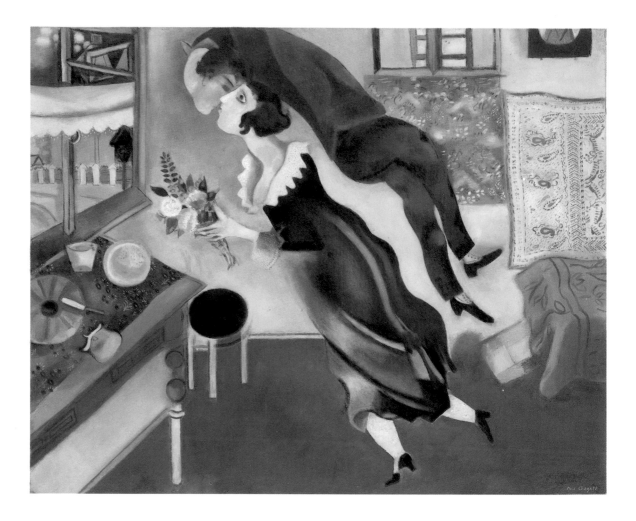

*N*ew lovers often liken their euphoria to the feeling of walking on air. Here Chagall has given visual expression to the sensation of light-footed joy. The event he records was a surprise visit by his beloved Bella on his birthday. He had not told her the date and was ecstatic to open the door of his room to find her standing there in her best dress, carrying flowers that she had picked on the outskirts of their town, Vitebsk. He quickly found a canvas and said to Bella, "Don't move—stay just like that." She later reminisced, "Through the window a cloud and a patch of blue sky called to us. The brightly hung walls whirled around us. We flew over fields of flowers, shuttered houses, roofs, yards, churches."

Glowing like a Byzantine mosaic, Klimt's picture brings the aura of a fairy tale to a kiss similar to that depicted by his contemporary Edvard Munch (page 87). As if in a wedding ceremony, the lovers kneel and press their bodies close to each other in tender embrace.

The man cradles the woman's face in his large hands, and she clutches his neck to bring his lips tighter to her cheek. Although the man has initiated the kiss, the woman is an eager participant and curls her toes with pleasure.

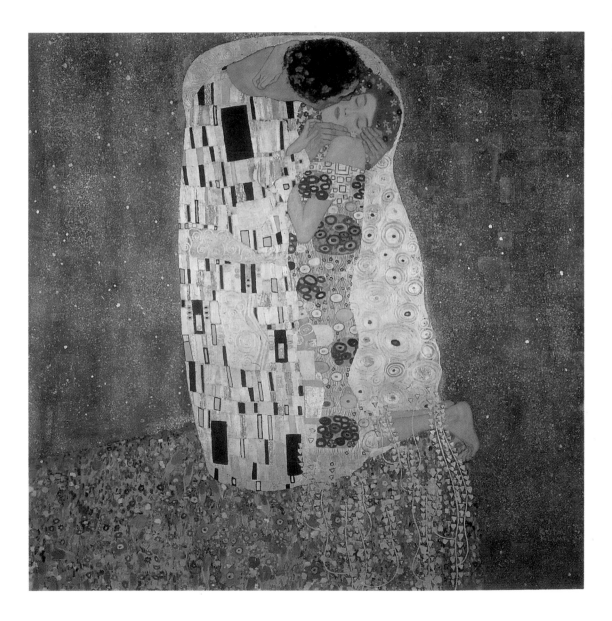

Gustav Klimt (1862–1918)
The Kiss, 1908
Oil on canvas, 70¾ x 70¾ in.
(180 x 180 cm)
Österreichische Galerie im
Belvedere, Vienna

Two swimmers in a whirlpool of love are irresistibly attracted to each other—or that is what at least one of them thinks, according to the caption at left. It is not uncommon to think of yourself as young and attractive when you are in love, and the artist has depicted the lovers in this feverish fantasy as they might imagine themselves to be. Why not give yourself a perfect nose, a strong jaw, and luscious lips, as Lichtenstein has done? His point in making this picture was to satirize contemporary clichés, and like the comic books and advertisements from which he borrows his style and imagery, Lichtenstein's art often concerns sex and violence. Happily, though, the two themes rarely collide—in fact, there could be nothing less violent than this ardent kiss-about-to-be.

Roy Lichtenstein (b. 1923)
We Rose up Slowly, 1964
Oil on canvas (two panels),
68 x 92 in. (172.7 x 233 cm)
Museum für Moderne Kunst,
Frankfurt am Main

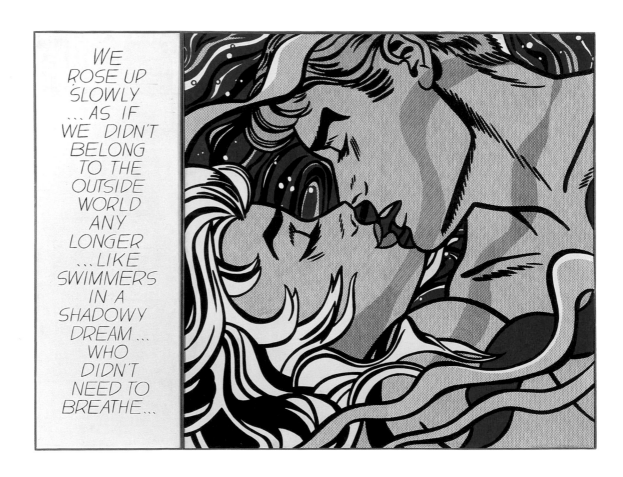

ome men are real pigs. And in his dealings with women, Grosz himself could be piggish. As a member of the anti-establishment group of artists who called themselves the Dadaists, Grosz subscribed to a manifesto that called for the "immediate regulation of all sexual relations in an international dadaist spirit by the establishment of a Dadaist sex headquarters." What the Dadaists wanted was free sex for all but not equality between the sexes. At a famous orgy Grosz threw at his studio, it was decided (by the men, of course) that the women would remove their clothes while the men would keep theirs on. That is, the men could keep their dignity while the women would lose their virginity.

Here Grosz displays his truly brilliant wit and portrays the ancient sorcerer-seductress Circe as a modern café girl in Berlin. Circe, daughter of the sun god Helius, lived on an island and carried a magic wand. Whenever someone, invariably a man, landed on her island, one touch of her wand would turn the hapless intruder into a squealing pig. Ulysses's men all became victims of Circe and soon he found himself general not of a platoon of soldiers but a herd of swine. So he immunized himself with a special drug, and married her. Moral: acting on an impulse of lust alone can turn you into a pig, but love can redeem you.

George Grosz (1893–1959)
Circe, 1927
Watercolor, pen and ink, and pencil on paper, 26 x 19¼ in.
(66 x 48.7 cm)

Collection, The Museum of Modern Art, New York; Gift of Mr. and Mrs. Walter Bareiss and an anonymous donor (by exchange)

Marisol (b. 1930)
Untitled, 1964
Left: watercolor on paper, 42 x 29½ in. (106.6 x 74.9 cm)
Center: pastel on paper, 39½ x 27 in. (100.3 x 68.5 cm)
Right: gouache on paper, 42 x 29½ in. (106.6 x 74.9 cm)
Mrs. Harry N. Abrams, New York

Advertising has made the phrase a cliché, but the command is no less valid: reach out and touch someone. We know from research that being touched is crucial to a newborn child's development, and now research has shown that older people greatly benefit from being touched as well. Perhaps we should follow the Chinese practice of Tai Chi, touching our own bodies on a regular basis. For a good sexual encounter, time must be allocated for touch before arousal; during arousal, of course; and, most important, during the resolution phase, after orgasm.

Women know this instinctively, and therefore it makes sense that Marisol, a female artist, has made this triptych a depiction of the sense of touch. Fingers are everywhere. The fingers on the brain are particularly effective, suggesting the importance of the brain in receiving messages from tactile stimulation. But the very long fingernails, especially in the vicinity of a sensitive, erect nipple, are a little worrisome—I don't want anyone to get hurt!

Red-Figure Cup with Two
Lovers, *c. 500 B.C.*
Greek
Diameter: 11¾ in. (34 cm)
*Antikensammlung, Staatliche
Museen, Berlin*

It is well known that the ancient Greeks approved a much greater variety of sexual practices and romantic attachments than those accepted today. It is not that the way people have sex has changed, it is simply that Western society has become less tolerant. Homosexuality, for example, was not only tolerated in Greece, it was encouraged. Adult men were expected to take young men as lovers for a certain length of time, serving as role models and completing the education of well-to-do youths. The young men relished the attention and the opportunity for advancement, and there is pictorial evidence that they enjoyed the sex as well. Nevertheless, as the youths matured they married, had children, and then set about educating the next generation of young men.

The courtship of two men of different ages is a frequent subject of the decoration on cups and wine jars, which were often used at the all-male parties called *symposia.* In some scenes, the older man is shown giving presents to the younger one—hares, chickens, and sometimes large, ungainly deer. In other scenes, the men are shown having sex. Anal intercourse is almost never depicted; instead, the older man would generally be shown placing his penis between the thighs of the younger man.

Quite exceptionally, the cup seen here depicts men of approximately the same age courting one another. If we were to imagine the men dressed in contemporary clothing, the scene is one that might be observed in a gay bar today.

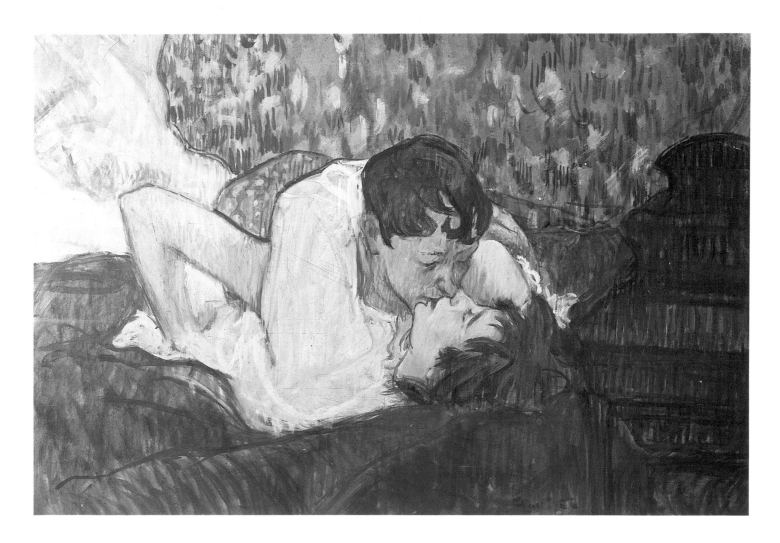

Lautrec's pictures of lesbians have less to do with the titillation of male fantasies than with honest representation of an alternative to heterosexuality. These two women kiss spontaneously, naturally. They hug each other with matched affection, and neither is dominant or submissive. Many of Lautrec's scenes with lesbian themes take place in brothels, of which he was a frequent inhabitant, but some, such as this work, deliberately avoid specifying any locale.

These scenes were collected by Lautrec's male friends and thus must have had some prurient appeal, but they are ultimately more interesting for what they do *not* show: explicit sex or sensationalized nudity. When we compare this picture to Courbet's *Sleepers* (page 170), we can see how much more sympathetic Lautrec was to lesbians. He showed them as he observed them, rather than making them conform to male heterosexual fantasies.

Henri de Toulouse-Lautrec
(1864–1901)
The Kiss, 1893
Oil on canvas, 15⅜ x 22¾ in.
(39 x 58 cm)
Private collection, Paris

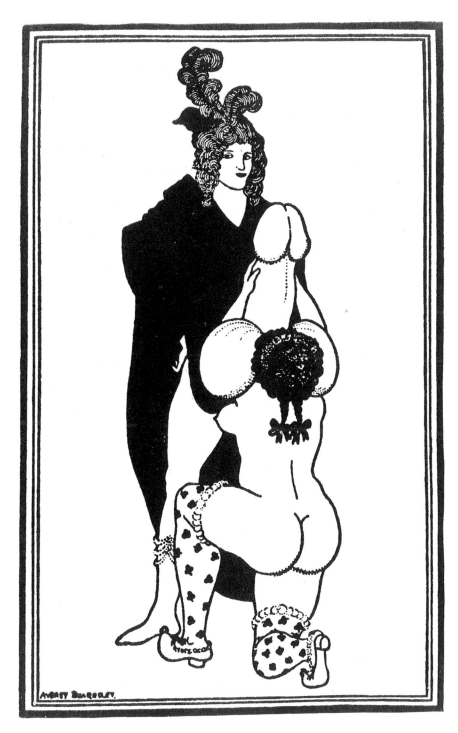

Since ancient times, penises have represented not just virility but power. And since ancient times, men have expected that women would want to worship their penises. Naturally it is disappointing to men when they learn that women are often indifferent to penises and, further, that many women do not enjoy fellatio. Fellatio is hardly abnormal or even uncommon (as some of the images in this book make clear), but many women are reluctant to practice it. Those who want to try it but are hesitant might begin by treating the penis like an ice-cream cone. The male will surely enjoy it, so long as the woman doesn't reveal her mental image—for men take their penises very, very seriously!

Beardsley, a talented illustrator in the homosexual circle of the notorious Oscar Wilde, took the bawdiness of Thomas Rowlandson's erotic drawings (page 117) to a new level of licentiousness. This drawing was part of a series of illustrations for a translation of the Greek playwright Aristophanes' sexual epic *Lysistrata,* but it was too provocative for publication during his lifetime. In his prolific but extremely curtailed career—Beardsley died when he was twenty-six—he perfected a dramatic and bold linear style that perfectly complemented his morbidly erotic subject matter.

Aubrey Beardsley (1872–1898) Illustration for "Lysistrata" *Published in Aristophanes,* Lysistrata, *Beardsley Press,* 1927

Department of Printing and Graphic Arts, Houghton Library, Harvard University, Cambridge, Massachusetts

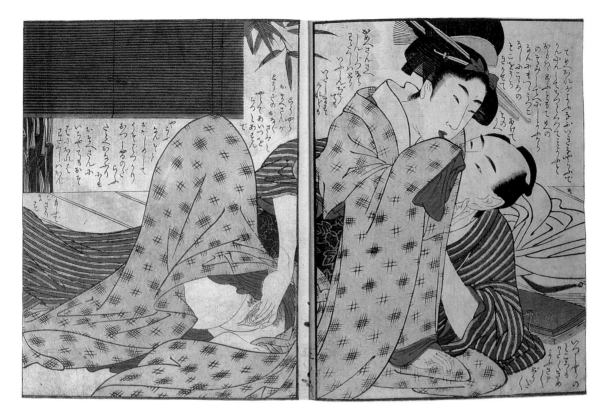

Utamaro (1754-1806)
Two Lovers, *from* The
Merry Drunkards, *c. 1790*
Color woodblock print, approximately 8 x 12 in.
(20.3 x 30.4 cm)
Ronin Gallery, New York

At first glance, there is little indication in the right half of this two-page spread of the activity taking place in the left half, but in one important respect the same thing is happening on both sides: both partners are stimulating each other, but in different ways. The man is arousing the woman by gently massaging her clitoris, while the woman is arousing the man by whispering sweet noth-ings in his ear. They are going to have fabulous sex.

I spend so much time reminding men of how much women enjoy talking that I some-times forget to remind women that some men find talk tremendously arousing. The words can be sweetly encouraging or downright dirty, but they are almost always a powerful aphrodisiac.

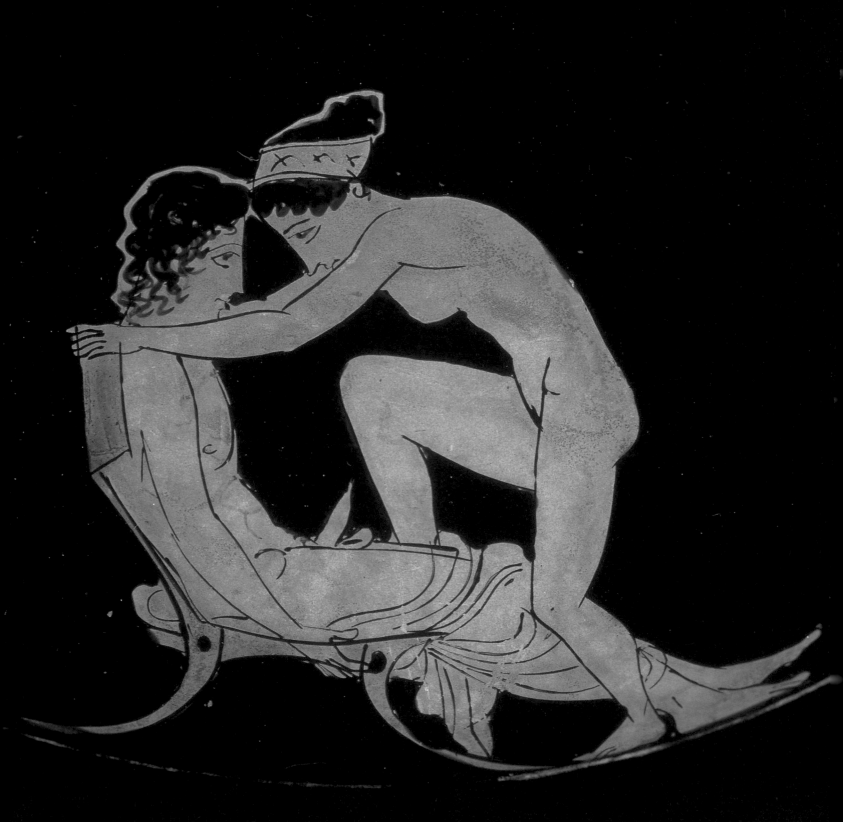

Most depictions of heterosexual couples on ancient Greek pottery show mature men and women, but this jug, exceptionally, displays a pair of young lovers. The woman is about to mount the man in a position that is frequently used today, but she stops to stare deeply into the eyes of her partner. His erect penis is a good indicator of what is on his mind, but the longing in their expressions seems to have less to do with simple sex and more to do with love—at least for this moment. What many couples today forget is that such a deep gaze can be just as arousing as physical foreplay.

Love, as distinct from sex, was an important aspect of Greek culture. Socrates said, "Union between man and woman is a creative act and has something divine about it. . . . The object of love is a creative union with beauty on both the spiritual and physical levels."

Attributed to the Shuvalov Painter
Red-Figure Wine Jug,
c. 430 B.C.
Greek
Height: 9⅜ in. (24.5 cm)
Antikensammlung Staatliche Museen, Berlin

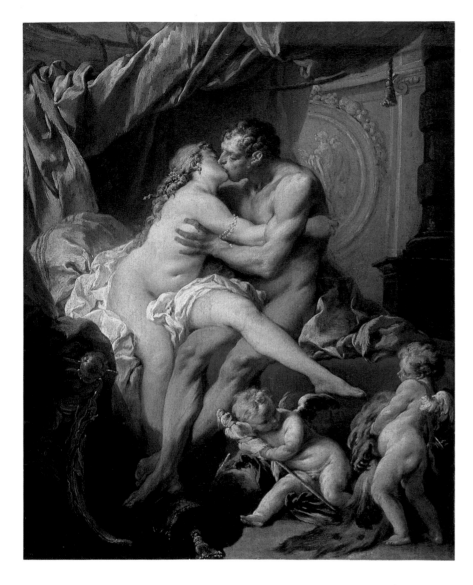

François Boucher (1703–1770)
Hercules and Omphale,
c. 1731–34
Oil on canvas, 35¼ x 29 in.
(90 x 74 cm)
The State Pushkin Museum,
Moscow

*T*his surely must be one of the most erotic pictures of a kiss ever painted, and yet, paradoxically, it is also among the least prurient or pornographic. Boucher was careful not to expose any genitalia or erogenous zones—even nipples are hidden from view. But the passion of the kiss and the intensity of the embrace make the sexual excitement as palpable as the creamy flesh of Omphale and the bronzed skin of Hercules.

Born as a result of one of Jupiter's infidelities, Hercules was relentlessly persecuted by Jupiter's jealous wife, Juno. At one point she managed to have him sold as a slave to the great Lydian queen, Omphale. As part of his year-long humiliation he was forced to do woman's work—hence the staff of wound flax—and Omphale took possession of his attribute, a lion skin. Here cupids play with these accessories while the adults are otherwise engaged in the hastily arranged bedroom.

We do not know whether Boucher consulted a translation of Ovid's *Loves of the Gods,* but this kiss is remarkably close to one described in another passage by the ancient author: "She passed around my neck her ivory arms, whiter than the Thracian snow, to give me passionate and penetrating kisses in which her tongue played with mine, she placed her thigh under mine, and told me a thousand sweet things, and called me her conqueror."

Although here we see Hercules as a slave, he was still the strongest man in antiquity, and Boucher was careful to portray him as such. He sits upright, the better to show off his muscles, and he kisses with a force matched by his passionate grip on Omphale's breast. Omphale, in contrast, is soft and sensual, and she seems to melt in his embrace. Her left leg, slung over Hercules's thighs, is in a position that in Renaissance pictures denotes sexual consummation. Her throat, neck, and shoulder, seen from a vantage that a lover might enjoy, are among the most beautiful in French painting.

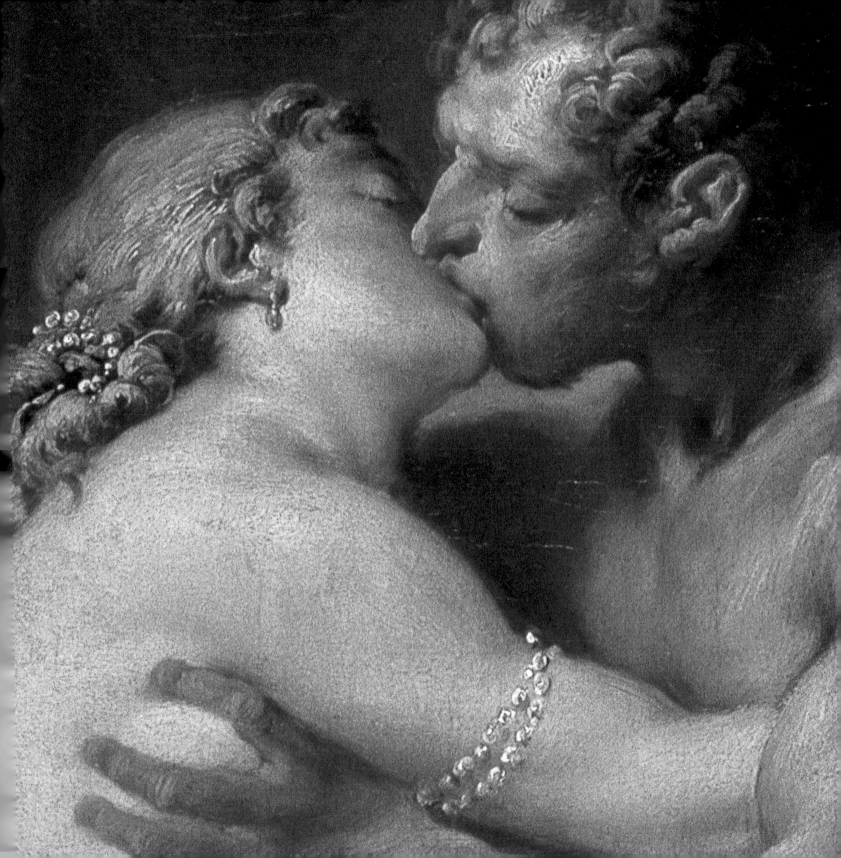

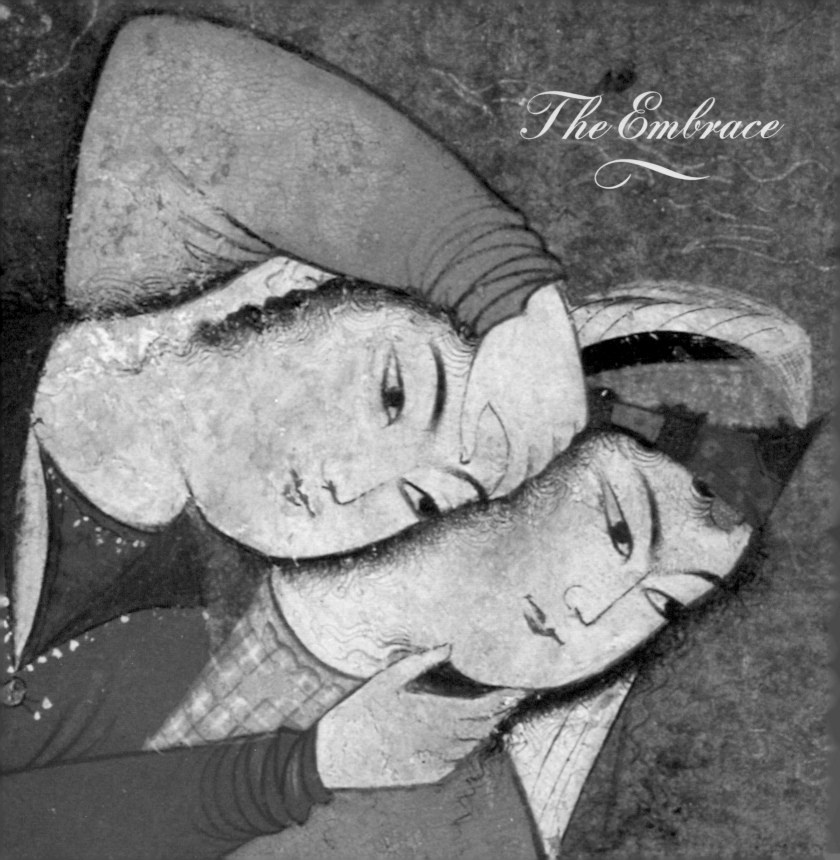

The Embrace

*I*t seems that almost every culture with a strong tradition of visual expression has produced some kind of dictionary of positions for sexual intercourse. In Japan, volumes called pillow books were placed in the bedclothes of newlyweds to advise them on the delights that awaited them. In Renaissance Italy, Giulio Romano produced a set of engravings called *I Modi (The Positions)*, which outlined some sixteen different variations: from the traditional missionary to the little-used wheelbarrow, which I recommend only for acrobats, gymnasts, and ballet dancers. The ancient Greeks displayed their diverse positions on wine jars and drinking vessels, reserving taboo positions for satyrs, who were only half-human. The Greeks knew a great deal about sexuality, both hetero- and homosexuality, and they recognized, for example, that the rear-entry position (by which I mean not anal intercourse but vaginal penetration from behind) is conducive to greater clitoral stimulation by either partner.

The Greeks also placed great emphasis—and we should learn from this—on the imagination. This is particularly important to women, for it helps them to focus on their sensations before and during orgasm. The many transformations of Jupiter—into a swan, for example, or a cloud—reflect the Greeks' understanding of the need for fantasy. Which is not to say that there is anything wrong with the old-fashioned position that Rembrandt demonstrates. The woman's supremely sweet smile indicates that she does not wish to be anywhere other than with her lover in her comfortable, pillowy bed at that very moment.

As we see in this chapter, throughout time and around the globe humans have continually rediscovered every imaginable position, all of which I can endorse. No matter how peculiar or unusual the contortions of the body might be, there is no reason to allow prudishness or inhibitions to impede variety. It is a cliché, but it is true: Variety is not only the spice of life, it is essential to a lasting relationship.

A voluptuous young woman embraces a handsome young man, who returns the kiss with equal ardor. Here, finally, is an eighteenth-century painting that is purely about love—or, to a cynic, sex—and not also about class distinctions, social customs, politics, or power struggles between men and women. But that is not to say that the assumptions of the day are not revealed. The woman, who is naked and therefore vulnerable, clings to the man, who is clothed and therefore unexposed. He does not cling to the woman but supports her with manly ease. Thus the painting is designed to appeal to the fantasies of Fragonard's primarily male clientele. Any male viewer could imagine himself to be the lucky lad in the painting and, at the same time, actually see what the lad cannot: the beautiful back of the woman who so freely engages in passionate kissing.

There is less in this work for a woman's fantasies. Although a woman could project herself into the body of this ravishing creature, Fragonard has deliberately obscured the model's face, so it is impossible to identify with her as an individual. And although it is always enjoyable to imagine being kissed by a handsome young man, it would have been nice if Fragonard had sparked the female imagination by showing how the lover looked without his clothes on!

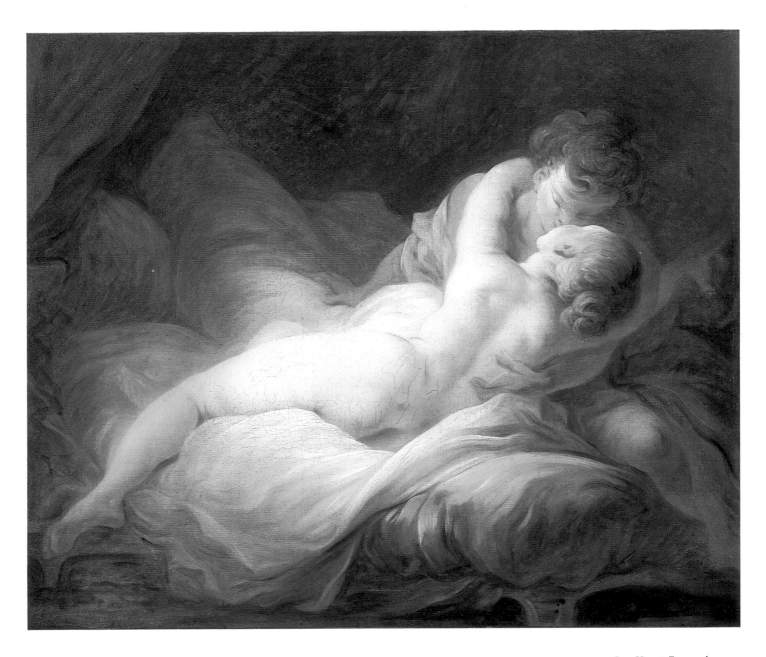

Jean-Honoré Fragonard
(1732–1806)
The Happy Lovers, *c. 1770*
Oil on canvas, 19⅜ x 23¾ in.
(49.5 x 60.5 cm)
Private collection, Switzerland

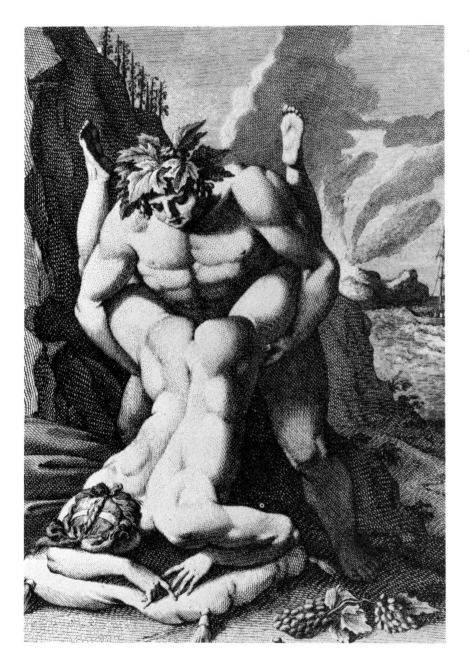

110

disassociate myself from the bad judgment and piggish custom which forbids the eyes to see what gives them most pleasure. What harm is there to see a man on top of a woman? Must animals have more freedom than we?" The answer to that last question is, of course, yes, but that did not deter the bad boy of the Italian Renaissance, Pietro Aretino, from writing explicit sonnets describing the sixteen different positions of intercourse depicted by the engraver Marcantanio Raimondi, who based his prints on a set of drawings by Giulio Romano, a former assistant to Raphael.

Raimondi was imprisoned immediately after the erotic engravings were published, and a Roman cardinal succeeded in having all but a handful of the prints destroyed, yet Aretino nonetheless published his sonnets a few years later. They, too, were reviled. In 1550 the artist and biographer Giorgio Vasari wrote, "I do not know which was the most revolting, the spectacle presented to the eyes by the designs of Giulio or the affront offered to the ear by the words of the Aretine [Aretino]."

Giulio's designs are known today only from censored fragments, copies by other artists, and the occasional engraving that survived unscathed. They show muscle-bound athletes—probably representing ancient gods—engaged in vigorous sex in an astonishing variety of poses. The graphic sexuality of *The Positions* is virtually unique in Western art, especially before the nineteenth century; they are among the few European works to rival in intensity the erotic illustrations produced in Japan.

One feminist art historian has described Gauguin's adventures in the South Seas as sexual tourism. While that may be an overly harsh assessment, there is no denying that part of the appeal that Tahiti had for Gauguin was the sexual freedom enjoyed by the local population, as well as their relative lack of inhibition.

It is curious, therefore, that when the artist made this lotus-shaped emblem of intercourse in his album, he depicted a couple in the "missionary" position. That is the name the Polynesians gave to intercourse in this manner, which was the only position that European missionaries condoned. Today, because it is such a standard position, it has become unchic to champion it. It should be defended, however, as a comfortable, practical approach. The man should rest his weight on his elbows, unless he is very light, and both partners should use their hands as much as possible to intensify their own and the other's pleasure. As a woman who liked Scotch whisky once said: "The mish posish is the Scotch of positions. You keep coming back to it."

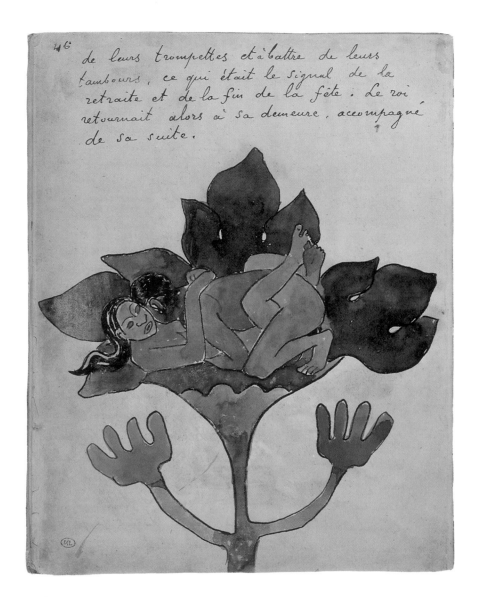

Paul Gauguin (1848–1903)
Ancient Mahori Sect, *c. 1893*
Pen and ink and watercolor on
paper, 8½ x 6⅝ in.
(21.7 x 16.9 cm)
Musée d'Orsay, Paris

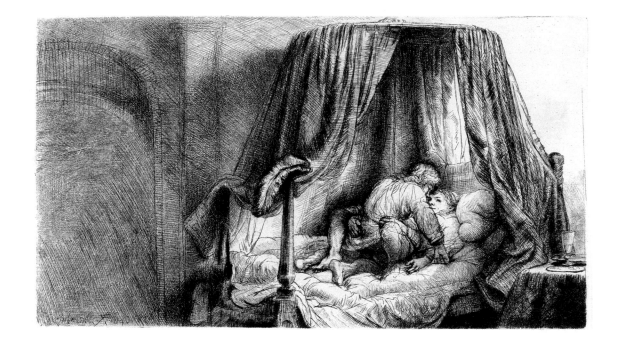

*I*f we look closely we find that this is a variant of the tried-and-true missionary position, with an important difference: the man is kneeling rather than lying on top of the woman. This enables both partners to gaze at one another lovingly and with expectation, because neither—at least, certainly not the woman—is near orgasm. For a woman to achieve orgasm, in most cases, she must concentrate on her own sensations; here she looks at and thinks about her partner. As she approaches climax, she should draw his head closer to hers, so that he cannot scrutinize her features while she focuses on her imminent orgasm.

These lovers are in an enviable position, enjoying the luxury of being together in such a splendid four-posted bed—beautifully draped and with a plump feather mattress—in the privacy of a spacious bedroom. Let us hope that afterward they will embrace each other in this cozy environment and whisper tender words to one another.

An attentive viewer will notice that Rembrandt gave the woman three arms with which to hold her lover—he changed his mind about their position and forgot to erase one of them. Rembrandt was about forty years old when he made this print, and he no doubt thought with longing back to his own youth. The work was made for his own enjoyment, but it would have been sold to the connoisseurs who avidly sought out each of his works—including this and a couple of other erotic subjects.

Although this extraordinary drawing has belonged to the Louvre since 1947, it was exhibited for the first time only in 1991, two hundred years after the artist was born. We can attribute this delay to the power of the drawing, for even though it is neither explicit nor pornographic, it shows a tremendously sexual embrace. These lovers are locked in a paroxysm of passion that is so strong it is almost uncomfortable to look at it in public. At the time Gericault made this drawing, he was involved in a passionate and illicit affair with his married aunt. In order to overcome the social sanctions against such an affair, their mutual attraction must have been overwhelming, and the vehemence of their love infuses this work.

The lovers conceived a child. Gericault's reputation survived the scandal, but his aunt's did not. Their baby was sent away to live with foster parents, while the mother went into exile in her husband's country house. She may never have seen Gericault again.

Théodore Gericault
(1791–1824)
The Embrace, c. 1817
Pencil, pen and brown ink, and
white gouache on blue paper,
5⅜ x 8⅜ in. (13.5 x 21.3 cm)
Musée du Louvre, Paris

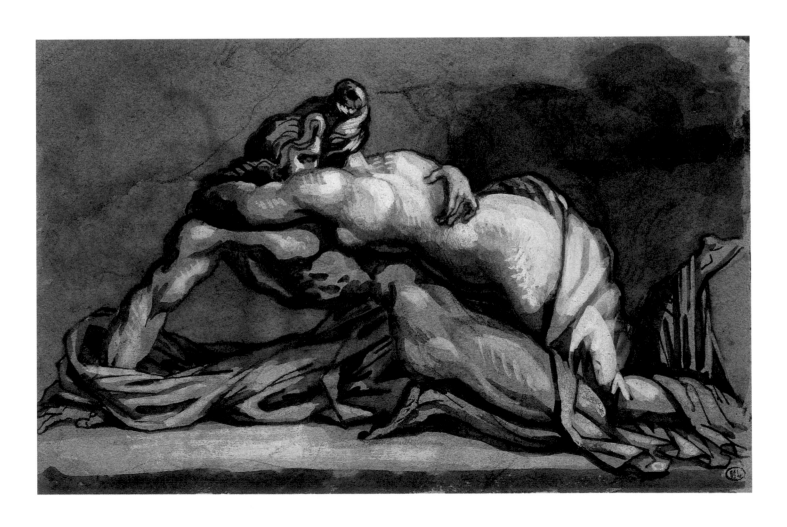

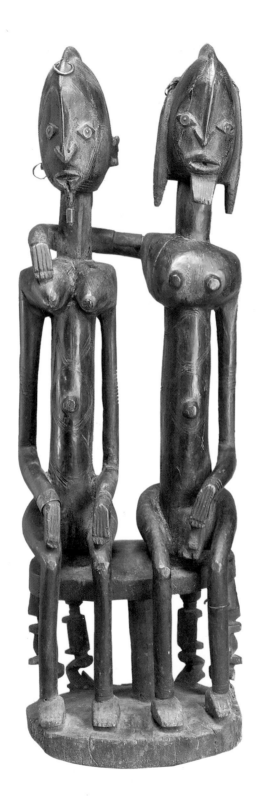

This sculpture was made by the Dogon people—western African cliff-dwellers who developed a complex mythology to explain their genesis. They knew that the territories they lived in had been occupied by earlier tribes, and they represented this fact with ceremonial stools such as this, symbolizing creation. The earth is portrayed as two disks—sky and land—that are joined by a tree. Supporting the sky with raised arms are four *nommos,* from whom have descended all those who occupy the Dogon lands. The primordial or prototypical couple seated above them symbolize the Dogon people. This pair, a kind of Ozzie and Harriet of Dogon life, are bedecked with the accouterments that were deemed essential for survival. The man has a quiver for arrows on his back, showing that he was a hunter; the woman carries a child, symbolizing her function as childbearer and nurturer for the next generation.

Just as a king holds a scepter to show his authority, this man holds his penis, emblem of his power and the instrument by which the Dogon people's progeny will be conceived. It is unlikely that the penis represents pleasure (as it would in most Western art), and the man's grasp of his partner is almost certainly a statement of possession rather than a loving caress. This does not mean that the Dogons did not know how to have good sex in private; it simply means that this ceremonial sculpture is making a statement about authority, ownership, and propagation.

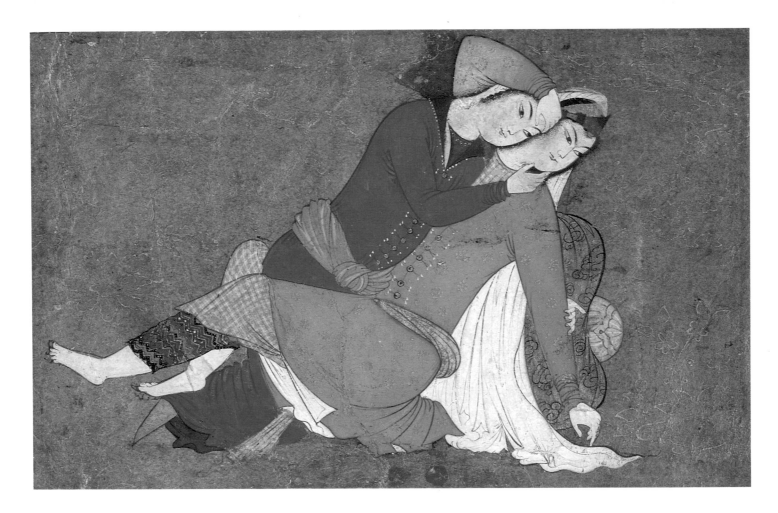

We see lovers everywhere: holding hands as they stroll down city streets, looking into each other's eyes while they dine in dimly lit restaurants, and embracing as they relax on grassy hillsides. The idea of lovers enjoying themselves in a bucolic setting is by no means modern—almost every age has created art depicting lovers in some sort of natural surroundings.

The theme of two lovers in a garden was particularly popular in seventeenth-century Persian miniatures. In this one the decorative quality of the image is compounded by the delicate vegetation scattered throughout the background. The position of the lovers' bodies belies their seemingly static shapes: the woman's legs are wrapped around her partner's body and her right arm encircles his head; he seems equally enamored of her.

What's the message of this painting? Well, one message might be: sometimes it's fun to step out of the bedroom and make love among the leaves!

The Lovers, c. 1630–40
Persian (Isfahan)
Ink, colors, and gold on paper,
4⅛ x 6½ in. (10.5 x 16.5 cm)
Minneapolis Institute of Arts;
Bequest of Margaret McMillan
Webber

THE WANTON FROLIC

Upon the carpet Cloe laid
Her heels toss'd higher than her head
No more her cloaths her beautys hide
But all is seen in native pride
While Strephon kneeling smiles to see
A thing so fit for love and he
His amorous sword of pleasure draws
Blest instrument in natures cause
The panting fair one waits its touch
And thinks it not a bit too much

Rowlandson executed a large number of bawdy drawings, chiefly for the delectation of the debauched Prince Regent (who later became George IV). This work is from a set of ten etchings, published in 1810, in which Rowlandson satirically chronicled the various kinds of social activity that might lead to intercourse—horseback riding, a carriage ride, and as seen here, a music lesson. In the popular imagination, music teachers were invariably handsome young men, and the aspiring musicians were invariably comely young women. Rowlandson provided an inspired verse to intensify the observer's experience:

> The Wanton Frolic
> *Upon the carpet Cloe laid*
> *Her heels tossed higher than her head*
> *No more her clothes her beauties hide*
> *But all is seen in native pride*
> *While Strephon kneeling smiles to see*
> *A thing so fit for love and he*
> *His amorous sword of pleasure draws*
> *Blest instrument in nature's cause*
> *The panting fair one wants its touch*
> *And thinks it not a bit too much.*

Rowlandson also supplied a fake editorial comment with this plate: "We object—strongly object—to the absurd form of the taper which the gentleman holds in his hand. It looks more like a carrot than the genuine article. It burns brightly enough, but the shape is monstrously unreal—as any fair devotee will know."

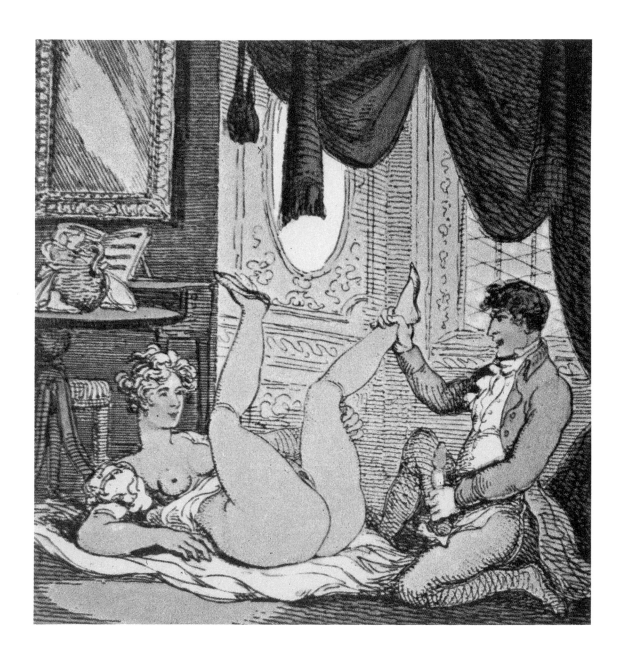

Thomas Rowlandson
(1756–1827)
The Wanton Frolic,
after 1812
Etching, 6½ x 4 in.
(16.6 x 10.4 cm)
Location unknown

Briseis Painter
Red-Figure Cup,
c. 474–50 B.C.
Terra-cotta
Museo Nazionale Tarquiniese,
Tarquinia, Italy

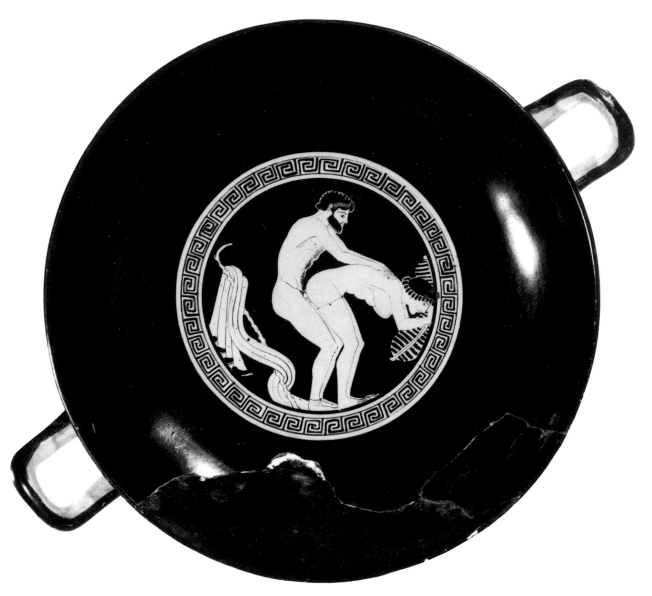

The sketchy background details suggest that this sexual scene takes place outdoors. Apparently the Greeks had the good sense to recognize that having intercourse in the same position, same place, and same time of day is boring!

Rather than forcefully entering his partner from behind, this smiling lover gently grasps his partner's back in order to steady himself and to draw her closer. If he is a considerate lover, after his own ejaculation he will turn her around and bring her to orgasm with cunnilingus or by stroking her clitoris with his fingers.

Cocteau, an extremely talented writer, draftsman, playwright, and filmmaker, occupied a position similar to that of Oscar Wilde before his trial and downfall. Never as famous, Cocteau was nonetheless just as clever as Wilde, although probably less disciplined in his work. Both were flamboyant homosexuals. Wilde, however, always maintained his position as outsider and social critic, whereas Cocteau desperately sought approval and recognition from the very society that persecuted homosexuals. For this reason, Cocteau would not put his name on *Le Livre blanc (The White Book)*, in which he chronicled his coming of age and the discovery of his sexuality. Ranging from his high school classroom—which reeked, he said, of gas (for light), chalk, and sperm—to the Turkish baths of Marseilles, where he developed his penchant for sailors, the book is filled with funny episodes of adolescent fumbling as well as sad incidents of denial and self-deprecation.

"SANTO-SOSPIR"
S͛ JEAN CAP-FERRAT
☎ 251-28

Jean Cocteau (1889–1963)
Study for "Le Livre blanc,"
2d edition, 1928
Colored pencil with graphite on
paper, 11¾ x 8¼ in.
(29.9 x 20.8 cm)
Severin Wunderman Museum,
Irvine, California

It is somehow typical of Italian Renaissance art that one of the most peculiar couples of ancient mythology inspired one of the era's most erotic pictures. Jupiter, always searching for a new disguise for an amorous adventure, transformed himself into a swan in order to make love to Leda, wife of the king of Sparta. She became pregnant and laid two eggs. From one hatched Castor and Clytemnestra, from the other came Pollux and Helen of Troy.

Over the centuries, artists devised numerous ways to depict the union of a swan with a mortal woman. Sometimes a swan simply stood nearby while a manly Jupiter made love to Leda, but in most compositions artists took advantage of the phallic appearance of a swan's neck in order to produce eroticized imagery. Michelangelo made a tempera painting of Leda and Jupiter for Alfonso I d'Este that was one of the most sensational of these pictures. It was sent to the French court at Fontainebleau, from which it disappeared, but not before engravers had an opportunity to reproduce the composition. Rubens based his picture on one such engraving by Cornelius Bos. It is one of several copies after famous Italian paintings that the young Rubens made either before or just after his arrival in Italy from Flanders.

Far from being a slavish copy, this work is in fact a reinterpretation of the Michelangelo. Whereas the prototype featured a heroic female nude who resembled a modern-day weight lifter, Rubens supplied an extraordinarily sensual nude woman, whose pose is languorous in comparison to Michelangelo's knotty and tense figure. But Rubens was true to the prototype in showing the swan actually engaged in intercourse; his tail feathers are shoved up against Leda's buttocks while he passionately pecks her lips with his bill. She responds in kind, cradling the swan between her legs and straining her mouth toward his.

Peter Paul Rubens (1577–1640)
Leda and the Swan,
c. 1600–1601
Oil on panel, 25⅜ x 31⅝ in.
(64.5 x 80.2 cm)
Stephen Mazoh, New York

In what could be seen as the ultimate perfume advertisement, a beautiful woman swoons in the embrace of—a cloud. She firmly holds one foggy appendage beneath her left arm and seems to take a hand with the other. But she turns her head away from the face of her evanescent lover, closes her eyes, lifts her right leg, and curls her toes in one of the most meltingly sweet orgasms ever depicted.

Painted by Correggio, a Renaissance painter who rivaled Titian in the sensuality of his figures, this image belongs to a suite of four paintings about the loves of Jupiter—possibly commissioned by Federigo Gonzaga as a gift for Holy Roman Emperor Charles V. In order to seduce Io, the ever-philandering Jupiter transformed himself into a cloud. But Jupiter's wife, Juno, caught her husband in the act despite this disguise, and she insisted that Io be turned into a cow—an inglorious conclusion to the thoroughly sensual encounter envisioned here.

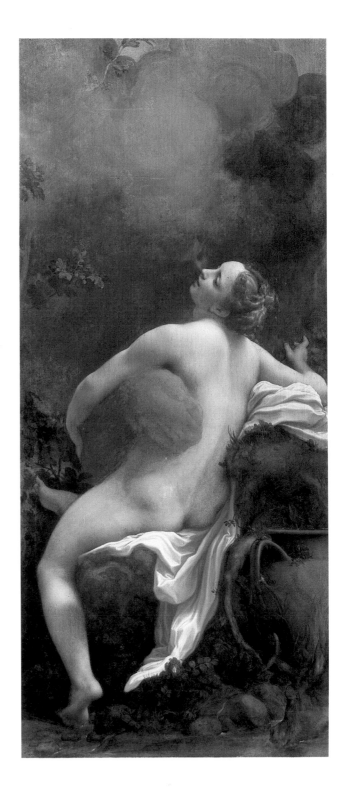

Antonio Correggio
(1489/94–1534)
Jupiter and Io, c. 1532
Oil on canvas, 63⅝ x 28⅞ in.
(162 x 73.5 cm)
Kunsthistorisches Museum,
Vienna

This is a decidedly unerotic drawing—not just to us, but to Leonardo as well. Some fifteen years after making it he noted, "The act of coitus and the parts employed therein are so repulsive that if it were not for the beauty of the faces and the adornments of the actors and the frenetic state of mind, nature would lose the human species." (How sad it is that Leonardo could not perceive the beau-

ty of sex.) His chief interest in this drawing was to demonstrate the belief then current that semen was composed of fluid from the spine, fluid from the testicles, and urine from the bladder. It was thought that the soul was imparted to the embryo through the spinal fluid, while the animal nature of a human being derived from testicular fluid.

Leonardo da Vinci (1452–1519)
Cross-Section of a Copulating
Couple, c. 1492–94
Pen and dark brown ink on
paper, 10¾ x 8 in.
(27.6 x 20.4 cm)
Windsor Castle, Royal Library;
Her Majesty Elizabeth II

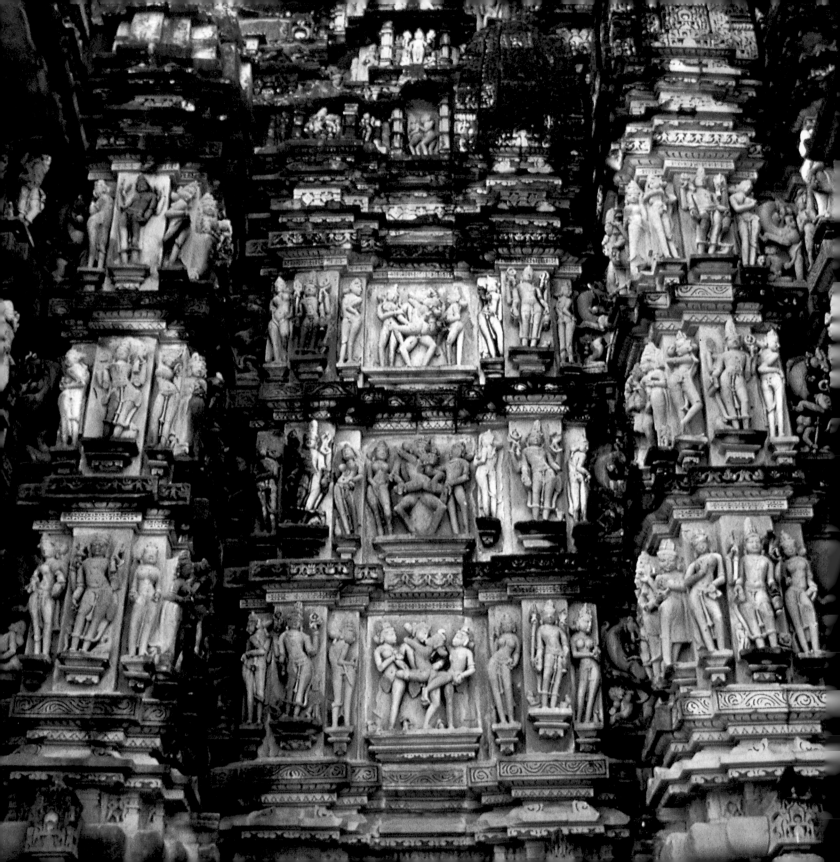

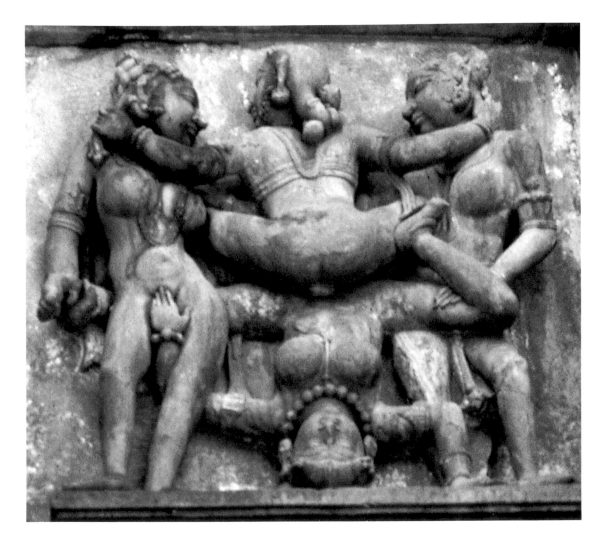

PAGES 126–29
Kandariya-Mahadeva Temple
and Visvanatha Temple
Khajoraho, India,
10th–11th century
Sandstone

OPPOSITE
North facade, Kandariya-
Mahadeva Temple

LEFT
North facade, Visvanatha
Temple

It is thought by some scholars that the sexual activity displayed on Indian temples is an aspect of Tantric belief, in which sexual acts are one of five offerings made to the deity. As society evolved, the ritual sex that once took place in magic ceremonies was replaced by sculptures of sexual acts on temple facades and interiors. Later the temple sculptures began to be understood as a kind of secret code referring to exalted states of being that went far beyond the erotic and the physical.

However esoteric the underlying symbolism may be, it is hard to believe that the figures represented in these carvings are not having a good time. In particular, we have to applaud the acrobatic man above, who at the moment of bliss does not forget the pleasure

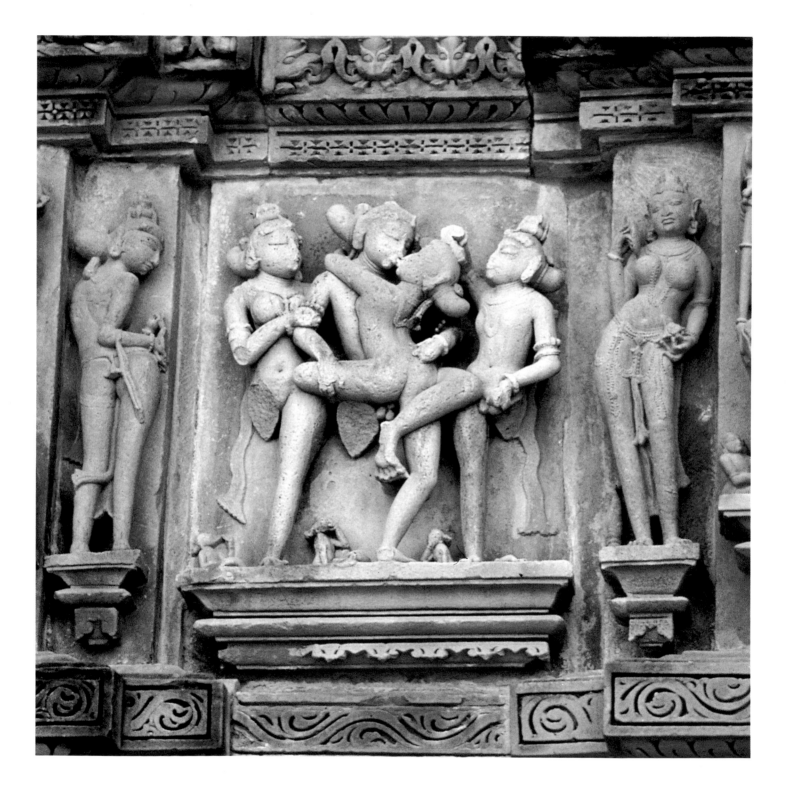

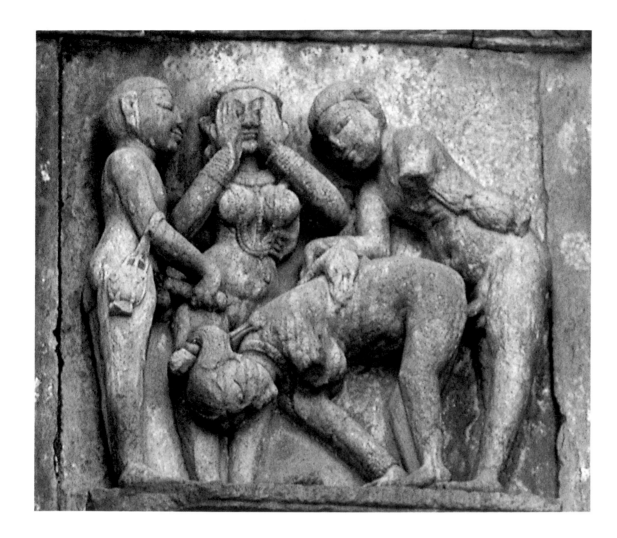

of the two women who support the one riding
his penis. If you look closely, you will see that
he is not steadying himself with his hands but
rather stroking the women's genitals. Instead
of jealousy, there are warm and supportive
looks being shared among the three women.
But that was over nine hundred years ago, and
it would be hard (and hardly wise!) to dupli-
cate such a successful foursome in our day.

Henri de Toulouse-Lautrec
(1864–1901)
In Bed, 1894
Oil on board, 20⅜ x 26⅜ in.
(52 x 67.3 cm)
Musée Toulouse-Lautrec, Albi,
France

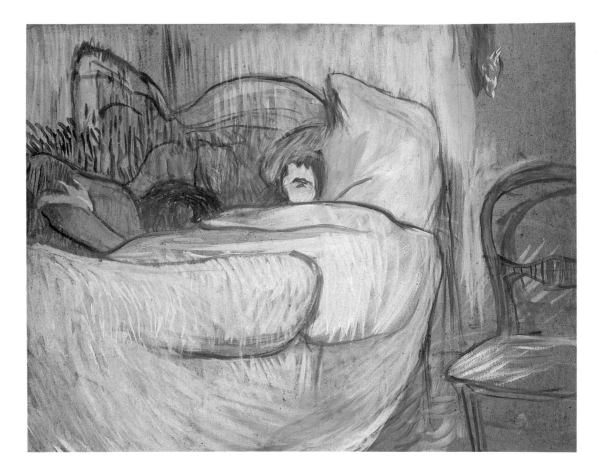

This is one of the rare brothel scenes by Lautrec that shows a sexual activity taking place. The head and arm of one figure, probably a female coworker, are visible as she performs cunnilingus on Rolande, a favorite model of Lautrec's. Rolande is recognizable by the distinctive shape of her nose and the color of her hair, both of which can be seen as her head sinks back into the pillows on the bed. No doubt made to appeal to a male connoisseur of brothels as well as of paintings, it shows a scene that few clients actually witnessed but that was the subject of many fantasies.

While most men enjoy having oral sex performed on them, many do not relish performing cunnilingus as much as the woman does in this picture. Some people dislike the smell and taste; others find it ambrosial. Different women enjoy having the clitoris stimulated by a lover's tongue and lips in different patterns, at different rates, and with different degrees of pressure. The only way for a woman's partner to know what she wants is for her to request it.

Dildoes have existed since ancient times and obviously were invented to fulfill a need. Many women find sexual stimulation in having something—whether a real penis or a fabricated substitute—inside the vagina; for some, a dildo is particularly useful because no cumbersome man is attached to it.

These two lesbians evidently have no need of men for sexual gratification, although they probably are courtesans from the "Green Houses" of Tokyo who had sex with men for money. Like the brothel denizens painted by Lautrec (pages 99, 130), they take sexual pleasure in each other's company, finding respite from the rigors of earning their living. According to Theodore Bowie, the inscription indicates that the woman on the left is impatient with her companion for pausing before inserting the two almond-shaped objects—either lubricants or stimulants.

Given the current antigay bigotry in the West, it is interesting to note that Eisho attached no stigma to the lesbians; he depicted their encounter as sympathetically as any of the many others he recounted over the years. However, he made this print not as an essay in realism nor as a special present for lesbians, but as an erotic image to be purchased by men.

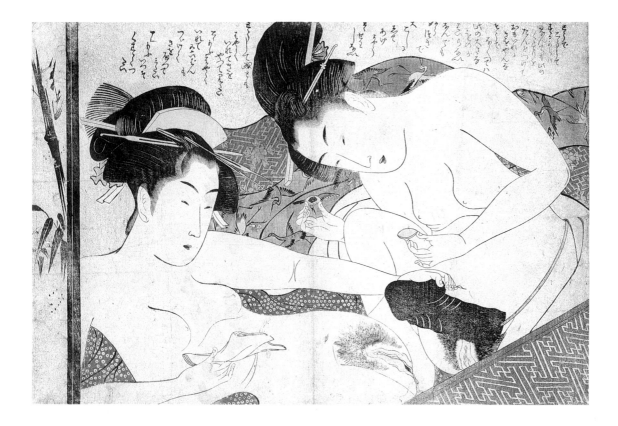

Eisho
Two Lesbians, *c. 1800*
Color woodblock, 14⅛ x 9¾ in.
(36 x 25 cm)
British Museum, London;
Reproduced by the courtesy of the
Trustees

Fashionable bedroom decorations in ancient Rome and Pompeii were mural paintings depicting the kinds of activities one would expect to occur in a bedroom. It is interesting to note that in many of these paintings of couples making love, the woman is on top. This position has a number of advantages: the woman can better control how much of the penis she wants inside her, her clitoris is exposed and therefore can easily be stimulated by herself or her partner, and she is not subjected to all of the man's weight. The man is comfortably supported by the bed and does not need to exert himself as much as in other positions. Most important, both have the opportunity of fully seeing each other's bodies in a state of sexual excitement. (If this mural were in better condition, we might find that the man's nipples were erect.)

Roman Wall Painting,
1st century A.D.
Casa del Cantenario, Pompei

Dubuffet's illustration deliberately mimics a child's drawing style in every possible way. The erect penis approaching the vagina and the simplified anatomy of the human bodies are intentionally naive and hilariously funny. But there is one sophisticated element to this work, and that is that the hands are very busy! One cannot overemphasize the important role that touching plays in making sex fully satisfying, and Dubuffet, quite unconsciously, betrays here his own expertise in matters of love.

This is one plate in an illustrated book written by the artist in a phonetic language that he invented. It tells the story of a libidinous woman with little regard for conventional mores who has sex with anyone who desires her. The childlike language and images used to tell this sexual tale call to mind the way many lovers use baby talk to differentiate between the seriousness of life and the playfulness of a good sexual encounter. They also suggest our longing to revert, with our partner, to the carefree days of childhood.

Jean Dubuffet (1901–1985)
Illustration from Labonfam
abeber par inbo nom, *1950*
Lithographic reproduction after
ink drawing, page: 11⅛ x 8⅜ in.
(28.1 x 22 cm), irregular
Collection, The Museum of
Modern Art, New York;
The Associates Fund

In the late eighteenth-century French edition of Aretino's scandalous work (page 110), this vision of familial bliss was accompanied by the following bawdy poem:

Sleep, my child, close your eyes
Like the song says.
And you, and you, charming mother,
See how the assault of my cock wakes up
 your con
What a most enjoyable exercise
Regular movement, my how you are sweet!
We do our jobs very well, us two
I cradle, I rock, and you screw.

As too-busy baby boomers beget the next generation, perhaps many among them will empathize with the difficulty of ever finding a moment alone for sexual pleasure with their spouses. The solution seen here is best abandoned to centuries past, in favor of genuine privacy that is less apt to be interrupted or observed.

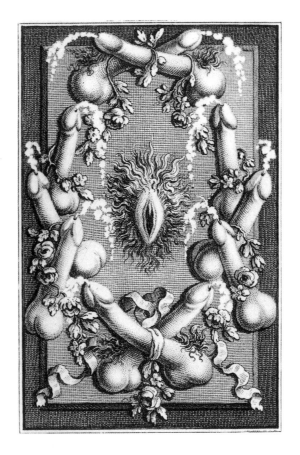

Frontispiece from Félix
Nogaret's L'Aretin français,
1787

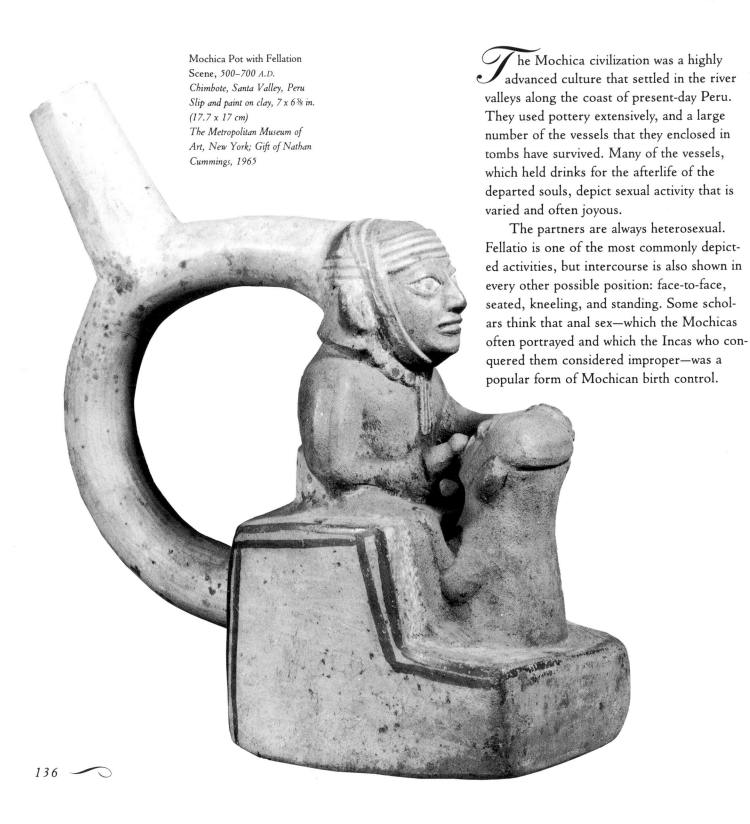

Mochica Pot with Fellation
Scene, 500–700 A.D.
Chimbote, Santa Valley, Peru
Slip and paint on clay, 7 x 6⅜ in.
(17.7 x 17 cm)
The Metropolitan Museum of
Art, New York; Gift of Nathan
Cummings, 1965

The Mochica civilization was a highly advanced culture that settled in the river valleys along the coast of present-day Peru. They used pottery extensively, and a large number of the vessels that they enclosed in tombs have survived. Many of the vessels, which held drinks for the afterlife of the departed souls, depict sexual activity that is varied and often joyous.

The partners are always heterosexual. Fellatio is one of the most commonly depicted activities, but intercourse is also shown in every other possible position: face-to-face, seated, kneeling, and standing. Some scholars think that anal sex—which the Mochicas often portrayed and which the Incas who conquered them considered improper—was a popular form of Mochican birth control.

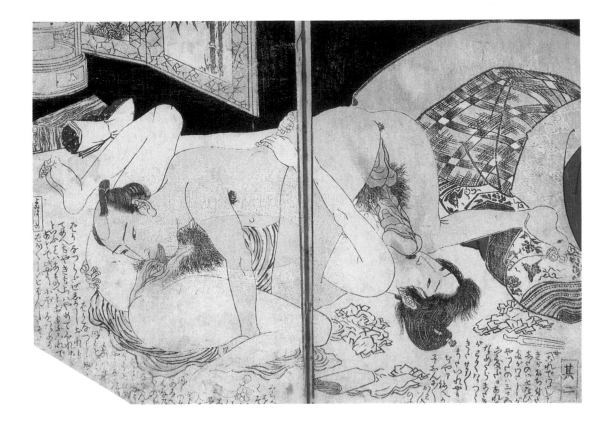

Kunisada (1789–1865)
Oral Love, *from* Oyugari no Koe (O Great Cry of Woman), *c. 1820–25*
Color woodcut, approximately 7½ x 10¼ in. (19 x 26 cm)
The Kinsey Institute for Research in Sex, Gender and Reproduction, Bloomington, Indiana

*M*ost of the Japanese erotic prints known today have been excerpted from "pillow books"—sex manuals that were illustrated by the greatest printmakers of each age, prized as heirlooms, and handed down from mother to daughter. Presumably the men did not think they needed them, but of course they did and still do!

Kunisada here describes a position that, for aficionados, is equally gratifying sexually for men and women. The artist has used exaggerated genitalia to show just how the man should stimulate the clitoris, while the woman stimulates the head of his penis without having to take the entire penis into her mouth. The caption explains, however, that even though the woman is enjoying herself, she is having difficulty with the large penis and would prefer to return to intercourse—a perfectly reasonable desire, given the overstated size of the penis shown here. Tissue paper is close at hand so that after they climax they can tidy up without having to get up.

These two lovers are so strongly attracted to each other that they could not be bothered to undress fully. So the gentleman has laid down his sword, tossed his red coat on the chair, and pulled his pants down, while the lady had only to hike her skirts and lean back on her bed. She has not even had time to remove her elaborate hat. A perfume burner peacefully scents the air, setting off by contrast the urgency of the encounter, which is indicated by the unstable stool.

Schall, a contemporary of Fragonard (pages 72–75, 109) who made a specialty of sexy pictures, has left nothing to the imagination in this beautifully painted picture, whose impact he has heightened with telling details. The ardent desire of the man is represented by his red jacket and heels; the sword symbolizes his virility. The woman's heels are a demure pink, but her true sexual response is revealed by the cat that arches its back and lifts its tail.

138

Jean-Frédéric Schall
(1753–1825)
An Amorous Encounter, n.d.
Oil on canvas, 12¼ x 10½ in.
(30.9 x 26.6 cm)
Private collection, New York

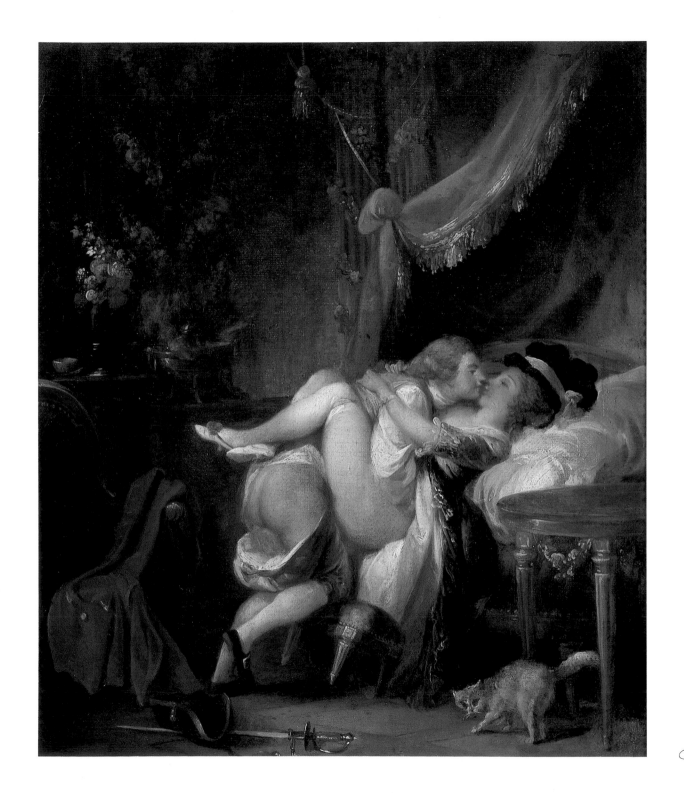

Solitary
and Group
Pleasures

Throughout this book we have shown couples engaged in sexual activity together. But, in reality, more orgasms come from pleasuring oneself than with someone else. Yet this is still a taboo subject. Not only is masturbation excluded from normal conversation, it is often excluded from the bedroom: in our society, even loving couples do not masturbate in front of each other. Masturbating when your partner is present is likely to be interpreted as a way of saying: "I don't need you, partner, I can do it all myself." This need not be true, however, for masturbation is only another way of expressing your sexuality.

Many people, of course, do not have a partner readily available every time that desire strikes. Your lover might be out of town or you might not be involved in a relationship at all. When this is true, masturbation is a healthy way to satisfy your own sexual hunger.

What the pictures in this chapter show is that masturbation is not an exclusively masculine activity. Despite puritanical teaching to the contrary, women do not need to wait for a man (or another woman) to arouse them. They are perfectly capable of having erotic dreams—complete with a real orgasmic response. When awake, they can bring themselves to a magnificent orgasm, as in Schiele's watercolor, by using fingers to stimulate their own clitoris. More important, many women need to discover their own body's erotic capabilities before anyone else can satisfy them.

Of course, a crucial component of masturbation is the fantasizing that goes with it, and this—for women and for men—can lead to more exciting sex with a partner. However, if you are like Narcissus and think only of yourself during sexual fantasy, it will be difficult to relate sexually to another human being. Self-love can only go so far.

Whether or not they talk about it, men are more accustomed to masturbation—not for psychological reasons but because of the simple fact that their penis is readily available and erections are hard to ignore. (Women, on the other hand, may have some difficulty finding their cli-

toris.) Rodin's *Balzac,* for example, grabs his organ with not one but two mighty hands. Rodin shows him masturbating not so much to indicate sexual activity but to symbolize the author's enormous creative energies. Schiele's sad self-portrait, to the contrary, shows us that masturbation can provide only temporary escape from worldly tension and anxieties.

Group encounters have been occurring for as long as masturbation has—but they are discussed and depicted even less frequently. I would have to say that as far as the images in this book are concerned, they deal more with the world of fantasy than with reality. It is certainly stimulating to think of yourself as a man who can satisfy seven women concurrently, but how often does that actually occur? Threesomes may not be so rare, for many men do want to observe two women making love first to each other and then to him; men also seem to enjoy fantasizing about situations involving two men and one or more women.

In antiquity and again in the 1970s, especially in male homosexual society, orgies were great occurrences, with all inhibitions abandoned to sexual pleasure. But today, because of the horrible scourge of AIDS and other sexually transmitted diseases, these activities should be avoided. That does not mean, however, that we must abandon our fantasies. The whole football team can be in your bed, or you can join a crowd bathing in the fountain in any village square—just as long as it remains a fantasy.

This was evidently a very popular composition, because Fragonard made at least four versions of it, and other painters and engravers made numerous copies of Fragonard's various versions. The painting now in Munich is perhaps the most beautiful of them all, with its remarkable play of flesh tones against the white bed linens, which in turn set off the rich color of the silken bed hangings—a lavish setting for a somewhat strange scene.

The pretty young woman seems to play with her dog quite naturally, and her fresh, youthful face belies the overt sexuality of the imagery. The girl might be innocently unaware of the implications of her activity, but she surely delights in the sensation produced by the dog's tail brushing against her genitals—a "strange distraction" that a nineteenth-century writer wickedly said was a vice of Madame du Barry, Louis XV's official mistress. In some versions of the picture (and in a sculpture by Clodion, Fragonard's contemporary), the young woman holds the dog aloft with her feet—a pose that enables the viewer to see, or to imagine seeing, between her legs. But in this work Fragonard, with false modesty, permits only a glimpse of a thigh and a breast. Thus, he seems to say, the viewer need not feel guilty for intruding on this innocent scene, for the girl is not disturbed, her modesty is protected, and, after all, she derives at least as much pleasure from her play with her dog as the observer does from watching her.

Jean-Honoré Fragonard
(1732–1806)
Young Girl Making Her Dog
Dance, c. 1768
Oil on canvas, 35 x 27½ in.
(89 x 70 cm)
Alte Pinakothek, Munich

Nicolas-Bernard Lépicié
(1735–1784)
Narcissus, *1771*
Oil on canvas, 44⅜ x 56½ in.
(113 x 143 cm)
Musée Antoine Lécuyer,
Saint-Quentin, France

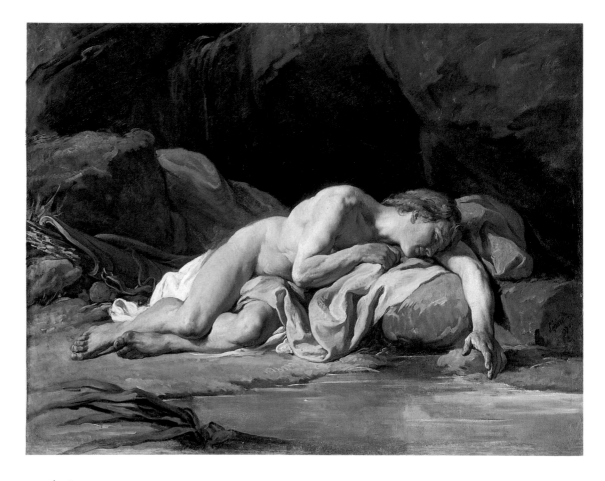

*N*arcissus, an ancient mythological figure, was an extremely handsome youth who habitually spurned the attentions of interested suitors. One rejected lover—a man, according to some writers—implored the gods to make Narcissus feel the pain of unrequited love. Soon thereafter the youth visited a quiet pool and immediately fell in love with his own reflection. Smiling, in Ovid's words, "in speechless wonder at himself," he attempted to embrace his image on the surface of the water. Made desperate by the absence of a response, he committed suicide. From his blood spilled at water's edge, says the myth, sprang the flower narcissus.

This golden-haired youth, with beautiful white skin heightened by a rosy blush, was probably painted as a study for a more elaborate composition installed as a decoration in the Petit Trianon, Louis XV's pleasure pavilion at Versailles. Lépicié, a rather conservative official painter, depicted Narcissus as a well-muscled young adult, but the virility inherent in his musculature is undermined by the passivity of his pose: he is slumped over in self-adoration. And since, according to the myth, sex was not Narcissus's forte, Lépicié wisely has hidden his breasts and genitals.

Rufino Tamayo (1899–1991)
Woman in Ecstasy, *1973*
Oil on canvas, 51⅜ x 76⅜ in.
(130.3 x 194.5 cm)
Robert E. Abrams, New York

*T*amayo is one of the finest artists to practice in Mexico during this century, and like many of his compatriots, he based his art on the rich culture that flourished there before the European invasion. This painting, for example, harks back to Aztec rituals in which figures were sacrificed on altars, but the subject is quite different: it is a woman in ecstasy, a woman having an orgasm in her dreams. The depth of her sleep is indicated by the arm slung over her shoulder, and the nature of her dream is revealed by the creature that she has conjured up. Is he a priest, a lover, or her husband? We shall never know.

It is unlikely that Schiele ever saw this drawing by Rodin, although he may have heard of the erotic drawings that Rodin kept in his studio. (The sculptor was famous for shocking his lady visitors with them.) The striking similarity between these two works is more likely a result of each artist's simply recording in a faithful manner the physical act before his eyes. How they persuaded their models to masturbate in front of them we do not know. Rodin's model has probably

assumed a masturbatory pose but is not actu-
ally masturbating. Schiele's model, however,
looks as if she is: her eyes are closed so she
can concentrate fully on her fantasies.
Rodin's model, to the contrary, looks toward
the artist, which seems to have more to do
with his fantasy (and ego) than hers.

 While it would be easy to dismiss these
works as pornography for men—and debasing
of women—these pictures can also be seen as
expressing an increasing awareness of women's
sexual self-sufficiency. That awareness led nat-
urally, but all too slowly, to greater indepen-
dence for women in all spheres of life. Perhaps
if Freud had seen these works he might not
have saddled us with his myth that women
require vaginal penetration to achieve orgasm.
He might have also realized that clitoral stimu-
lation is neither regressive nor immature but
rather a healthy way for a woman to give her-
self pleasure—or to receive pleasure from
someone else.

Egon Schiele (1890–1918)
Reclining Nude, *1918*
Black crayon on paper,
11¾ x 18¼ in.
(29.7 x 46.2 cm)
The Metropolitan Museum of
Art, New York; Bequest of
Scofield Thayer, 1982

147

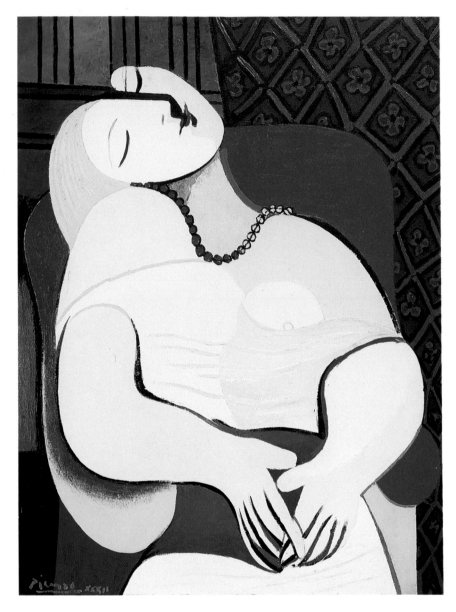

It is no coincidence that in the same year that Picasso painted this gentle portrait of his young mistress, Marie-Thérèse Walter, he was portraying his wife Olga as a praying mantis. For Picasso, women were not just "goddesses or doormats," to use his words, they were also threatening creatures as well as tender, nurturing souls. Often one woman would precipitate a variety of conflicting responses, but Marie-Thérèse seems to have brought out only Picasso's most affectionate nature.

This is one of a series of studio portraits in which Marie-Thérèse is shown sleeping in a chair. Some interpret it as a depiction of a sexual dream or masturbatory fantasy. Picasso has lowered her dress in order to expose a breast, symbol of her sexual appeal. The armchair, a distinctly masculine presence, embraces her as the artist's surrogate, and Marie-Thérèse smiles sweetly as if in a state of bliss. Picasso shows her basking in his regard, while the act of painting the portrait was no doubt a metaphor for making love to her.

Pablo Picasso (1881–1973)
The Dream, 1932
Oil on canvas, 51¼ x 38⅛ in.
(130 x 97 cm)
Mrs. Victor W. Ganz, New York

Few visitors to the monument to the French writer Honoré de Balzac near Montparnasse in Paris realize what Balzac is doing with his hands under his dressing gown. As this study for the monument reveals, Balzac is masturbating. And his penis is so large that it takes two hands to support it. Rodin has thus equated Balzac's enormous productivity with sexual power; the writer created characters, lives, and books as a father creates children.

It is interesting to note that Rodin made this study headless, just as he did with *Iris* (page 32). One might otherwise have assumed that he would not have subjected a male figure to the same depersonalizing treatment as a female one, but in fact for Rodin all humans could be powerfully represented as extensions of their sexual organs.

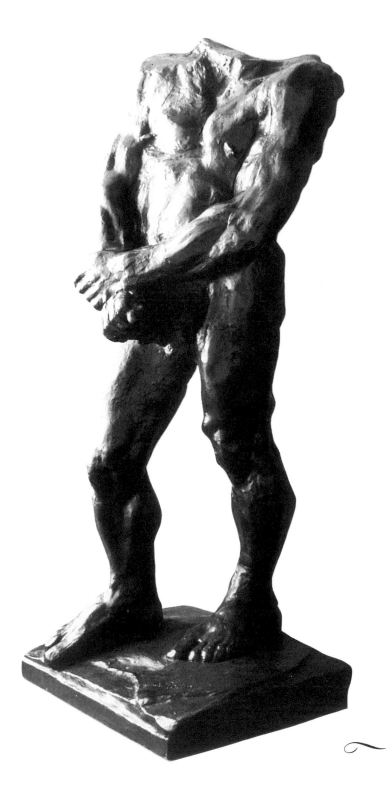

Auguste Rodin (1840–1917)
Naked Balzac, 1896
Bronze, 36¼ x 14⅜ x 14¾ in.
(91.9 x 36 x 37.8 cm)
The Brooklyn Museum; Iris and
B. Gerald Cantor

Many women complain that their lovers do not caress them enough, so what better fantasy than to imagine being loved by not one but two eight-armed octopi. This bit of erotica was made by a man for the titillation of other men, but the image can in fact be interpreted as a positive one for women. The pearl diver is not being abused or demeaned but rather is realizing her wildest dreams of sexual satisfaction. Since the inscription indicates that the octopi are also experiencing pleasure, they are obviously intended as metaphors for men. For Japanese men in the early nineteenth century, the idea of a woman fully enjoying her sexuality, essentially for her own pleasure, must have been tremendously exciting.

Masami Teraoka is a contemporary artist who bases his imagery on famous examples of Japanese art. Here he parodies Hokusai's pearl diver, transforming her into a voluptuous California blonde. She is being

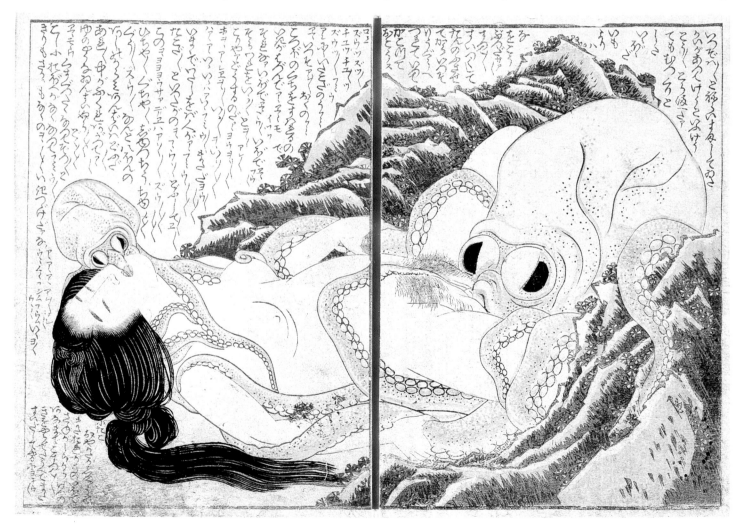

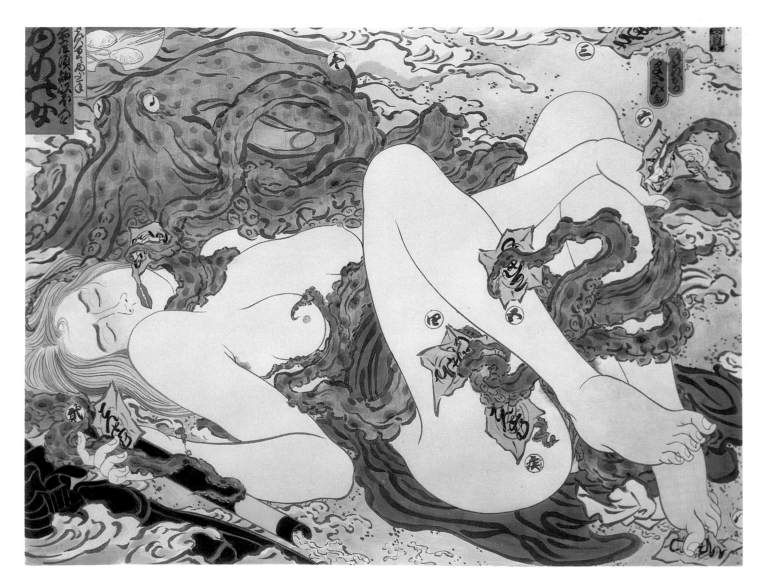

pleasured by a modern octopus that, like a well-trained boy scout, is fully prepared: Teraoka shows eight condom wrappers, one for each arm. The penislike shape near the octopus's head does not have a condom, however, even though it looks erect. It is a perfectly proportioned, circumcised penis, but it would be even better if it were wearing a condom—not only to prevent an unwanted pregnancy, but also to make a strong statement for the 1990s that one cannot be over-prepared to thwart sexually transmissible diseases in general and the fatal AIDS-causing virus in particular. All of this occurs in the woman's dream, and a dream that includes safer sex is certainly the kind of erotic fantasy best suited to our age.

Masami Teraoka (b. 1936) New Wave Series: Eight-Condom Fantasy, 1992 Watercolor on paper, 22⅜ x 30 in. (56.6 x 76.2 cm) Pamela Auchincloss Gallery, New York

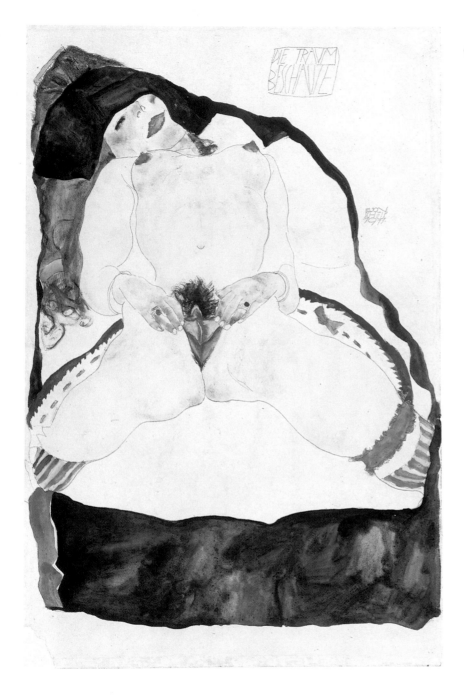

According to Schiele, this is what he saw in his dream, and his fantasy is one that is shared by millions of men. Who would not desire a comely woman, with melon-shaped breasts and erect nipples, who so cheerfully exposes herself for the viewer's delight. Her pose is conveying, without hesitation, "Here it is, come and get it!"

It is amazing how powerful this image remains, despite our inundation with pornography. But the fact is that this is just what many men want, and Schiele has created a refreshingly straightforward embodiment of unabashed masculine desire.

Egon Schiele (1890–1918)
Girl Seen in a Dream, 1911
Watercolor and pencil on paper,
18⅞ x 12⅜ in. (48 x 32 cm)
The Metropolitan Museum of
Art, New York; Bequest of
Scofield Thayer, 1982

Schiele, like Picasso, equated sex with creativity and art. But unlike the many works by Picasso in which the artist shows himself or one of his alter egos joyously sporting an erection or having sex, Schiele's works show the reverse side of the coin: a sad world where sex is a joyless relief from the anxieties of modern life. Schiele was persecuted for displaying his sexually explicit art, and even served a sentence in prison. He died, depressed and destitute, at twenty-eight.

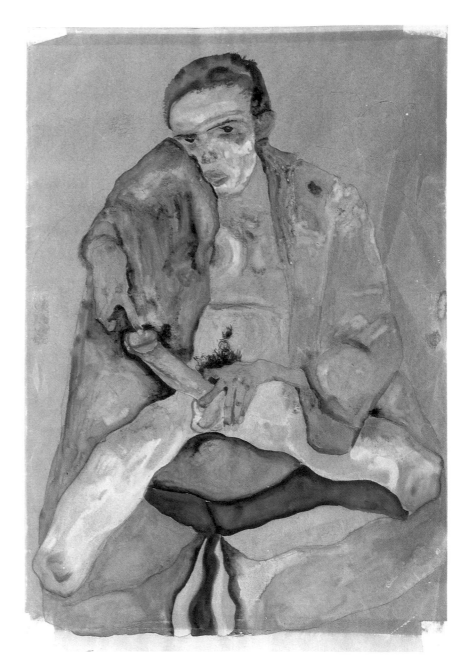

Egon Schiele (1890–1918)
Eros, 1911
Gouache, watercolor, and black
crayon on paper, 22 x 18 in.
(55.9 x 45.7 cm)
Private collection

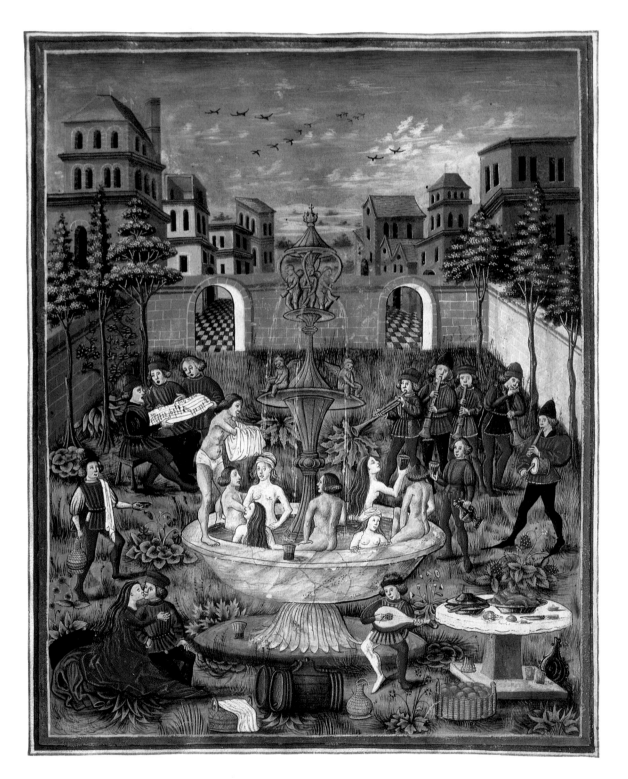

Medieval Bathing Scene,
15th century
Manuscript
Biblioteca Estense, Modena,
Italy

The centuries after the fall of the Roman Empire were a dark and dirty time for Europeans. People stopped taking baths. But the Roman fashion for luxurious bathing came back after the Crusades, after the knights of Northern Europe had become accustomed to the marvelous Turkish baths and wonderfully scented women of the Near East. Baths were set up within or adjacent to most medieval towns, but of course bathing was not the only activity that transpired there. The titillating sight of naked flesh and the abandon that came from the alcoholic refreshments often led to sex. This scene does not show intercourse, only a kissing couple at the bottom left. But the inclusion of musicians, singers, and copious food and drink all indicate that pleasures are about to be indulged in at this festive occasion.

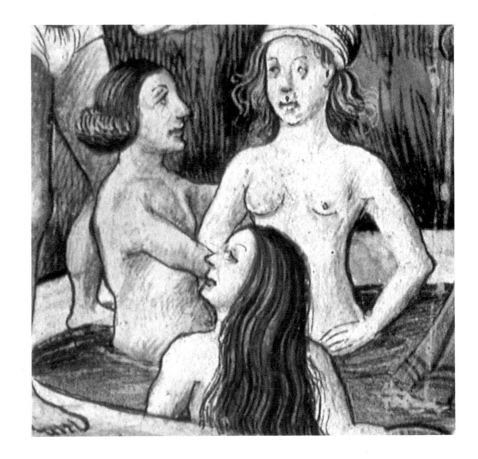

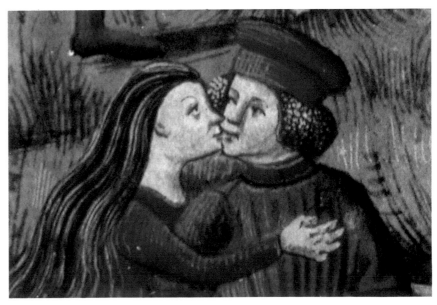

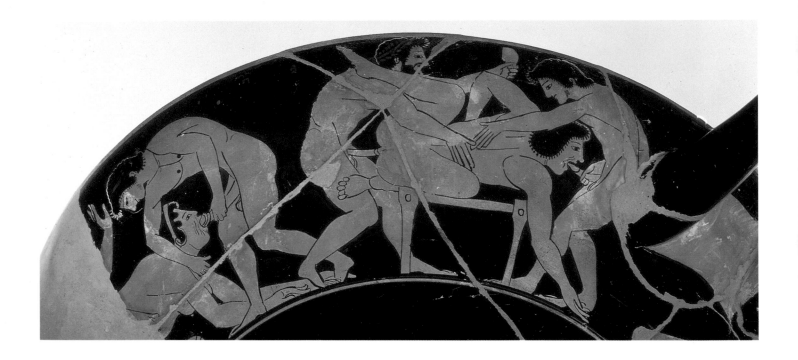

*T*his orgy scene constitutes a virtual catalog of sexual activities, from fellatio to vaginal intercourse—ample proof, if proof be necessary, that nothing is new under the sun. The orgy may represent a symposium, a party for men to which *hetairai* were sometimes invited. Thought by some to be prostitutes, *hetairai* were actually more equivalent to geishas: cultured women who entertained the minds as well as the bodies of men. The philosopher Demosthenes put it simply when he stated, "We keep courtesans [*hetairai*] as mistresses for pleasure, prostitutes for daily service, and wives for legitimate childbearing and looking after our home." According to John Field, cups such as these were often given by satisfied men to their *hetairai*.

*O*nly kings were allowed to own elephants in ancient India. The great beast—called "Gaja" in Hindu—thus came to symbolize royalty and everything that went with it: wealth, strength, and virility. In other cultures the elephant has been likened to "rainclouds walking on earth," and this correlation between elephants and water has caused the animals to be considered symbols of fertility. Virility, fertility—with these sexy associations in mind, this Persian painting of an elephant becomes much more understandable. From a distance we read the figure as that of an elephant, but on closer inspection we see that it is composed of eleven figures enjoying all sorts of stimulating sexual activities. This elephant is indeed a virile beast!

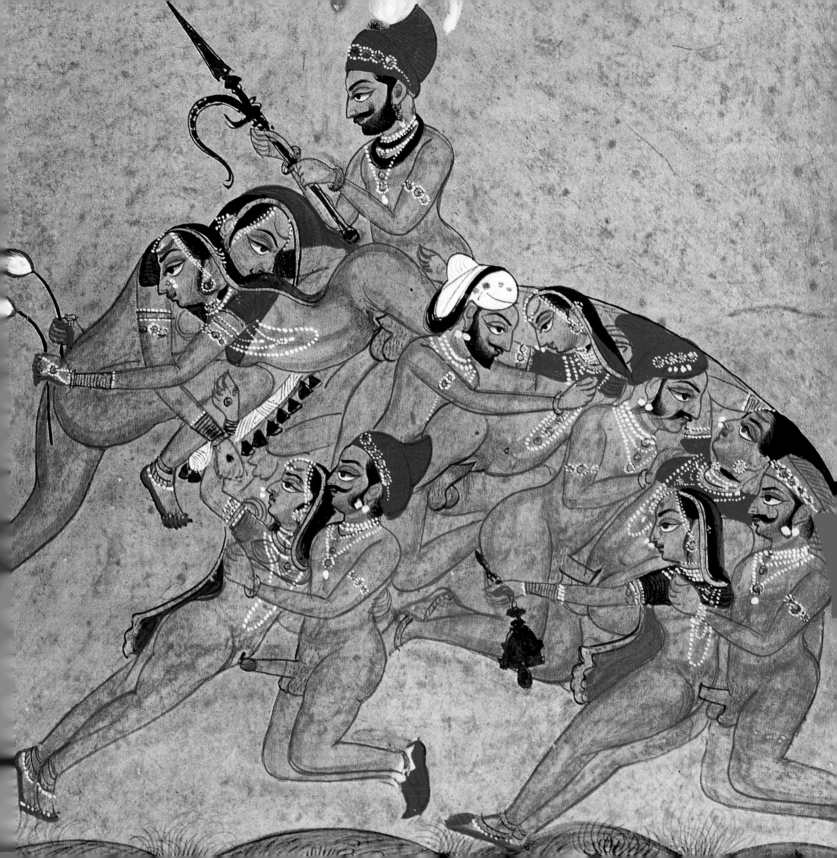

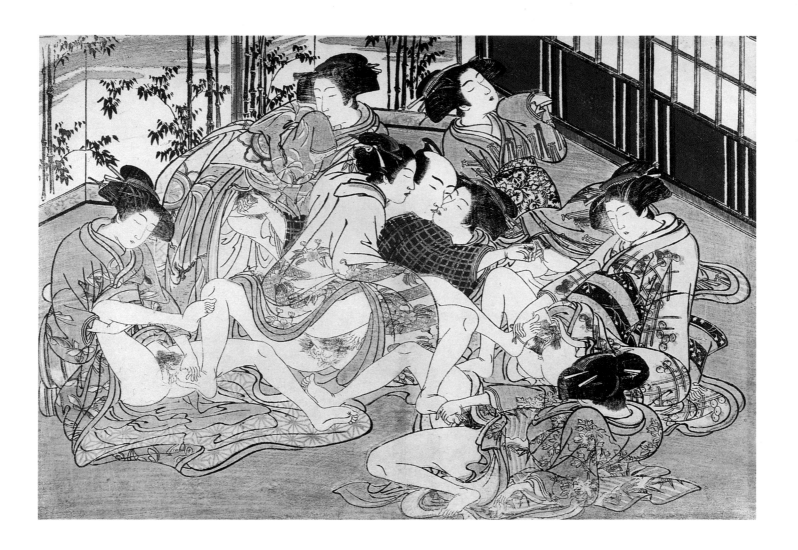

Kitao Shigemasa
A Man with Seven Women,
1780
Color woodblock print,
10 x 14 in. (25.4 x 35.5 cm)
Ronin Gallery, New York

One might think that to satisfy a male fantasy, the author of a composition of seven women and one man might have the women cater to the man's every orifice and appendage. To the contrary, Shigemasa imagined that it would be even more exciting to have the seven women grabbing various body parts in order to stimulate themselves. Fingers and toes are called into play, but there are not enough to go around. One woman, so as not to be left out, has tied a dildo around the foot of another woman to stimulate herself. Clearly Japanese society placed equal emphasis on the sexual satisfaction of women as well as men—a decidedly healthy point of view.

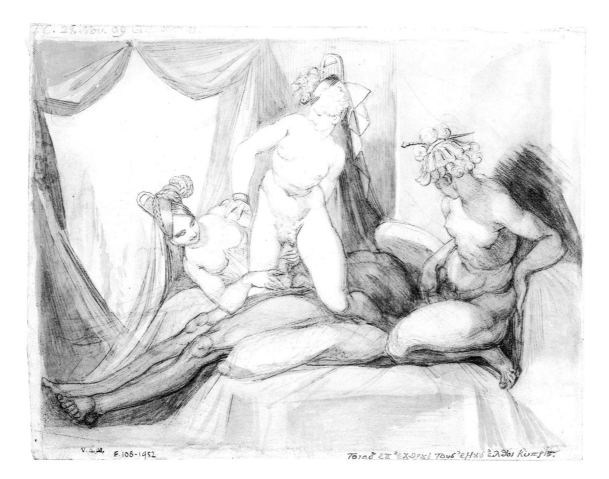

Henri Fuseli (1741–1825)
A Man and Three Women,
c. 1809–10
Pencil on paper,
7⅜ x 9⅜ in. (18.9 x 24.5 cm)
Victoria and Albert Museum,
London

*I*t is hard to know who is satisfying whom in this bedroom scene. For a change, the man is being treated as an anonymous sex object while the women converse and cavort. Nevertheless, this drawing was made by a man to fuel male fantasies, and this viewpoint is made evident by the inclusion of a woman who gently strokes the man's testicles while another woman slides down over his penis. This sort of group sex cannot be recommended in today's world, but women can learn from this picture not to forget the testicles, while men can learn how pleasurable cunnilingus is to many women.

As has been true with most artists, Fuseli's erotic work was not discovered until after his death. It is said that his wife burned many of his sexually explicit drawings, but the fact is that a few do survive, and it could well be that she was the one who preserved them.

*K*eith Haring practiced his art by drawing on the black paper placed over expired advertisements in the underground stations of the New York subway. Inspired by the graffiti that was rampant in New York in the 1980s, he developed an all-over style of drawing that masked the outrageous sexual content of much of his imagery. If you look carefully at this picture, you will see a man performing fellatio on another man, while a third mounts the first guy from behind. All three are riding, as if they were bareback cowboys, on a huge penis, and it is easy to imagine one of them yelling "Yee-hah!"

Haring has said that "a lot of the drawings are about power and force." One does not need to be a feminist art historian to recognize the huge penis as an emblem of power. But a sexual therapist can find another hidden meaning in this picture. The background is filled with figures, each of which has a little squiggle inside. It could well be that those squiggles are viruses. And Haring, whose tragic death at the age of thirty-one came from the virus that causes AIDS, might be showing us the risk of unprotected, promiscuous sex.

Keith Haring (1958–1990)
Untitled, *1982*
Sumi ink on paper, 72 x 672 in.
(182.8 x 1706.8 cm)
Collection, The Museum of
Modern Art, New York

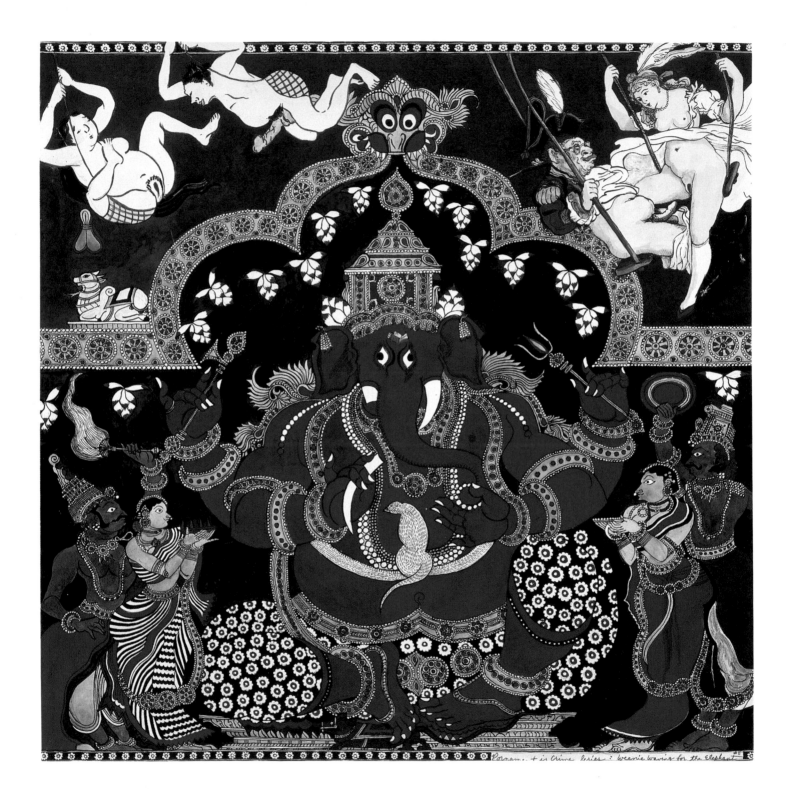

Pornama...t is Crime Series : weenie waving for the Elephant

Joyce Kozloff is one of a new generation
of female artists who have taken frankly
erotic sexuality as their subjects, and she
explores it with a refreshing humor and
sophistication. Rather than condemning porno-
graphy, as so many have done, she seeks to
understand it. Studying erotic art from a
wide-ranging variety of cultures and epochs,
she crafts her discoveries into complex, often
hilarious images that underscore the univer-
sality of sex. Here she shows, for example, a
detail from a Japanese print of a swinging
couple alongside a parody of a Thomas
Rowlandson drawing, which is itself a parody
of Fragonard's *The Swing* (page 51).

Kozloff calls this work *Weenie Waving for
the Elephant*. The elephant is Ganesha, exu-
berant son of the Hindu god Shiva, and we
must assume that the weenies are the penises
of the high flyers in the upper margins. The
artist cleverly notes the Japanese penchant
for exaggerated penises, which she juxtaposes
with the more modest member of the
European at the right.

Joyce Kozloff (b. 1942)
Pornament Is Crime: #8,
Weenie Waving
for the Elephant, *1987*
Watercolor on paper, 22 x 22 in.
(55.8 x 55.8 cm)
Sidney and Shirley Singer

This is the smallest chapter in the book because postcoital activity has been portrayed so rarely: it does not make for very active imagery, but that does not make it any less important than the other stages of lovemaking.

Every erotic experience ideally should leave both partners thoroughly satisfied, and that means that lovemaking doesn't end with orgasm. The resolution phase is longer for women than for men, but for both partners the investment of time in afterplay—in caressing, in affectionate cuddling, in holding each other close as you drift off to sleep—will pay great dividends at the time of the next encounter.

Women, if your partner has trouble staying awake after sex, take a tip from Botticelli's Venus and do whatever is necessary to rouse him. Any kind of conversation after sex is nice, so long as it is pleasant. Don't expect a lengthy intellectual discussion, and *don't* analyze what you have just done ("How was it for you?" is a terrible turn-off). Don't bring up unfinished business, nagging complaints about your relationship, or—above all—comparisons to other lovers (even favorable ones).

Take the time to savor the moment with the person who is lying next to you. Enjoy this encounter as if it may never happen again, but at the same time bring it to a loving conclusion that will make the next experience even better. Think of afterplay as foreplay for the future!

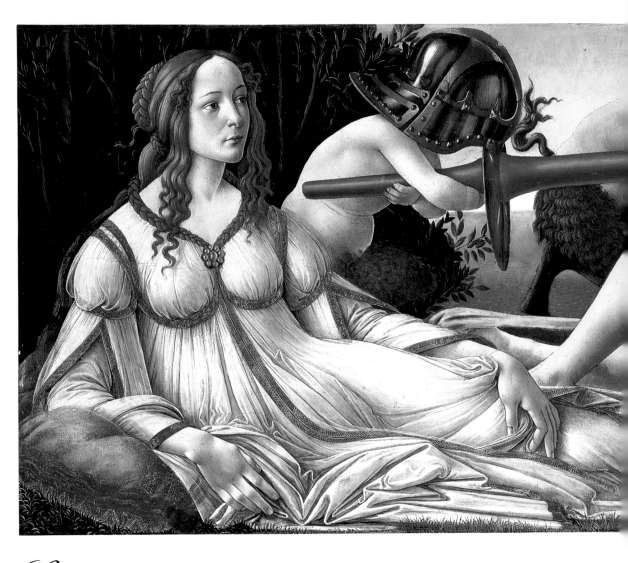

*S*cholars have not identified any text or mythological episode that inspired this painting, and they have never been able to agree on what exactly it is about, but most likely it alludes to events at the court of Lorenzo de Medici or perhaps in the life of his brother Giuliano.

What no one doubts is that Botticelli has portrayed the goddess of love, Venus, easily recognizable by her idealized beauty and cost-ly gown, and the god of war, Mars, just as recognizable by his discarded armor (which has been taken up by the playful young satyrs). It is also clear that Botticelli assumed his audience would know that Mars was having an illicit affair with Venus, wife of his brother, Vulcan.

But what is really going on in this painting? In the Renaissance, as in antiquity, where there are satyrs there is sex. Has Mars

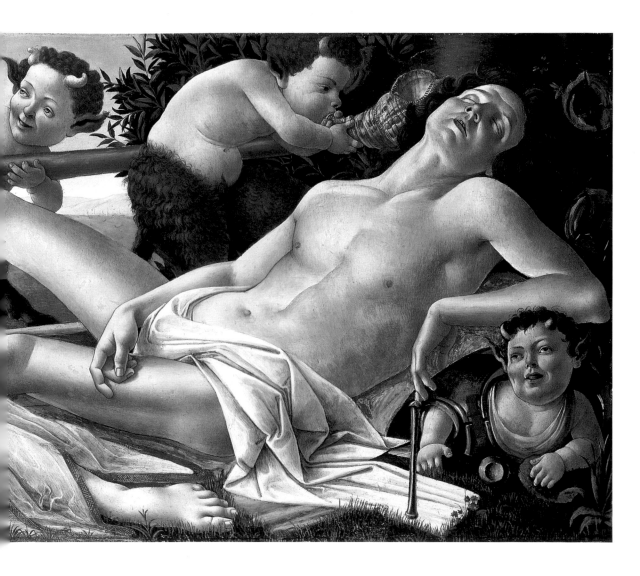

conjured up Venus in an erotic dream? Or
has Mars fallen asleep after sex, and has
Venus, left unsatisfied, instructed the satyrs
to rudely awaken him with a blast in his ear?
Venus represents harmony and spiritual love
while Mars represents discord and erotic
love, so it is also possible that Botticelli is
telling us that erotic love quickly tires, but
spiritual love is eternally ready to be renewed.

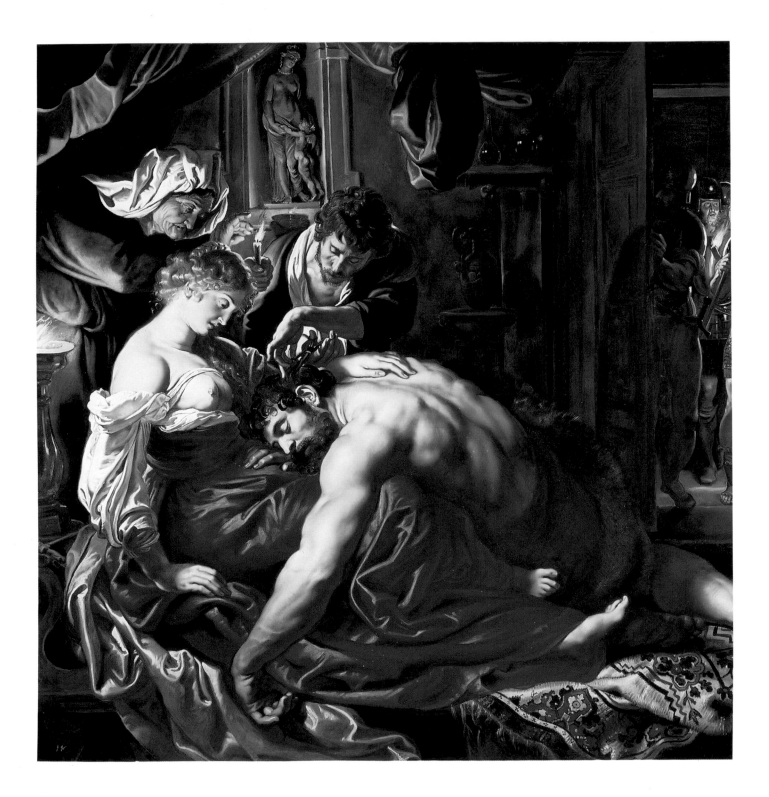

Like Jupiter of the Romans, the Hebrew Samson had a sexual appetite as insatiable as his strength was inexhaustible. Chapter sixteen of the book of Judges relates how Samson slept with a prostitute in Gaza and afterward still had the stamina to pick up the gates of the city, "and the two posts . . . bar and all," and to carry them to the top of a neighboring hill.

The lords of the Philistines wanted to do away with Samson, so they bribed one of his mistresses, Delilah, to discover the source of his superhuman strength. After three misleading statements, he confessed that his power lay in the fact that his head had never been shaved, because he had always strictly conformed to the tenets of his religious sect. Delilah revealed his secret to the Philistines, and, presumably after exhausting him with sex, "she made him sleep upon her knees; and she called for a man, and she caused him to shave off the seven locks of his head; and she began to afflict him, and his strength went from him."

Rubens, faithful to the biblical text, shows the brute asleep on his temptress's lap, her breasts exposed as a symbol of the lust that was his downfall. The jubilant Philistines wait behind the door, but their victory was to prove incomplete. Samson's hair grew back. And just as the Philistines were preparing to humiliate their captive, God gave him the strength to bring down the prison, killing not only himself but thousands of Philistines as well.

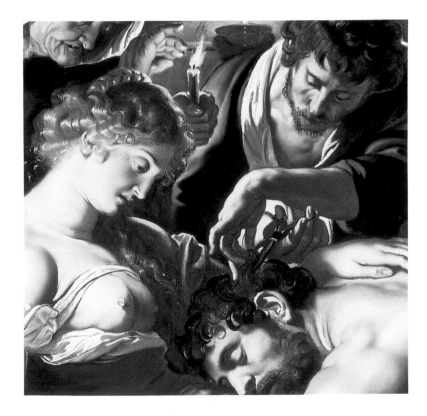

Peter Paul Rubens (1577–1640)
Samson and Delilah,
c. 1609–10
Oil on wood, 72¾ x 81 in.
(185 x 205 cm)
The National Gallery, London;
Reproduced by the courtesy of the
Trustees

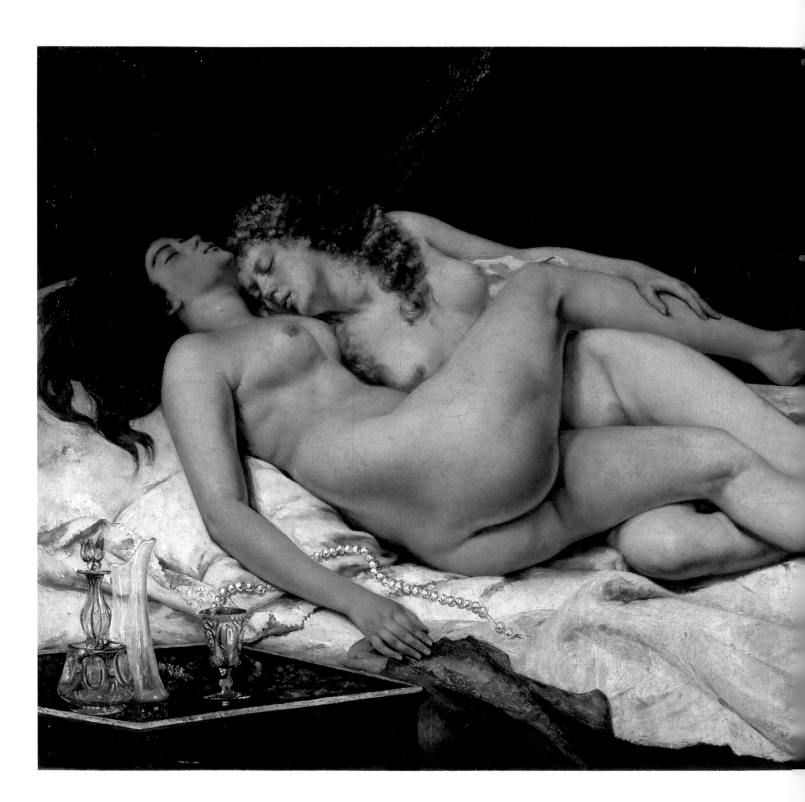

On a bed strewn with jewelry that was discarded during passionate lovemaking, two women cuddle in sleepy aftermath. Unlike most men, women often desire close contact after orgasm, and the Realist painter Courbet ostensibly has revealed here his intimate knowledge of female sexuality. No one can deny that female flesh was portrayed knowingly and lovingly by the hand of Courbet, who was deeply moved by the look, feel, weight, and smell of women.

What is not explicit in this image is that Courbet borrowed the subject and the composition from a Romantic lithograph by Achille Devéria that was an illustration to a novel by Sir Walter Scott. Once we recognize this, the painting seems less a truthful evocation of a scene that Courbet had experienced himself than an attempt to bring a still-shocking subject to the realm of high art. Scenes of lesbian love have long been used to arouse men, who seem to find extra excitement in the thought or sight of two or more women giving pleasure to each other. The man who commissioned this picture, a rich Turk named Khalil Bey, also owned another famous painting with lesbian overtones, Jean-Auguste-Dominique Ingres's *Turkish Bath,* as well as Courbet's notorious *Origin of the World* (page 34).

Gustave Courbet (1819–1877)
The Sleepers, *1866*
Oil on canvas, 53 x 78⅜ in.
(135 x 200 cm)
Petit Palais, Paris

*H*ow wonderful to lie with one's lover after sex and order room service, as Cézanne's couple has just done! These lovers, however, are surely not married, for the title suggests a romantic interlude in a brothel in Naples. It is clear that Cézanne never witnessed such a scene but, with his fervent imagination, has invented it. He wanted his painting to conjure up reminiscences of Edouard Manet's *Olympia* (page 18) or Thomas Couture's *Romans of the*

Decadence, paintings that had created great commotions at the annual Salon in Paris. Cézanne submitted to the 1867 exhibition a painting with a subject similar to that of *Afternoon in Naples,* but, unlike the *Olympia,* it was never shown.

Cézanne's own sex life is still the subject of speculation. He had a strong fantasy life, but he may never have acted upon it. His marriage to his model Hortense Figuet does not seem to have been fulfilling for either of them.

Bonnard's exquisite harmonies of red and green mellow but do not mask the sexual content of this picture. And, like Bonnard's gentle palette, the sexual content is expressed without tension or anxiety. With natural ease a man, probably the artist himself, stands up to dress after making love with his companion—most likely the painter's wife, Marthe. Although Bonnard has set up an opposition by separating man from woman with a dressing mirror, the opposition is compositional rather than psychological. The artist probably wanted a way to cloak the male in shadow so that his nudity would not become too great a distraction from the beautiful figure of Marthe, who peacefully plays with the household cats.

Bonnard was one of several artists at the turn of the century who, reacting against the emotional excesses of Symbolism, downplayed the sensational aspects of sex and returned it to the realm of natural human activity. Many of his pictures of Marthe around 1900 are sweetly erotic. Although she continued to be his principal model and muse, Bonnard's pictures later became less erotic and more formal.

Pierre Bonnard (1867–1947)
Man and Woman, *1906*
Oil on canvas, 45⅜ x 28⅜ in.
(115 x 72 cm)
Musée d'Orsay, Paris

173

Acknowledgments

Let his left hand be under my head and the right hand embrace me. . . . that ye awake not nor stir up love until it please.

SONG OF SONGS 2:6–7

My gratitude goes to the following people who made this publishing venture not only a reality but such a tremendous pleasure! First thanks go to Robert E. Abrams and Mark Magowan at Abbeville Press and to Barbara Greenman of the Literary Guild, who conceived of the idea.

Andrew Shelton spent weeks in the library, with a smile on his face, doing the research essential to making the initial choice of pictures and to telling the story of each object. Other scholars provided rich lodes of research that have been mined for this far-ranging book, and I'm grateful to them all. Although they are too numerous to name individually, I would like to single out Ken Hamma and Jan and Chuck Rosenak.

Anne Manning, Lori Hogan, and Margot Clark-Junkins toiled tirelessly to secure the photographs. My heartfelt thanks go to them and to all the museums and private collectors who responded to our requests with enthusiastic cooperation. Patricia Fabricant created an exuberantly romantic book design that captures the spirit of these lively images, and for that I am most appreciative.

Last and greatest thanks go to Nancy Grubb, who has been a full partner in every stage of this endeavor. I recognized right at the beginning that she was a superb editor, but now she has also become a friend. We are already planning a sequel—with this same cast of characters.

A final word of gratitude goes to my family and friends: Fred, Miriam, and Joel Westheimer, Joel and Ari Einleger, Pierre Lehu, Fred and Ann Rosenberg, Fred Howard, Bonnie Kaye, Sydell and Henry Ostberg, John A. Silberman, Hannah Strauss, and Gary Tinterow.

Index

Page numbers in *italics* refer to illustrations.

Photography Credits